Picasso's Weeping Woman

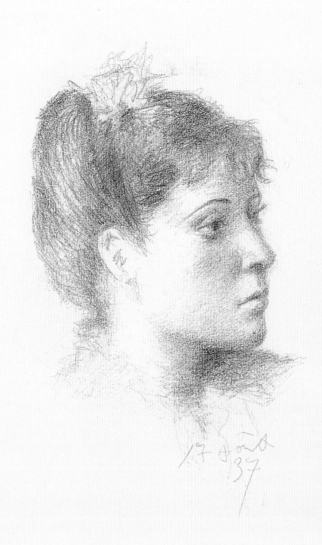

Picasso's Weeping Woman

The Life and Art of Dora Maar

MARY ANN CAWS

A BULFINCH PRESS BOOK
LITTLE, BROWN AND COMPANY
BOSTON · NEW YORK · LONDON

The publishers would like to express their thanks first and foremost to Patrick Mauriès, to whose initiative this project owes its origin. Equally warm thanks are due to PIASA (Picard, Audap, Solanet & Associés), 5 rue Drouot, Paris, without whose generous cooperation it could not have come about.

Frontispiece: Pablo Picasso, *Dora with a Chignon*, 17 August 1937.
p. 6: Pablo Picasso, *Portrait of Dora Maar*, 11 September 1936.
This pen-and-ink drawing reads "fait par coeur" (made by heart).
Dora Maar began to appear in Picasso's art soon after they became lovers in 1936. By mid-September, his intimacy with his new muse was complete.

First published in the United Kingdom in 2000
by Thames & Hudson Ltd, London

First North American Edition, 2000
ISBN 0-8212-2693-2

Library of Congress Control Number 00-104296

Bulfinch Press is an imprint and trademark of
Little, Brown and Company (Inc.)

PRINTED IN ITALY

Contents

Mougins 11 septembre XXXVII
fait par cœur

'They're all Picassos, not one is Dora Maar…. Do you think I care?

Does Madame Cézanne care? Does Saskia Rembrandt care?'

DORA MAAR TO JAMES LORD

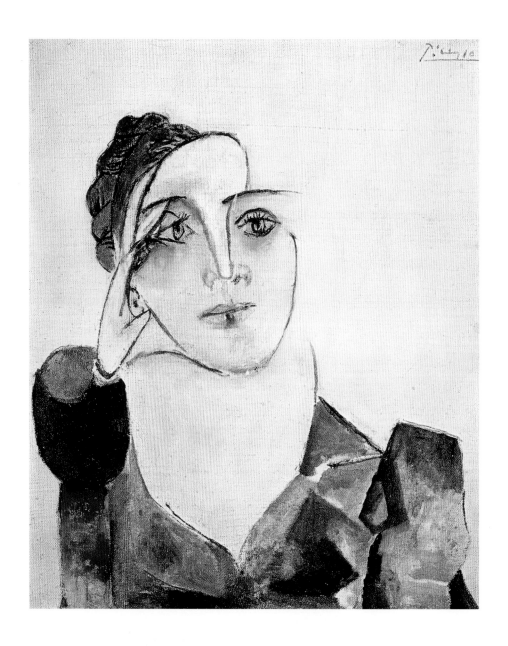

Yes. I believe it. My fate is magnificent however it seems.

I used to say my fate was very harsh however it seemed.

DORA MAAR, 23 MAY 1946

'Picasso's Weeping Woman!' For years, this epithet has followed every mention of Dora Maar, as if tears were her only significant characteristic. Or, more sympathetically: 'The trajectory of Dora Maar, in life as in photography, seems that of a meteorite which came too near the sun….' Dora Maar's later years, lived as a recluse, further fixed her as a victim. She was said to have suffered 'a nervous breakdown nearly of madhouse gravity and to be living in seclusion.'[1]

Dora Maar's life was not so different from such portrayals, but it was far fuller, and her work, particularly her photography, more inventive, more original and more deserving of attention than they suggest. A few of her photographs, such as *Portrait of Ubu*, *Silence* and *29 rue d'Astorg*, are emblems of the Surrealist movement, and are still frequently reproduced (see pp. 72–78).

Even so, Dora Maar's reputation as a photographer has been sustained largely by her record of the creation of Picasso's *Guernica* in 1937, in which the traits of her face are represented in those of the woman raising a lamp in the centre of the work. She was also the subject of numerous Weeping Women painted during that year. After her abandonment by Picasso, the tragedy of Spain was read back into her face; she became, in the public eye, an archetypal figure of grief. The melodrama of her life and her representation by Picasso have obscured a woman of talent, passion and conviction.

She had great dignity too. The American writer and art historian James Lord described her as possessing the 'temperament, the personal greatness' for the major ordeal of loving the philosopher Georges Bataille and then Picasso himself. Her own studies of the Weeping Woman (*Weeping Woman on a Red Background*, for example, on p. 130), are self-conscious but not self-pitying; they are sophisticated references to Picasso's depiction of her. As the artist Raymond Mason put it: 'At the time of Guernica she was grief-stricken, no wonder she wept. She was exactly the contrary of what people say. She was *très à gauche* and a great influence on Picasso. We often dined together, she and Janine [Mason's wife] and myself, she

Pablo Picasso, *Portrait of Dora Maar*, 1936. Picasso's earliest portraits of Dora Maar are often tender and calm. It was in 1937, the year of *Guernica* and the *Weeping Woman*, that her image underwent the ravaging distortions that have ever after shaped the popular idea of her character. As a committed anti-Fascist, Dora Maar shared Picasso's dismay at the civil war engulfing his homeland; but above all, in the words of Pierre Daix, 'Picasso shouted his rage through the heads and faces of the women in his life'.

9

liked talking with us. I once asked her: if Picasso asked you to marry him, would you accept now? *S'il le faisait de la bonne façon*, she replied. (Yes, if he asked the right way.)'[2]

We can no longer hear Dora Maar, but we do know more all the time about her life apart from as well as with Picasso. Her training and practice as a photographer and a painter have begun to come under scrutiny in recent years. After her death on 16 July 1997, many came to pay her homage at the series of sales of items from her estate.

This book pays her homage too, placing her time with Picasso within the scope of her long life of ninety years. She had other lovers, including not only Bataille but the film-maker Louis Chavance. From her early years in Argentina, through her Surrealist period, and then her 'worldly period' immersed in the cultural life of Paris, she was an intensely social person. And even at her most reclusive, she was never lacking in friends. She would have lengthy conversations with them on the telephone … although she often refused to see them when they appeared. Her command of her own life – as a photographer, an artist, a lover, a reserved and elegant woman, and finally as a religious recluse – should be given its due. The woman Picasso encountered in 1936 was an established artist, whose strong political convictions and relationships with other men had given her considerable worldly assurance. Françoise Gilot, her successor in Picasso's affections, conceded that Dora Maar was 'an artist who understood him to a far greater degree than the others.'[3]

This account is based on material published and unpublished, on interviews with those who knew her, and on a perusal of her work and correspondence. The views of her are various, both of her person and her personality, but all agree on a crucial point: what defined Dora Maar above all was an acute intelligence, personal pride and creative passion. Her qualities were well expressed by one of her Paris neighbours in the phrase '*amour-orgueil*', love and pride mingled.[4] When she turned from Picasso to God (from whom, we might hope, she has had better treatment) it remained intact, as her recently discovered poems make clear.

All her friends comment on her striking presence, especially her eyes and voice, though few descriptions concur. Her eyes are remembered as compassionate and kind, or intense and burning. Her neighbour in Paris, Ariane Mercier, recollects them as possessing extraordinary gentleness and depth. Those pale eyes, say Brassaï and René Crespelle. Her dark eyes, glimmering like jewels, says one source, or again the 'streaks of blue sky crossing her black eyes'. Her oval face, husky voice and bronze-green eyes, says still another.[5] In Picasso's own vision of her, they are always dark.

Her voice, too, is remembered variously. For Raymond Mason, it was deep, trembling and enormously appealing. Her English friend June Jones, another neighbour and the person closest to her at the end of her life, found it attractive; she heard it a great deal, for they knew each other well. James Lord speaks of the 'unique beauty of her speech, the extraordinary birdsong resonance of her intonations, as if from her throat issued the quivering but inimitable voice of the skies, ever so sweet, almost melancholy, yet quick, in flight and incisive at the same time.'[6] Dora Maar was fully aware of this. She once criticized her friend and helper Rose Toro Garcia for wearing a short skirt; it was not gracious, she told her. 'But,' said Rose, 'how could you have seduced Picasso if you hadn't done it like this?' 'Ah,' Dora replied: 'with my voice.'[7]

INTRODUCTION

The indefinability of her voice, her eyes, her being was a major part of her seductive appeal. Dora Maar, so remarkably elusive, is a subject worthy of obsession. She must have known this. As one commentator pointed out: 'Maar seems to have had abiding faith that history would give her her due ... selecting silence instead of the celebrity she might have earned by capitalizing on her years with the great man.'[8]

How do you write about a recluse, the details of whose early life as well as of her thirty years set apart from the world are equally unavailable for comment? If interpretation is part of modern biography, it is certainly required in the case of speaking about 'the astute and perceptive Dora Maar'.[9] Despite her choice for privacy, extraordinary public spotlight has been shone on her in recent years by such events as the 1999 Sotheby's auction in New York of the Saidenberg collection, at which her portrait by Picasso, *Portrait of Dora in a Garden* (10 December 1938, p. 125), fetched forty-nine and a half million dollars. Yet if her anguished face has become the very symbol of tragedy, Dora Maar was not always weeping, even for Picasso. The subject of *Portrait of Dora in a Garden* is elegant, distinguished and composed. Another portrait, *Woman Seated on a Chair* (7 May 1938, p. 122), was the star of the 1999 London auction of the Versace Collection. Here again she is not weeping, as she was so often depicted a year earlier, at the time of *Guernica*. No less sensitive than Picasso to the horrors of that bombing episode, she had every reason to weep.

The sale of her estate was, according to one witness, Picasso's 'true, if long-delayed, apotheosis. The painter would have relished the scene with his sardonic smile and that burning glint in the eye. The attendants gobbled up every single lot down to the merest scrap at financial levels that said little about the art market and all about the price of a myth – the myth that Picasso has become....' The excitement, and the prices, generated by her collection of Picassos were as much about historic and sentimental value as artistic merit: 'The Dora Maar sale was a sequel to the Duchess of Windsor auction in Geneva and the Jacqueline Kennedy Onassis auction in New York. It was less about substance than about myth. The substance was not art but verbiage.'[10] The fallout from all this was predictable: she too became a myth.

Although Dora Maar left many memorable works, such as her portrait of Alice B. Toklas in the Beinecke Library at Yale University, and although study of her art and life has been begun by Victoria Combalía, to whom all those who write about Dora Maar are in enormous debt,[11] discussion of her development as an artist has largely revolved around the same topic: the influence of Picasso. Was her personality and her art exclusively ruled by his? Were her Picasso-like canvases mere imitations? Was her great talent as a photographer wasted when she reverted to painting during her relationship with Picasso? Did she take up painting again purely at his behest, as she let her hair grow long in the Spanish style since he liked it in that fashion? And in her last years of religious devotion and reclusion, had she abandoned her sense of humour and incisive intelligence? When we look at the shape of her life, what sort of sense does it make on its own? To that last question, this book tries to give an answer. It means to be not about a myth, but about a person, her life and her art.

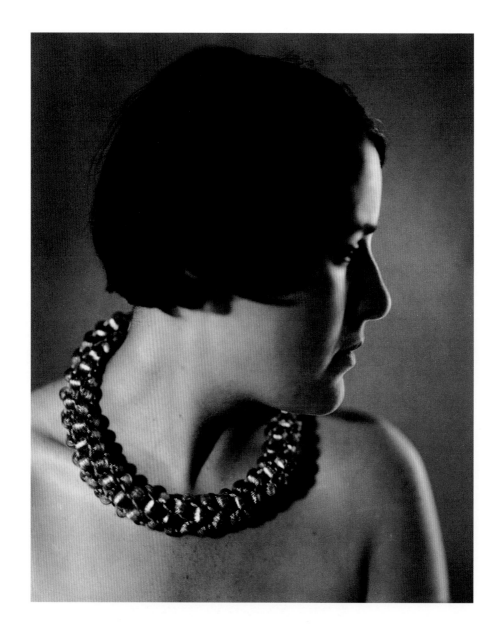

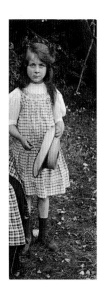

The memory of the garden returns
Around the peaceful house
My mother and I loved her...
Songs and tears
Unique magnolia pure, so far off
DORA MAAR, AFTER 1970

Opposite: An anonymous portrait of
Dora Maar in the early 1930s when
she was first building her career as
a photographer in Paris. Dora Maar
– or Theodora Markovitch as she was
originally – spent much of her youth
in Argentina, where her father practised
as an architect. Her parents were
comfortably well-off but unhappily
married, and she was a dreamy,
introverted child (above).

Henriette Theodora Markovitch was born in Paris on 22 November 1907 on the
rue d'Assas in the sixth arrondissement. She was the only daughter of a Croatian
architect, Joseph Markovitch (1874–1969), who had studied in Zagreb, then
Vienna, and arrived in Paris in November 1896. By some accounts he was Jewish,
though Dora Maar denied that in her later life, and the truth is now obscure. Her
mother was a French Catholic from Tours, *née* Julie Voisin (1877–1942), whose
father, Jules Voisin, died in 1924.

When Theodora was three years old, the family left for Buenos Aires. Her
father had secured commissions for several important buildings there, including
the Austro-Hungarian Embassy, for which the Emperor Franz Josef I gave him a
decoration. Yet Dora told James Lord that her father must have been 'the only
architect who failed to make a fortune in Buenos Aires.'[1] Her facility in Spanish
would be a part of her appeal for Picasso: it seems that when they first met, he
addressed her in French and she replied in his native tongue. As one of the more
lurid accounts of the meeting put it, 'the collision course was set.'

She confided in James Lord about the strife between her parents, and the
lack of privacy she suffered during her childhood. Her room had a glass door
covered by a curtain to the outside, so that she could be spied on at any time and
could never be entirely alone. Perhaps her late reclusiveness was influenced by her
early lack of privacy; we can only speculate.

At school in Argentina Theodora made good friends, in particular with an
English girl from whom she learned her English. She spoke both Spanish and
French fluently, and read widely in English until the end of her life. Like many
left-handed children of her time, she was made to write, eat and conduct her
normal affairs with her right hand. However, she drew and painted with her left
hand her whole life long.[2] This may go some way towards explaining the occa-
sional awkwardness of her paintings.

 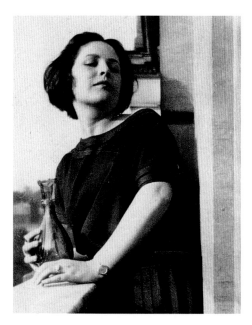

Above: Family snaps of Dora Maar as a teenager. Opposite: This portrait with skeletons (possibly a self-portrait) dates from her years as a student and young bohemian in Paris in the late 1920s. The fairground photograph taken while she was still in Argentina shows her as a teenager (arm resting forward) in the company of friends and perhaps her parents. It is an amusing precursor of Dora Maar's photomontages of the 1930s.

In 1926, when she was nineteen years old, her family moved back to Paris. Theodora took up studies at the Union Centrale des Arts Décoratifs and the Ecole de Photographie, before entering the Académie Julian, where women were able to receive the same training as male students at the Ecole des Beaux-Arts. The school had been founded in 1868 by Rodolphe Julian. It had several locations, including Notre-Dame-de-Lorette, 28 rue Fontaine; 5 rue de Berri, on the Boulevard Montmartre, in the Passage des Panoramas; and at 55 rue du Cherche-Midi. Female students there were permitted to study from the nude model, since they did not have to paint in the same room as men.[3] Theodora also attended lessons on painting in André Lhote's studio, where she met the young Henri Cartier-Bresson. It was in this period that she shortened her name to Dora Maar. She divided her time between painting and photography, until she began to receive far more encouragement for her photography and decided to pursue that full time. Yet when Picasso belittled her photographic talent, and urged her to resume painting instead, she was to acquiesce: no sacrifice was too great.

An early fairground snapshot of Dora and her family in a zeppelin, taken in Buenos Aires, is joyous and characteristic of the period. It also, by chance, prefigures the Surrealists' attraction to fairgrounds, circuses and places of performance. The poet Paul Eluard, to become Dora's closest male friend, first saw his future wife Nusch practising cartwheels on the street while he was out walking with the poet René Char. A frail and lovely seventeen-year-old, she was a performer at the Grand Guignol before she married Eluard. Such magical encounters were part of the Surrealist myth. After Nusch's early death, he was to fall in love with another circus performer, Diane Deriaz. She was a star of the flying trapeze with the Pindar circus until a fall put an end to her career. One of the many characteristics Dora shared with Paul Eluard was this attraction to persons and places of performance at high risk. Her photographs of this period and the early 1930s have something almost Expressionist about them, a taste for high drama, along with something more troubling. Her innate sense of humour, on which all her friends

BEFORE IT ALL

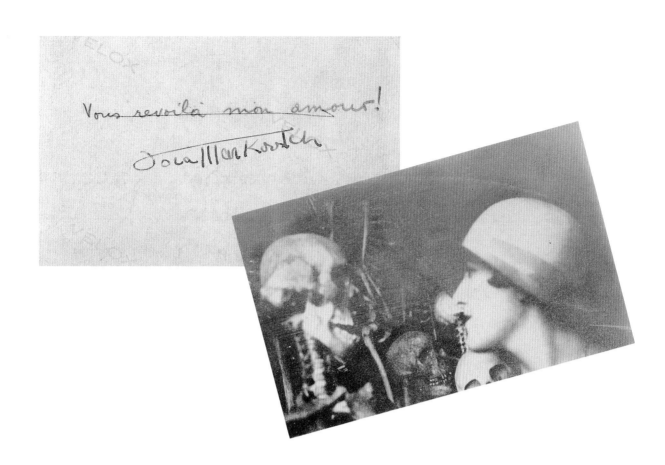

Vous revoilà mon amour!

Jola Markörtch

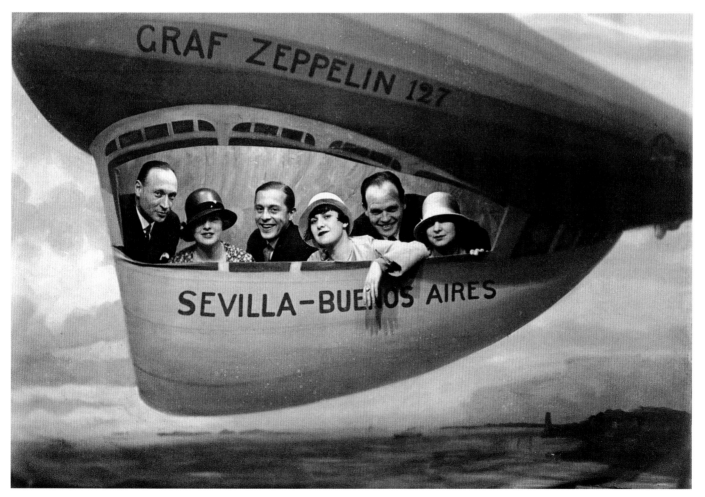

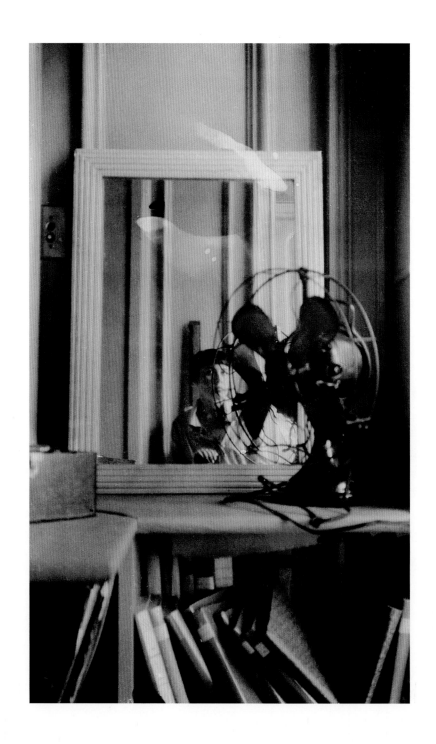

Opposite: An early self-portrait from the late 1920s that captures all the layered, reflective poise of Dora Maar's character. Above: Adventure on the high seas – three photographs taken with her Rolleiflex camera (below) during her early travels.

have commented, has a similarly macabre edge: in a humorous yet not so humorous pose with a skeleton of *c*. 1927, a self-portrait or student collaboration, Dora is smiling into the face of a skull. The inscription reads: 'There you are again, my love! Dora Markovitch.' This confrontation of life and death, smile and skull, has the combination of Expressionist and Baroque qualities so frequently found in Surrealism. Recalling a *vanitas* painting – a woman before her mirror, a table gleaming with delights, and a *memento mori*, a reminder of death, in a timepiece or a skull – this photograph is a clear indication that Dora Maar was already in possession of the techniques and temperament befitting a Surrealist artist. She was undaunted by extremes.

Dora Maar's earliest surviving photographs were taken with her beloved Rolleiflex camera on a cargo ship bound for the Cape Verde Islands in the early 1920s. The foghorns and the lifebelts, the chains and open decks, project a tremendous sense of adventure on the high seas. Dora herself was always willing to yield to new and strange experiences, always ready to set out for adventure.

It was this venturesome attitude that so fully qualified her for the Surrealist enterprise, for companionship with a great artist, and, finally, for her own journey into reclusion and religion. In the late 1920s she photographed her reflection in a mirror, the shape of her face echoing and yet obscured by a fan standing before it on a ledge. Surrounding the circles of fan and face are truncated rectangular shapes – the wall behind the mirror, the mirror's frame, the ledge and a shelf of books in the foreground. Frame within frame and circle within circle: from the beginning, Dora Maar's photographs show a flair for complexity which never diminishes the drama that sets them apart.

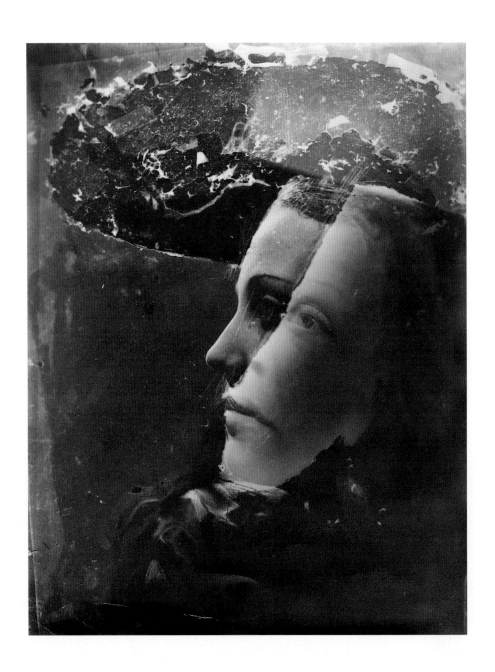

…the photographic plate turning on an axis at a greater speed than the images moving around it and finding the bouquet of surprises already faded not yet plucked…

PABLO PICASSO, 7 JANUARY 1940

In 1931 Dora Maar photographed Mont-Saint-Michel for an illustrated book by the art critic Germain Bazin. Her pictures, made in partnership with Pierre Kéfer, another young photographer, capture the sense of mystery that pervades the island monastery, seen upon its rocks against the sky. They concentrate on the play of angles and shadows and on sharply plunging perspectives caught in the downward fall or the vertical ascent of the flight of steps, leading into a sort of nothingness, like the beginning of a good mystery. A drama of desertion permeates Mont-Saint-Michel, and these photographs give the feeling of abandonment, sensed in those lonely walls against the open heavens. Humour is also at play: above the fabled and dangerous inrush of tides, she and a fellow photographer (probably Kéfer) spoof themselves and their tricks in a picture that shows them apparently about to fall off the edge … clutching their cameras, of course.

Opposite: A photomontage dating from Dora Maar's first years as a professional photographer in the early 1930s, perhaps commissioned for a beauty magazine or advertisement. The double profile made by superimposing two negatives creates a strikingly Picasso-esque effect. Right: A light-hearted moment at Mont-Saint-Michel in 1931 with fellow photographer Pierre Kéfer. Most photographs of Dora Maar express her stillness and poise; this playful shot, like the anonymous snap above, is a rare exception.

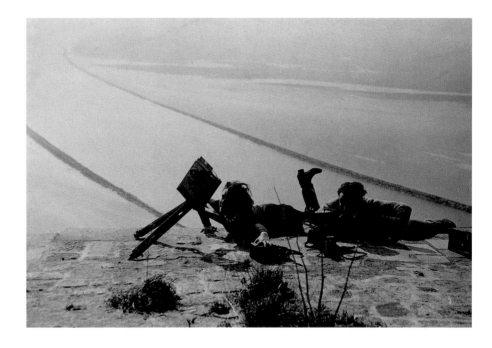

Below: Like many of Dora Maar's photographs, these late-1920s shots of Paris after heavy rains owe their impact to sheer perspective. Opposite: One of a series of photographs by Dora Maar and Pierre Kéfer of Mont-Saint-Michel, commissioned by the art historian Germain Bazin in 1931 to illustrate his book about the island monastery. This was one of her first jobs as a professional photographer.

The power of Dora Maar's photography often arises from her feel for plunging perspective. It is particularly effective in her rendering of a rainswept Paris, photographed from high above the treetops. She captures the mysterious, in a combination of the unresolved and the sharply angled. This frequently creates a sense of ambiguity, even menace. Objects jut out across the field of vision or the view plunges downwards in a way that owes much to the tradition of Japanese prints, such as those of Utamaro and Hiroshige.

Dora Maar set up a studio with Pierre Kéfer in the early 1930s. Kéfer had previously worked as a set designer: he created the sets for the film *The Fall of the House of Usher*, directed by Jean Epstein and Luis Buñuel in 1928. Their first studio was in the garden of the Kéfer family residence at Neuilly, but they soon moved to their own premises at 9 rue Campagne Première, in the fourteenth arrondissement, in the vicinity of Raspail-Montparnasse. They were lent this space by a mutual friend, Harry Ossip Meerson, a Pole who was to become an American citizen and a famous fashion photographer for *Paris-Magazine*; he would eventually join his brother, the art director Lazare Meerson, in Hollywood. In exchange for the loan, Dora Maar helped Meerson retouch his photographs, sharing the darkroom with the Hungarian-born photographer Brassaï. He was already famous by that date, and Dora Maar was an admirer of his work.[1] This meeting marked the beginning of an acquaintance that lasted well into the 1940s, throughout and beyond her years with Picasso.

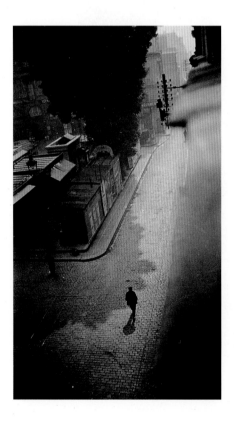 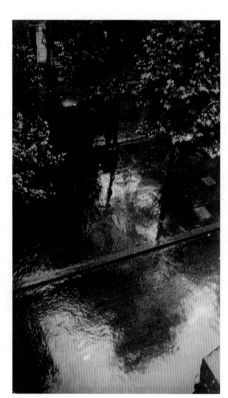 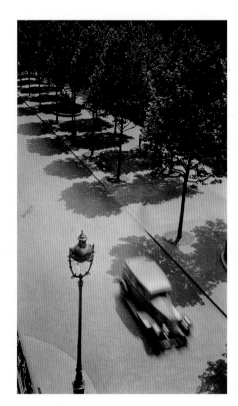

THE YOUNG PHOTOGRAPHER

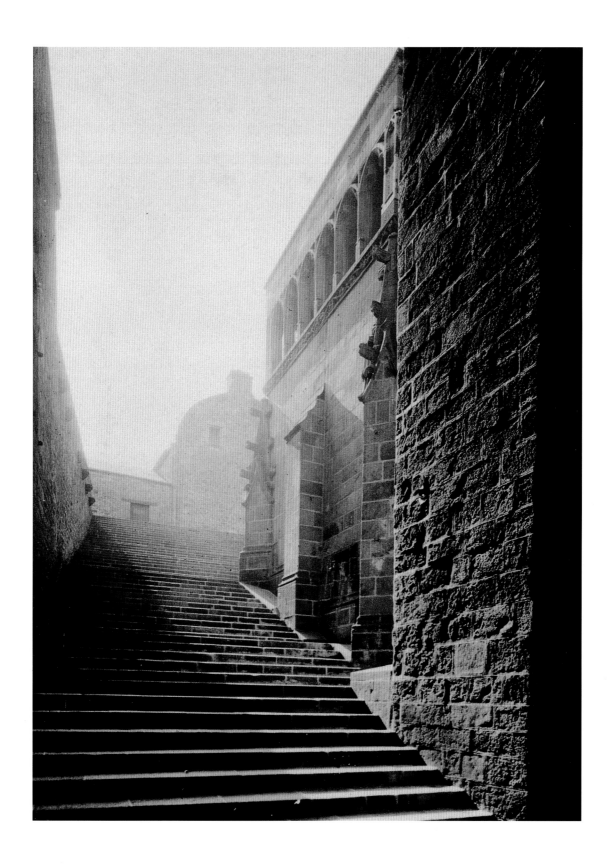

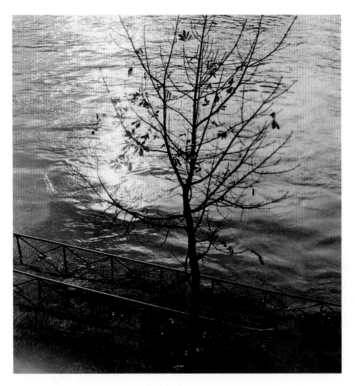

Above: The silhouettes of autumn trees
on a riverside, photographed by Dora
Maar in *c*. 1927. Opposite: An eerily
organic rock formation, a foretaste of
the kind of stark landscape and mood
that were to permeate Dora Maar's
poetry in her later years.

Through her connection with Marcel Zahar, an art historian and critic, Dora was introduced to Emmanuel Sougez, whom she would always regard as her mentor. Louis-Victor Emmanuel Sougez (1889–1972) began his career with publicity and archeological photography. He was one of the founders of the important magazine *L'Illustration* and in later years an influential historian of photography. In the 1930s he was a prominent spokesman in France for the New Photography. This international movement rejected what its practitioners saw as the sentimental and painterly photography of the past in favour of a much starker and more realist aesthetic. In Germany it was called the *Neue Sachlichkeit* or New Objectivity; the Group f.64 in the United States shared similar objectives. In France, where pictorialism and tradition remained strong, the strictness of this new northern style (which flourished first in Holland, Belgium and Germany) met with a certain resistance. Sougez studied in Germany and Switzerland, and back in France, along with Florence Henri, became a leading advocate of the new school, while at the same time remaining vocal in his support for French photography within the highly international artistic community of Paris.[2] As a professional practitioner, Sougez worked a great deal in advertising and publicity. He was also known for his large-scale still-lifes of ordinary objects, including piles of rags and cords, which typified the New Photography's emphasis on directness of vision, on materials, and on the beauty of everyday and manmade objects. When Dora Maar returned to painting in 1937, she was often to focus on a single mundane object in just this style.

She was also fascinated by the technical innovations of the contemporary avant-garde: shifts of viewpoint, plunging perspectives, photomontage, and deformations produced during the shoot or in the darkroom. Commercial photographers made use of all of these techniques. In advertising, atmosphere was often given greater weight than the product itself, as in an influential advertisement by Sougez for Urodonal (an anti-arthritis medicine), which made high drama from the x-ray of a hand.[3]

By 1929–30, just as Dora Maar was embarking on her career, the New Photography was at its height in France. When she was hesitating between painting and photography, Sougez was among those who recommended she continue as a photographer, and his was a persuasive voice. Impressed with her talent and her beauty (both of which he suggested in his shot of her slender fingers, p. 26), he helped her locate the best sources from which she could purchase cameras, projectors and other equipment. In an interview with Victoria Combalía, Dora recalled that on leaving art school she had approached Man Ray and asked to be his assistant.[4] His response was to claim that he never used assistants (facts to the contrary – Lee Miller and Berenice Abbott were particularly successful examples), but he did promise to be at her disposal if ever she needed advice. During her years as Picasso's lover, she was to become well acquainted with Man Ray, and some of her photographs are strongly reminiscent of his. The striping sun and shadow of her images taken in the gardens of the Hôtel Vaste Horizon in Mougins (p. 94, for example), where she and Picasso stayed in 1936 and 1937 with André Breton, Roland Penrose, Lee Miller and others, recall Man Ray's 1923 *Return to Reason*, in which stripes of shadow run diagonally over a naked female body, or his photographs of Lee Miller with sunlight striping her nude torso through a blind.

THE YOUNG PHOTOGRAPHER

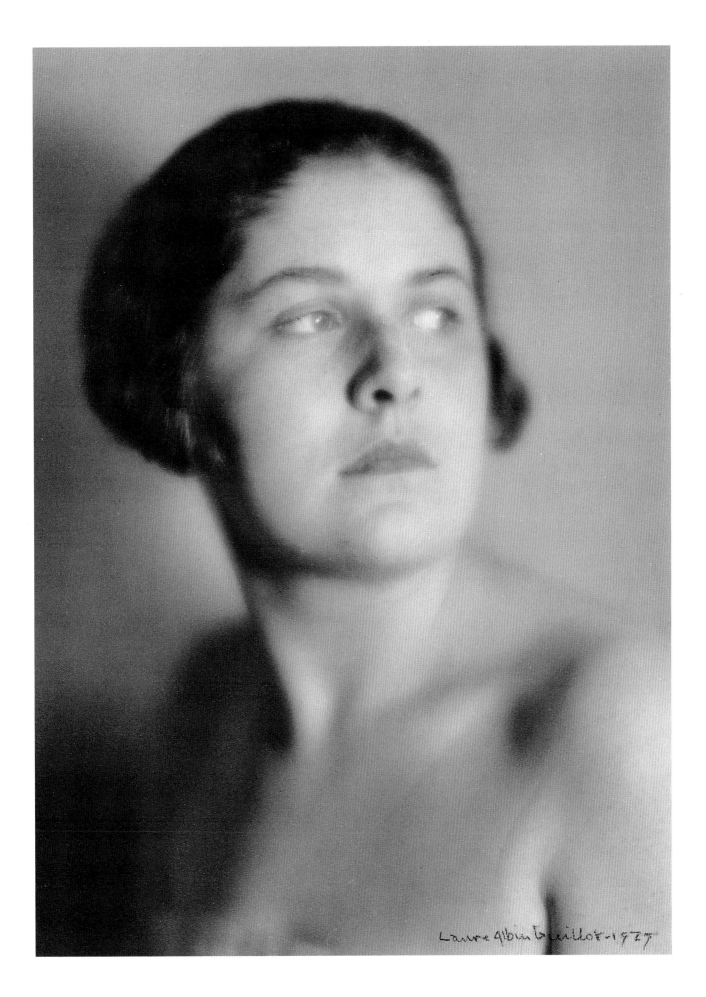

Laure Albin Guillot · 1927

THE YOUNG PHOTOGRAPHER

In the 1930s Emmanuel Sougez was the leading spokesman in France for the New Photography movement. He was also a friend and mentor to Dora Maar, urging her to pursue photography professionally. In his photograph (opposite right), taken in the late 1920s, her hands have an endearingly girlish quality. By 1936, when she was photographed by Man Ray and first appeared in Picasso's art, her naturally elegant fingers were perfectly manicured and brightly painted in crimson, purple or green, giving them an erotic, almost fetishistic quality. Opposite left and below: Anonymous photographs of Dora Maar in her student days, her hair fashionably cropped and parted.

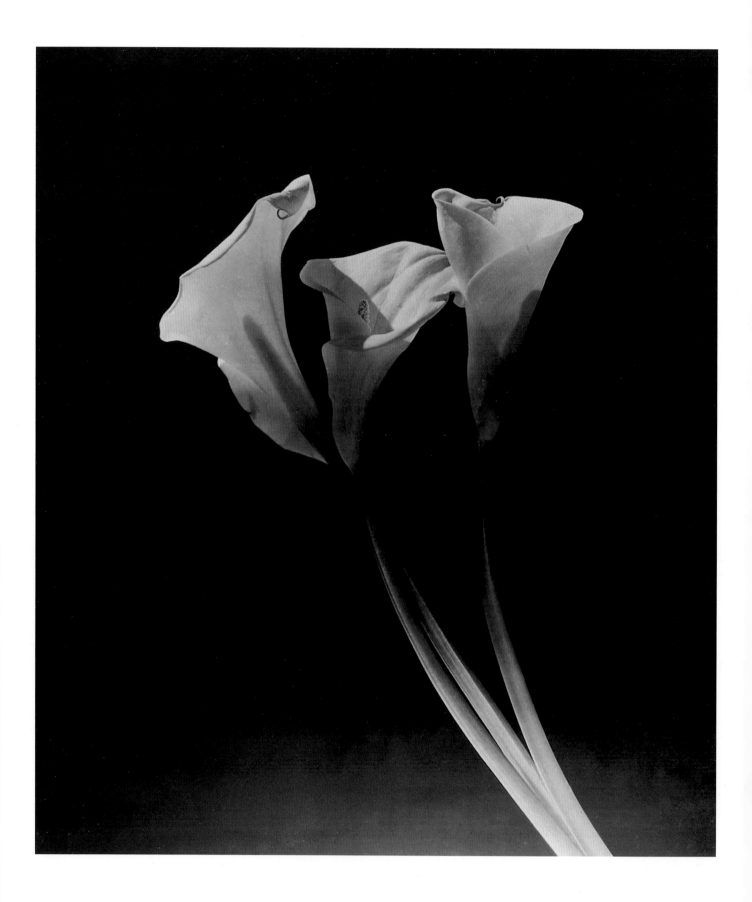

THE YOUNG PHOTOGRAPHER

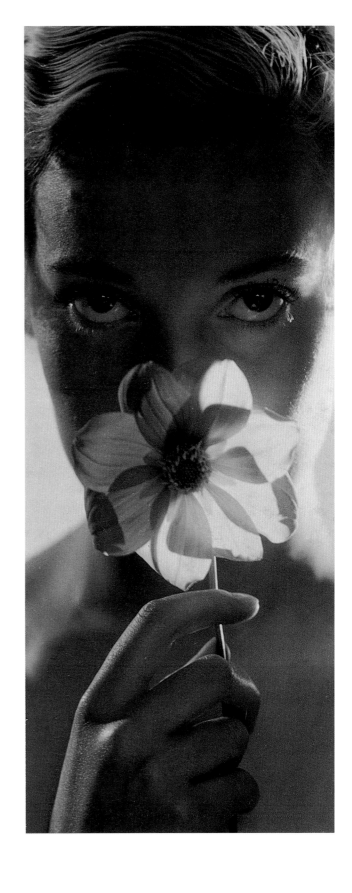

Opposite: Dora Maar, *Arum Lilies*, 1930.
Close-ups of plant-heads, seeds or
flowers were one of the genres that
flourished during the years of the New
Photography. Dora Maar's expressive
flower studies, delicate compositions
of light and shade, have a sensuous,
luminous quality. Right: An enticing
close-up of Assia, contemporary starlet
and favourite model of the Surrealists,
taken by Dora Maar in *c.* 1934.

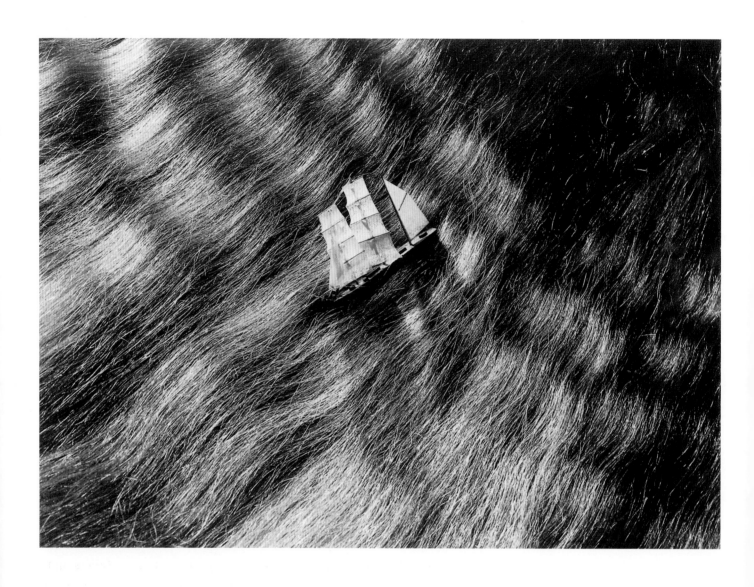

THE YOUNG PHOTOGRAPHER

Brassaï recollected Dora Maar in these early days in her long white coat, a true professional already and always, stalking about her subject as a huntress around her prey as she searched for the most telling detail. Later, in the autumn of 1935, Brassaï described her as having 'bright eyes and an attentive gaze, a disturbing stare at times.' 'Sometimes we had a show together,' he recalled. When she became Picasso's companion, she also became his photographic collaborator. Brassaï found her watching 'jealously over this role that she considered as a prerogative and assumed moreover with diligence and talent. She was the one who photographed his sculpted stones, some of his statues, helped him in his photographic experiments in the darkroom…. So as not to provoke her sensitivity, inclined as she was to storms and outbursts, I was very careful not to tread on what was from now on her domain.'[5]

Her association with Brassaï brought Dora Maar into contact with many photographers and photojournalists. She thrived in the atmosphere of collective excitement of these years, as she would in that of the Surrealists. She maintained a fierce intensity in all the work she did, public and private: in her portraits and her still lifes, in her photography and her poetry. This was heightened by the strain she constantly put herself under, in her career and her emotional life. For she was, by all accounts, as intense a personality as her later lovers: Georges Bataille, no less than Picasso, was a notorious bundle of contradictions and ferocities. There was in all Dora Maar's relationships and her work an authenticity as disquieting, sometimes as off-putting, as it was admirable. She could be extreme, even absolutist in her most private emotions. One poem of this period reads: 'Here are our fates face to face/we shall love each other reverently.'

Some of Dora Maar's own works of these years, particularly her photograph of *Arum Lilies* of 1930 and other flower studies, are in accordance with the aesthetics of the New Photography. Her close-ups can be as startling as the paintings of Georgia O'Keeffe, as if they took up all of the viewer's breathing space. One of the most effective publicity photographs turned out by the Kéfer–Dora Maar studio, advertising a hair oil, shows a miniature ship gliding diagonally up a mane of thick, smooth hair, as if borne upon the waves. Dora Maar also made photograms (or rayographs), the technique invented by Man Ray in which he made images without a camera by placing objects directly onto light-sensitive paper. She made these alone, and later in collaboration with Picasso, concentrating an intense gaze on one object from a plunging perspective, or on its transformation by superimpression. The technique recurs in her photographs from beginning to end: in the 1980s, without the benefit of instruments of any kind, she rediscovered her early fondness for manipulating photographic images and superimposed some of her old portraits with crystals, parsley and corn kernels (p. 204). Her contact in the 1930s with great photographers and the worlds of photojournalism and photopublicity exerted an indelible influence all her life.

Pierre Kéfer and Dora Maar's productions bore their joint signature: Kéfer–Dora Maar. In the centre of their studio there was a pool, subject of a notable photograph in which the sun beats down and casts a moiré pattern on the water and on the bathing suit of a stretched-out model (p. 35). Her body in its

Commercial and art photography were mutually influenced and invigorated during this highly fertile period. This tiny ship on a sea of hair photographed in voluptuous close-up was produced by the Kéfer–Dora Maar studio in *c.* 1935 as an advertisement for Pétrole Hahn, a hair oil.

Below: Marie-Laure de Noailles, millionairess banker's daughter and distant descendant of the Marquis de Sade, photographed by Dora Maar in *c.* 1940. The two women were great friends in the 1940s. Opposite: Christian Bérard, artist and designer for theatre, cinema and fashion, playfully posed in the home of the Vicomte Charles and Marie-Laure de Noailles on the Place des Etats-Unis in Paris, *c.* 1935. The de Noailles were influential patrons of avant-garde art in the 1920s and to a lesser extent in the 1930s.

dark suit is a sweep of stillness against the texture and ripple of the pool, poetic and paradoxical. There is a sense of high adventure in these pictures, including those commissioned for advertisements and fashion magazines, and in the ideas they provoke in the observer's mind. At the Paris home of Marie-Laure de Noailles – in future years a close friend of Dora – she pictured the artist and designer Christian ('Bébé') Bérard with his head appearing to float above the water of an ornamental cistern. The pose is described by Michael Kimmelman as 'wry and mischievous, with only his head perceived above a fountain, as if he were John the Baptist on a silver platter.'[6]

Dora and Pierre Kéfer also took portraits of such beauties as Assia, the celebrated model of the Surrealists. With her face against a fur rug, she lies in luxury (p. 36); nude but masked, grasping a ring, she both reveals and conceals (p. 34). Their fashion photographs have a sophisticated wit and inventiveness. In one a star replaces the model's head and looks out on the starry night – a double play on the idea of stardom. A model in a simple black dress takes a provocative pose beside the padding of a cushioned, buttoned chair: the furniture is buttoned down, but she seems not. Objects appear to dream along with the models. The draped dress of a woman holding a mandolin echoes the drape of a curtain; the sound of mandolin music seems to accompany her reverie.

The Kéfer–Dora Maar studio closed in 1934. Dora Maar had always been on good terms with her father and he now provided her with the money for her own studio and dark room at 29 rue d'Astorg, in the eighth arrondissement, near the church of Saint-Augustin. Its address was to become the title of one of her most famous Surrealist photomontages (pp. 72–73). It was, by chance, near Picasso's apartment on the rue la Boétie and next door to the Galerie Simon at 29 bis rue d'Astorg, owned by Picasso's dealer, Daniel-Henry Kahnweiler (who chose the name Simon because his own sounded too Jewish). Since the family's return to Paris in 1926, Dora had met up with her father every Sunday for lunch at the Lutétia, near Sèvres-Babylone. Monsieur Markovitch was a fussy and irascible client, and his failure to find fault with a meal was rare. Indeed his vociferous complaints were so much the rule that the head waiter at the Lutétia would simply respond with gestures of resignation, sighing 'Monsieur Markovitch is always right.' Dora found this funny, but acknowledged her father's 'tyrannical and captious temperament.'[7] Without the studio he gave her, however, she would have been forced to take on commissions instead of pursuing her creative work, and for that she was grateful.

Although as an artist – whether as photographer, painter or private poet – Dora Maar had shortened her name, her electricity bills and phone bills continued to be addressed to Henriette Theodora Markovitch. All of her carers at the end of her life also knew her by that name: 'I loved Madame Markovitch,' Rose Toro Garcia told me. Markovitch remained her legal inscription throughout her life; she was one person legally and another creatively. Even her signature might be of interest to a graphologist, for she always drew the letter M far taller than the letter D, almost as if she knew that her last name would remain untouched; it would never be supplanted by anyone else's.

THE YOUNG PHOTOGRAPHER

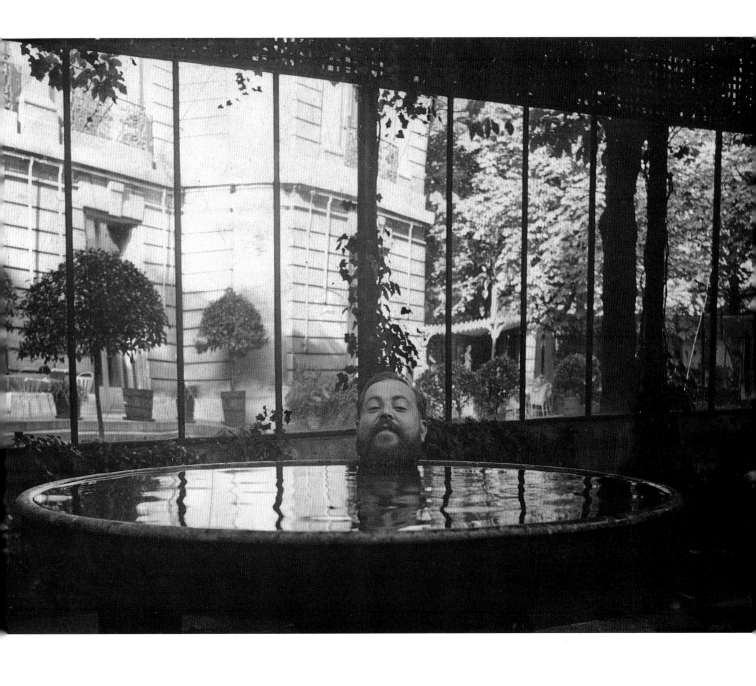

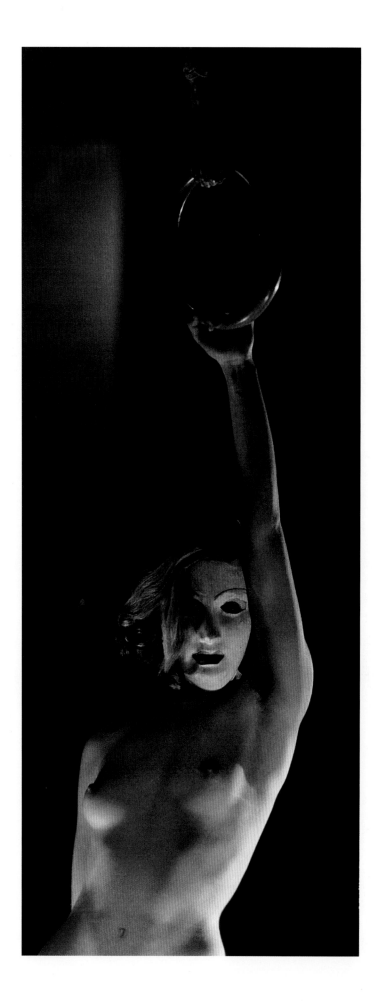

Left: Assia, mysteriously masked and hanging from a gymnast's ring in a photograph of *c.* 1934. Dora Maar worked to commission not only for conventional fashion magazines but also for erotic reviews such as *Beauté et Sex Appeal*; this may have been destined for such a publication. Opposite: This *c.* 1935 photomontage of a fashion model in a bathing suit superimposed with the pattern of sun-dappled water was no doubt commissioned for a more conventional magazine.

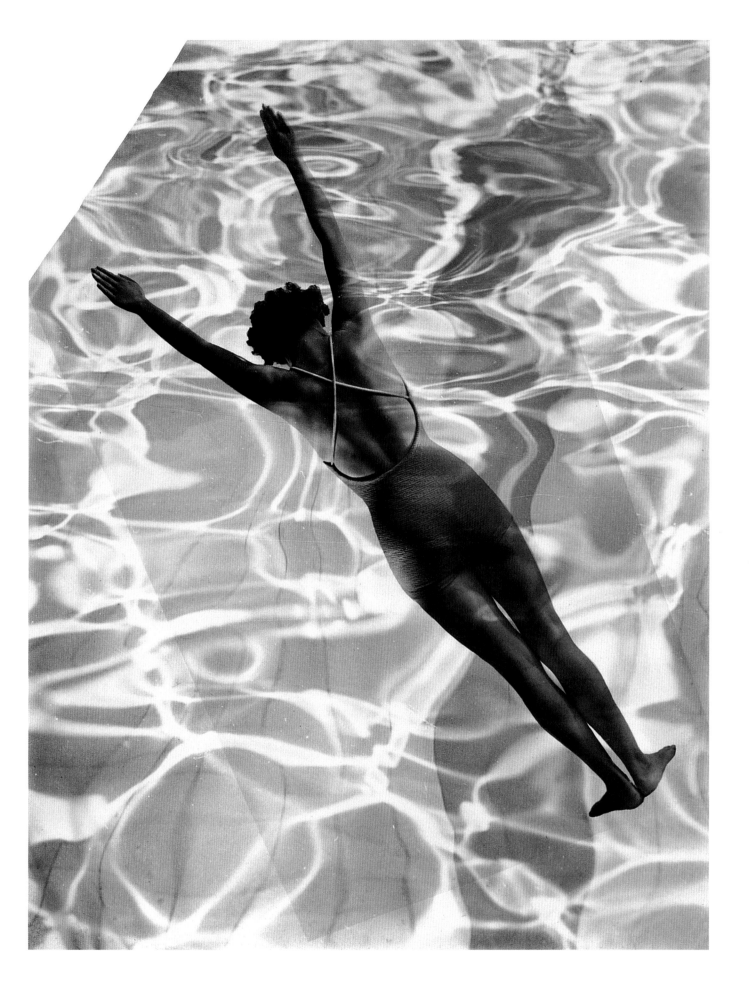

THE YOUNG PHOTOGRAPHER

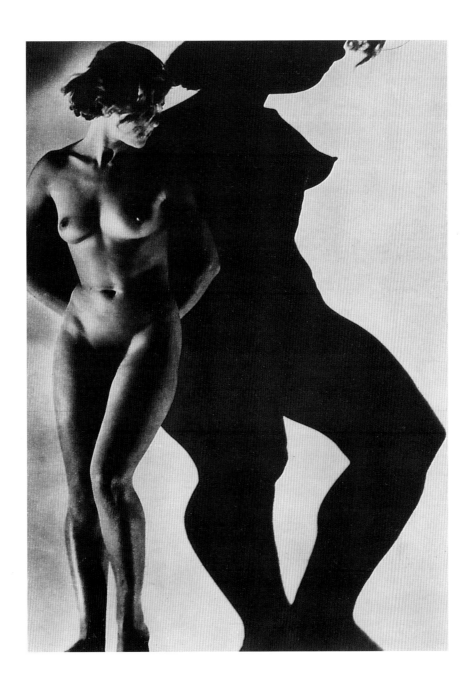

Assia in an intentionally sensuous pose
against a fur rug (opposite) and dwarfed by
her own monstrous shadow (above); both
photographs were by Dora Maar in 1934.
Their play of doubles in texture and scale
creates a powerfully erotic effect.

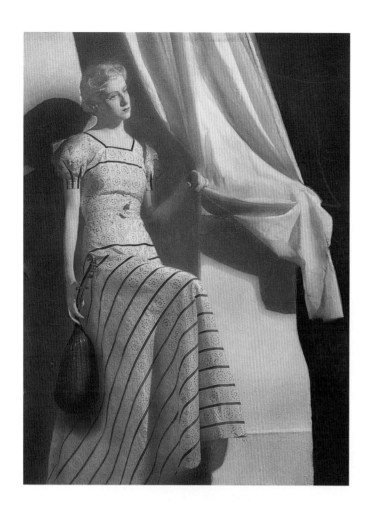

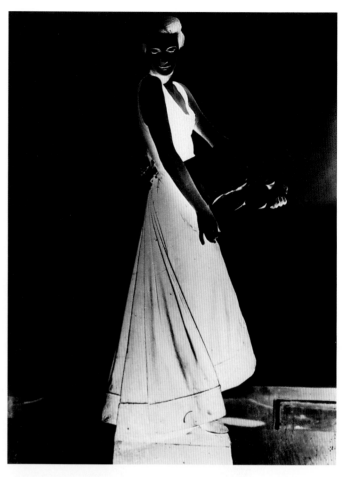

Elegantly inventive fashion photography
was a staple of the Kéfer–Dora Maar
studio. Their pictures were commissioned
by a variety of magazines, including
Madame Figaro and *Magazine Beauté*.
Dora Maar continued to produce this kind
of work after she and Kéfer parted
company in 1934: the model with a
mandolin, a hand-coloured print (above),
and the woman gazing upon mock stars
(opposite) were both made in 1936, when
Dora Maar was working independently
from her own studio at 29 rue d'Astorg.

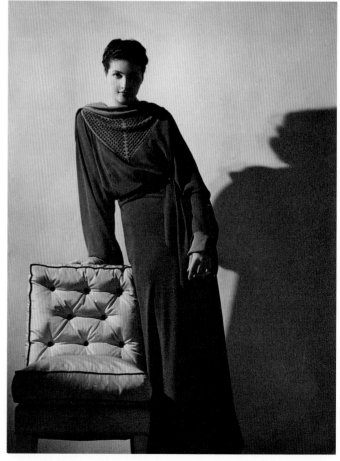

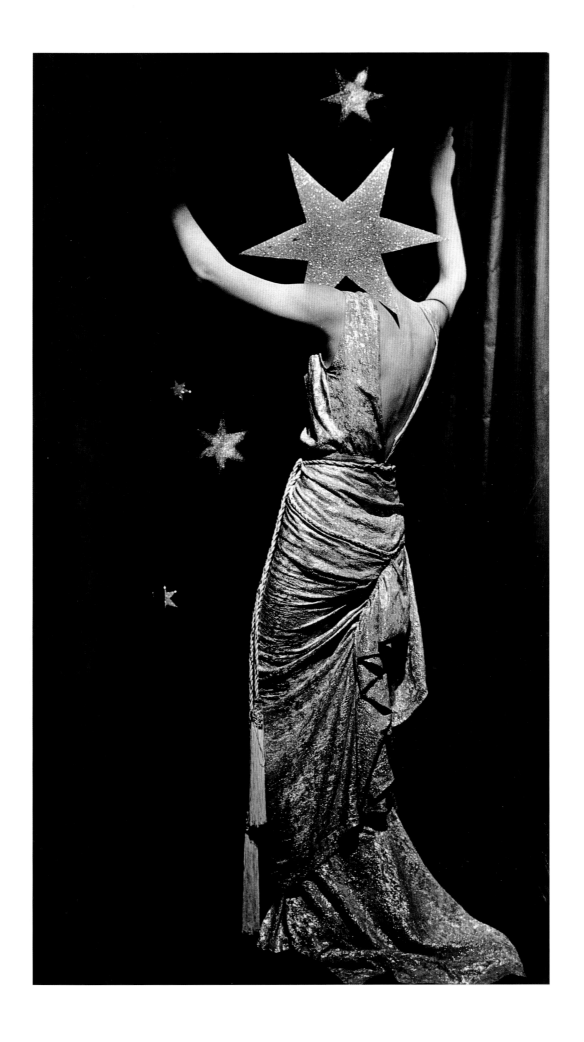

Dora Maar's street photography
– taken in Barcelona, London and Paris
– combines a strong sense of social
justice with an eye for the uncanny and
for inadvertent humour. Below: *Step
Inside and Consult the Original Spanish
Gypsy*, 1934. The raised hand of the
palmist's sign beckons to London
passers-by. Opposite: *Barcelona*, 1934,
a chorus of contradictory posters spied
on a Barcelona facade, surveyed by
the improbable figure of an armless,
semi-clothed mannequin.

Dora Maar travelled alone to Spain in 1934.[8] The country offered splendid
subjects for photographers and her friends made many suggestions of where to go;
but she had, as always, her own ideas. Her first destination was Tossá de Mar on the
Costa Brava, where the sun beat down heavily, and where many of her photographs
were overexposed and had to be discarded. But her pictures of Barcelona have
survived. They show, as do those taken in London that same year, her attraction to
what might seem the antithesis of her fashion and avant-garde photographs: the
street life of modest, often impoverished people. The contrast between these
approaches reflects what the Parisian intellectual Bernard Minoret sees as the
constant pull between the two sides of her character, between her exuberance and
her self-constraint.

Dora Maar was especially apt to seize on the ironies and mysteries of the
street. In *Barcelona*, a wall bears posters announcing a lecture and a public gather-
ing either side of a sign clearly forbidding the sticking up of posters. The inadver-
tent humour caught here does not trouble the lonely mannequin, armless and
hairless, who calmly surveys the street from on high in her underwear, flanked by
piles of old papers. The photograph, with its shutters and blinds, gives a strong

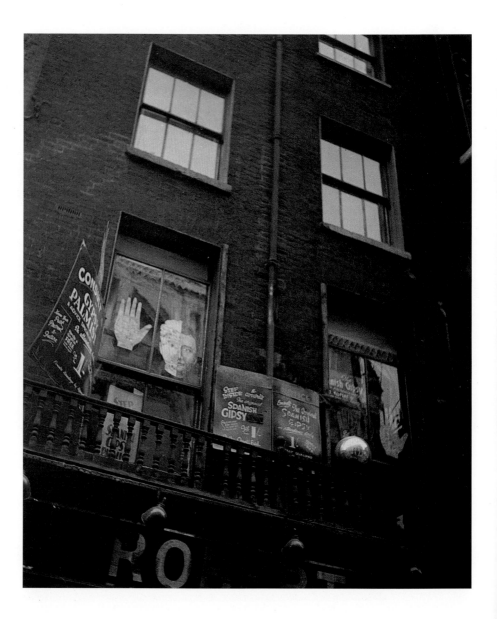

THE YOUNG PHOTOGRAPHER

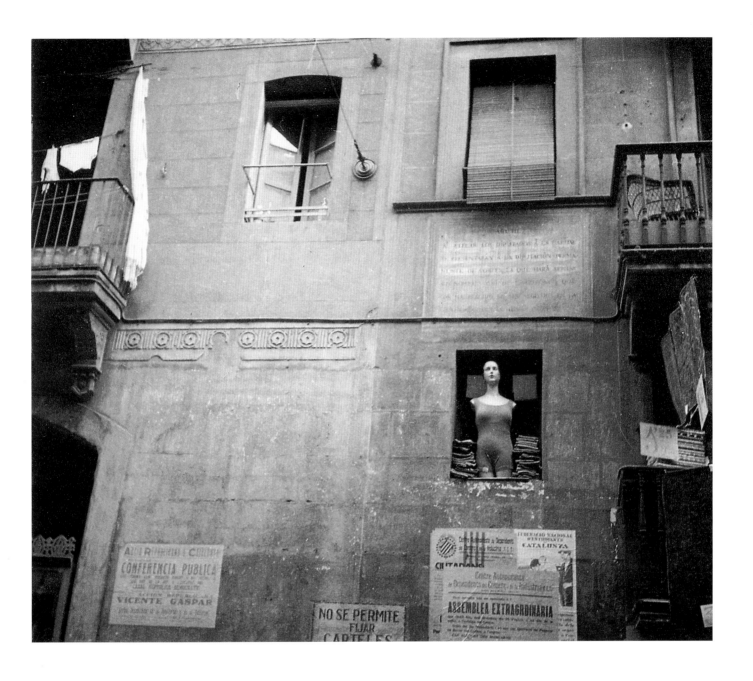

sense of the hidden and the exposed, of what you can see and what you cannot depending on where you are placed. In *Money and Morals* (p. 43) two little girls clamber up to peek at something out of sight, innocent of the weighty words posted around them. Dora Maar's fascination with sight and the absence of it, things open and closed, determines what she sees and what she permits us to see. Blindness – literal or metaphorical – is ever-present in these images.

Her pictures of poverty seize the desperation and desolation of the Depression. A ragged Parisian urchin with one sock falling down around his ankle strikes a defiantly nonchalant pose. Dora's sense of justice is powerful and her photographs make a clear moral statement, sometimes leavened by humour. In London she continued to photograph the paradoxes of poverty and wealth. What the crash of a business enterprise can do to the spirit is all too clear in *No Dole*: the gentleman in his suit reduced to selling matches on the street projects a terrible contrast of garb and occupation (p. 45).

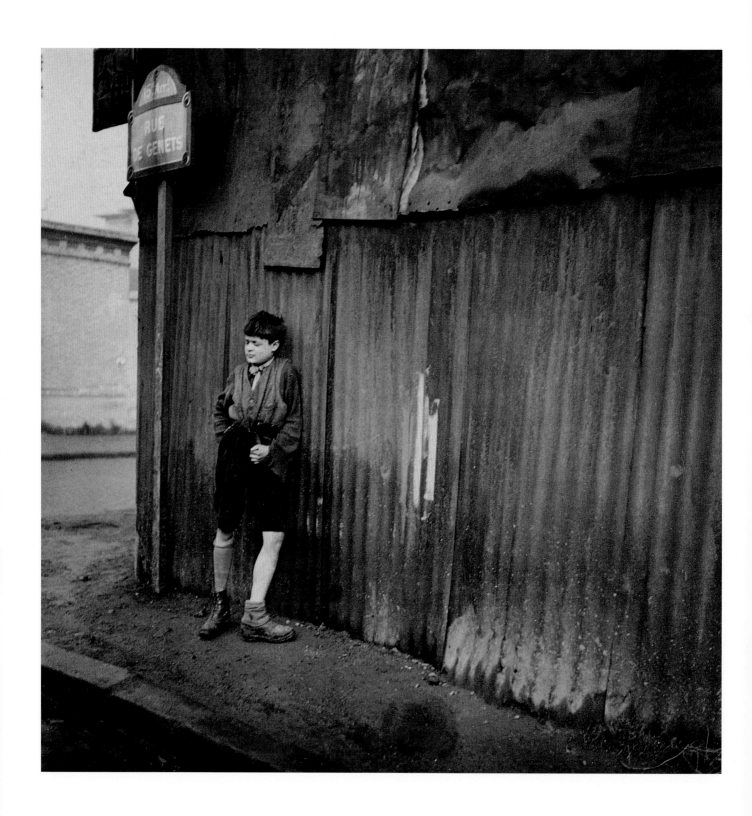

Above: *Street Boy on the Corner of the rue de Genets*, one sock falling over his shoe, photographed by Dora Maar in 1933 with characteristic sympathy and unflinching realism. Opposite: *Money and Morals*, 1934. Innocence on the rise, as two young girls in England clamber up to peek over a wall of posters.

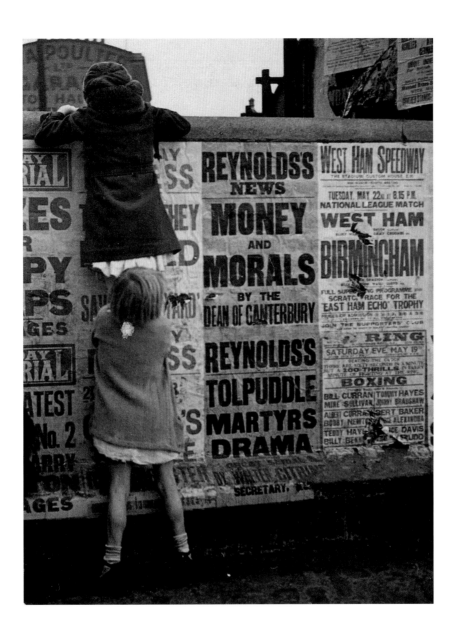

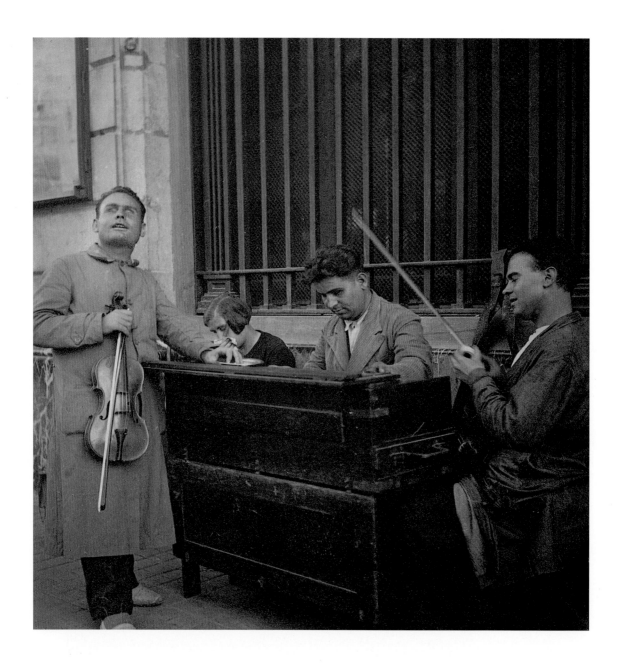

Dora Maar often focused her artist's
gaze upon blindness. Above: The lead
violinist of *Blind Street Quartet*,
photographed in London in 1934, stares
past us into a dimension inaccessible
to the sighted. Opposite: *No Dole*, 1934,
another photograph from the same trip.
A businessman ruined by the Depression
struggles to retain his dignity as his sign
pleads for help from passers-by.

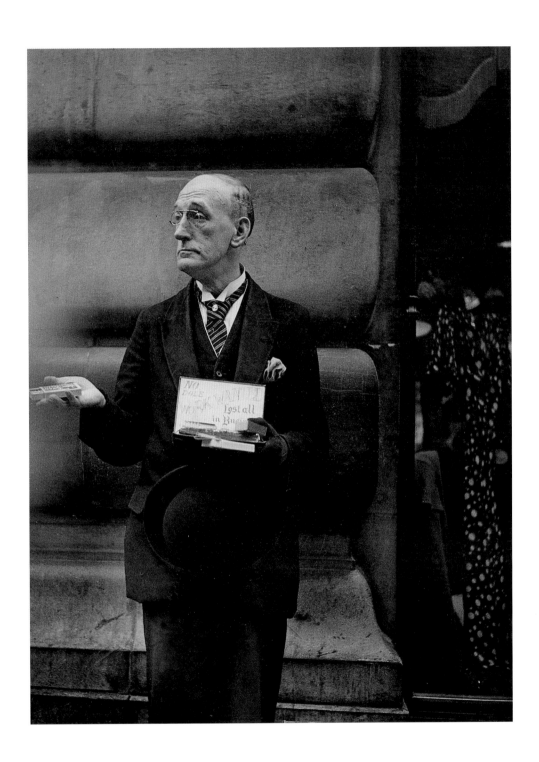

Dora Maar was exceptional among Surrealist women in her degree of political engagement. She was associated with a number of activist groups during the 1930s and signed many of their manifestos. One of these was October, a radical collective of left-wing actors and writers. She photographed her fellow members, who included Max Morise and J.B. Brunius (below, seated left and right), as well as their productions, such as the *Tableau des merveilles* (*Tableau of Marvels*), adapted from Cervantes by Jacques Prévert. This was staged in 1936 and starred Marcel Duhamel, Max Morise and Fabien Loris (opposite right). Dora Maar photographed Prévert with his brother Pierre in *c.* 1936 (opposite left, with Jacques to the right).

In 1932 Dora Maar had a love affair with the filmmaker Louis Chavance. This was a time of happiness and clarity, and the romantic aspect of her nature is clearly in evidence. In a poem dated 4 May of that year she wrote:

> The shade of your sweetness is measureless
> Time surges forth from light

Chavance was to become best known for his 1937 script for *Le Corbeau*, based on a novel by Georges Simenon. This controversial film, directed by Henri-Georges Clouzot, was made during the occupation by the German-owned company La Continental.[9] Centring on a deluge of poison-pen letters signed '*le Corbeau*' (the Raven) in a small provincial town, it was seen by some as collaborationist. It is famed for the visual melodrama of its major scene, in which the hero is questioned in the ambiguous light of the swaying lamp that creates a heavy glaucous atmosphere: 'in the alternating dark and light: "You think the good is light and that dark is evil. But where is the dark? Where is the light?"'[10]

Such drama was fully compatible with Dora Maar's emotional world. She was already writing about the high staging of jealousy, of it clawing at her until the blood came. She was a passionate sufferer, with an emerging masochistic strain to which she gave sometimes lurid expression in her private poetry:

> let patience and silence
> Take my hands
> let jealousy
> dangle its proud claws
> And absence ready its needles
> awaiting me at the break of day
> They waken me
> Blood shakes its wings
> I speak

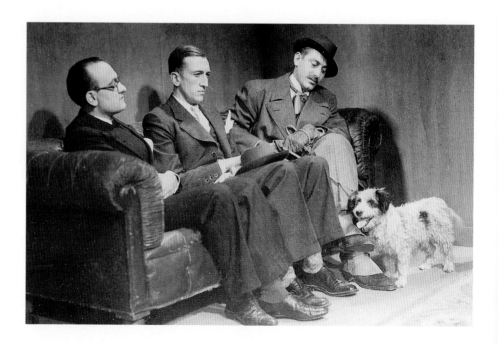

THE YOUNG PHOTOGRAPHER

She was a perfect heroine for Chavance's imagination. With him, she continued to consider herself as much a painter as a photographer. Her art would be her salvation: in her painting, time stood still, and the pangs of jealousy were powerless over her. In a poem of 8 May, she wrote:

> I see the landscape unreachable
> The light has stretched out.
> Its nuance seems eternal
> and the hour of my canvas
> will mark afternoons forever
> My happiness is like silence

In the early 1930s, the period in which Dora Maar's photographic work was at its finest, she was politically aligned with the Left. Her images of street life in Barcelona, Paris and London, of the poverty-stricken, the lame, the blind and the down-and-out, mark clearly her interest, personal, artistic and political. Her relationships with Chavance and then with Georges Bataille were in accordance with the political programme they, and she, espoused. The rise of Fascism in Europe in these years was a great spur and cohesive force to the French Left. Dora Maar was very involved with activist groups such as *Appel à la lutte* (Call to the Struggle), whose manifesto appealing for a general strike she and Chavance signed on 10 February 1934:

> There's not a moment to lose
> Unity of action
> Call for a general strike![11]

Dora Maar met Georges Bataille through the allied ultraleftist association *Masses*, of which he was a member from October 1933 to March 1934. His brilliance and his revolutionary politics were immediately attractive to her. They shared first a friendship and, beginning at the end of 1933 and ending in 1934, a love affair of several months' duration. Bataille's political programme was inspired

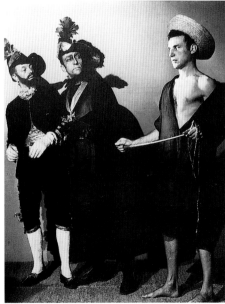

by a disgust with what he saw as the nightmare of bourgeois liberalism combined with a fascination for general confusion and violence. Brassaï describes Bataille in his paradoxes as: 'A true scholar in knowledge, background, and the scope of his intellect; a child in his sensitivity and freshness of vision; a libertine, a descendant of the Marquis de Sade, but clothed in the flesh of an anchorite, prey to all the remorse of sin, the wounds and mortifications of conscience; torn between eroticism and a profound feeling for the essential tragedy of life....'[12]

Masses was composed of about fifty manual and intellectual workers, led by René Lefèvre and managed by Jacques Soustelle. It laid great emphasis upon the spontaneous movement of the people ('*les masses*') in opposition to the inertia of bureaucratic systems, and offered courses in political economy and sociology. It was open both to Marxists and non-Marxists, and had the allegiance of those Communists opposed to the official Party structure such as Paul Bénichou and Simone Weil. *Masses* was short-lived, but it was directly succeeded by *Contre-Attaque* (Counter Attack) a similarly revolutionary group that was also fiercely anti-nationalistic, 'violently hostile to any tendency, whatever form it might take, that would appropriate the revolution for the use of the ideas of nation or country.'[13] Its inaugural manifesto – proclaiming 'Death to all slaves of capitalism!'[14] – was signed by Dora Maar on 7 October 1935, along with Chavance, Paul Eluard, the Surrealist Marcel Jean, the photographer Claude Cahun, and Pierre Klossowski, brother of the painter Balthus.

Contre-Attaque was jointly led by Georges Bataille and André Breton, who temporarily reconciled their differences after a serious schism five years earlier, when Breton had accused Bataille of a 'delirious overindulgence' in masturbation and sadomasochism, and an erotomaniac obsession with death. Bataille had retaliated with a pamphlet in which he called Breton 'soiled, senile, rank, sordid, lewd and doddering.'[15] Not surprisingly, their reconciliation was relatively brief. *Contre-Attaque* lasted just eighteen months; such political groups came and went in rapid succession. This was an age of manifestos, and Dora Maar joined in with glee and sincerity, moved by the collective spirit. Another, allied group that she was associated with was October, a left-wing collective of actors and writers who came together to bring affordable theatre to the workers. Through the October Group Dora Maar was acquainted with Jacques Prévert, filmmaker and poet; the director Roger Blin; the brilliant writer and art historian André Malraux, author of *La Condition humaine* (*Man's Fate*) and later Charles de Gaulle's right-hand man; the Surrealists Antonin Artaud, creator of the *Theatre of Cruelty*, and Max Morise; and the beautiful actress Sylvia Bataille, at this point the wife of Georges Bataille, himself heavily involved with Dora Maar. Louis Chavance and fellow filmmaker Jean Renoir were also active in the October Group from 1935. In late 1935 Dora Maar was set photographer on *Le Crime de Monsieur Lange*, directed by Jean Renoir and co-written by him and Jacques Prévert. This classic film celebrates the collective spirit when the workers through solidarity triumph against a tyrannical boss. Opening in January 1936, it had a decided influence on the electoral campaign in May of that year, which brought a socialist government to power in France.[16]

Tales of the intense erotic complications within Bataille's circle, particularly involving Dora Maar, have come down to us. They certainly accord with Bataille's writing, notably with the super-steamy *Histoire de l'oeil* (*Story of the Eye*), a

Man Ray's famous solarized portrait of Dora Maar was taken in 1936. Dora approached Man Ray and asked to be his assistant when she first left college, but he declined. By the time she met him again through the Surrealist circle, she had gained considerable sophistication and allure. Like Picasso, Man Ray was fascinated by the erotic aura of her perfectly manicured hands.

THE YOUNG PHOTOGRAPHER

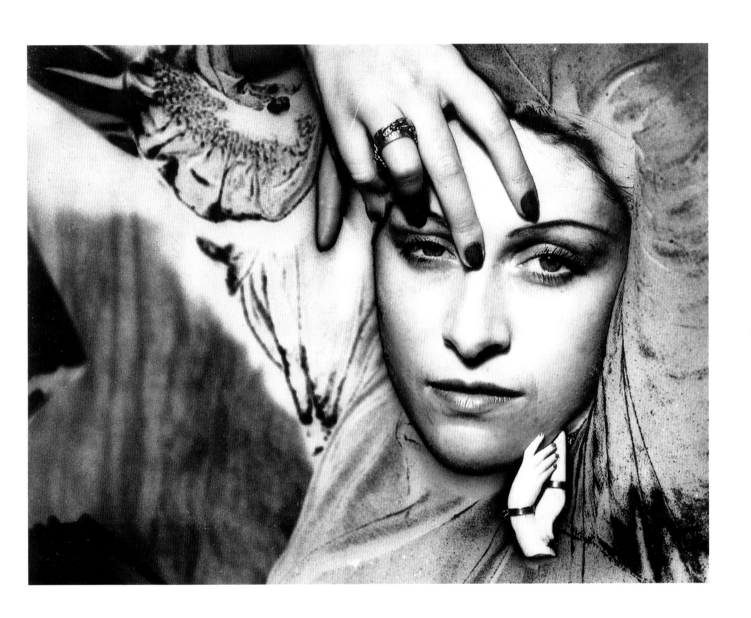

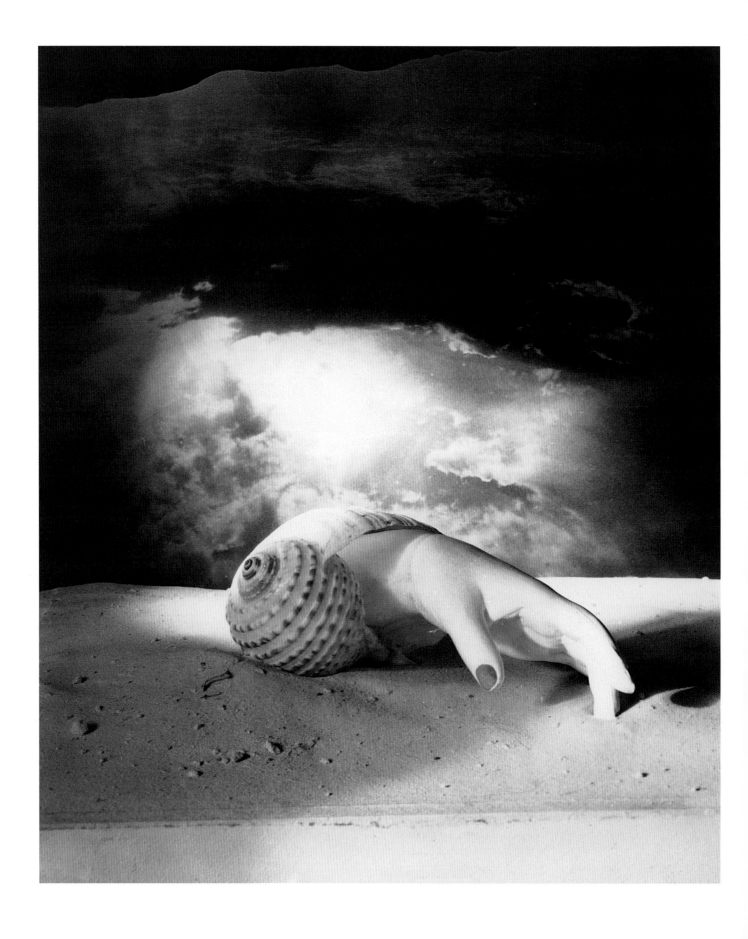

Dora Maar, *Untitled*, 1933–34. Her most famous Surrealist photographs date from 1935–36, but Dora Maar was already making arrestingly strange images a couple of years before that. This photomontage creates an eerie sense of time slowed down, as the hand emerges from the shell to finger gently the sandy surface under glowing light filtered through lowering clouds. Overleaf: Dora Maar, *Legs I and II*, c. 1935. Anatomically frank and strikingly erotic, this remarkable pair of images demonstrates a very daring eye and lens. With their triangular openings and the smoky intrusion in the second print, they invoke both the human and the animal.

ferocious and dazzling pornographic mixture of the monstrous and the lyric, as the egg/eye is inserted into the vagina.[17] In Bataille's image of the eye, violence, self-destruction and blindness are intertwined. Noting the proximity of seduction and horror, he wrote that:

> …the eye could be compared to *the blade*, the sight of which equally provokes sharp and contradictory reactions: that is just what the makers of *Un Chien Andalou* must have felt, so atrociously and darkly, when at the very first images of the film, they determined the bloody sexual encounters of these two beings. The razor blade slicing right through the dazzling eye of a young and charming woman drives the young man watching to the point of frenzy, as he himself is watched by a little cat lying beside him. Holding, by chance, a teaspoon, he is suddenly consumed by a desire to catch an eye in the spoon. A very peculiar desire, obviously, on the part of a white man, from whom the eyes of the oxen, the lambs and the pigs he eats have always been hidden. For the eye, such a *cannibalistic delicacy* in Stevenson's exquisite expression, is so upsetting to us that we will never bite into it.[18]

In such writings for the *Critical Dictionary* and for *Documents*, the anthropological journal he edited, Bataille's conflagration of super-sadomasochistic eroticism, detailed physiological knowledge, and philosophical speculation took imaginative and terrorizing textual fire. The imagery of closed eyes, or blindness, is also one of Surrealism's major themes. Nadja, in Breton's book of the same name, tries to cover Breton's eyes while he is at the steering-wheel; blind people and images of blindness appear and reappear in Dora Maar's work. True vision is interior vision: what Surrealism will call, finally, the interior model. Breton believed that our universe is limited only by the paucity of our vocabulary and the short stretch of our vision in the exterior world.

The violent sensual impact of an unexpected visual combination, particularly that of the human and natural worlds, is perfectly illustrated by Dora Maar's remarkable image of a miniature artificial hand emerging from a conch shell, its finger poking languorously into the sandy surface. The very slowdown or delay felt in the touch is monstrously erotic, while the heavy play of cloud and light in the heavens above gives this monstrousness a strange weight. The painted fingernails remind the viewer of Dora's own brightly painted nails – red, green or black.

The conch image and its connotations find a parallel in Eileen Agar's tale of Paul Eluard's lunch with her lover Joseph Bard at the Savage Club in London. As she reports, the poet was especially taken with the dessert, 'a quivering orange mass of jelly that resembled nothing more than an undulating, miniature, nubile breast. Eluard … began prodding, poking and playing with the new toy, using his spoon like an inquisitive finger. He did this for quite a while as Bard and the other members watched. Then he devoured it.'[19]

Eating, devouring, consuming: cruelty is an inescapable part of sensuality. It all begins with the *Mouth:*

> The mouth is the beginning or, if one prefers, the prow of animals; in the most characteristic cases, it is the most living part, in other words,

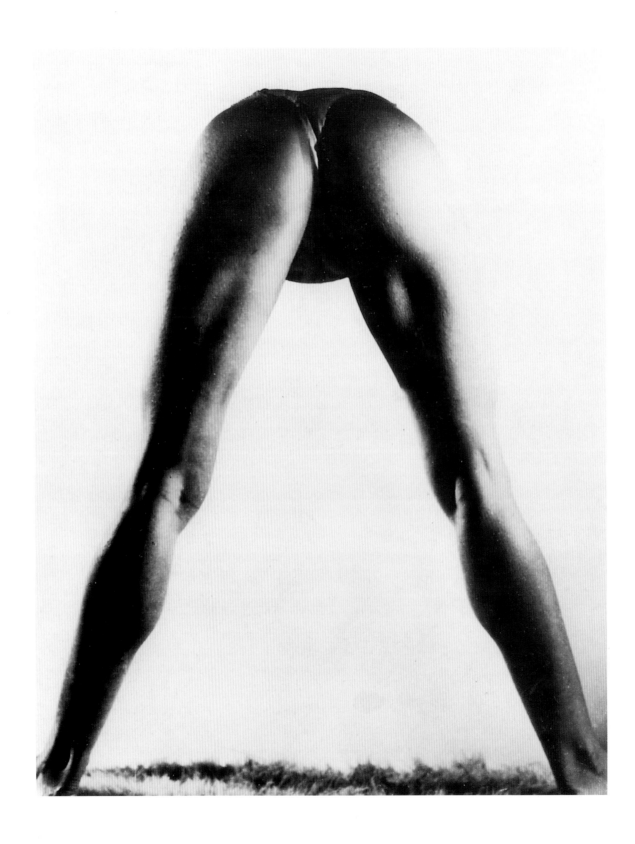

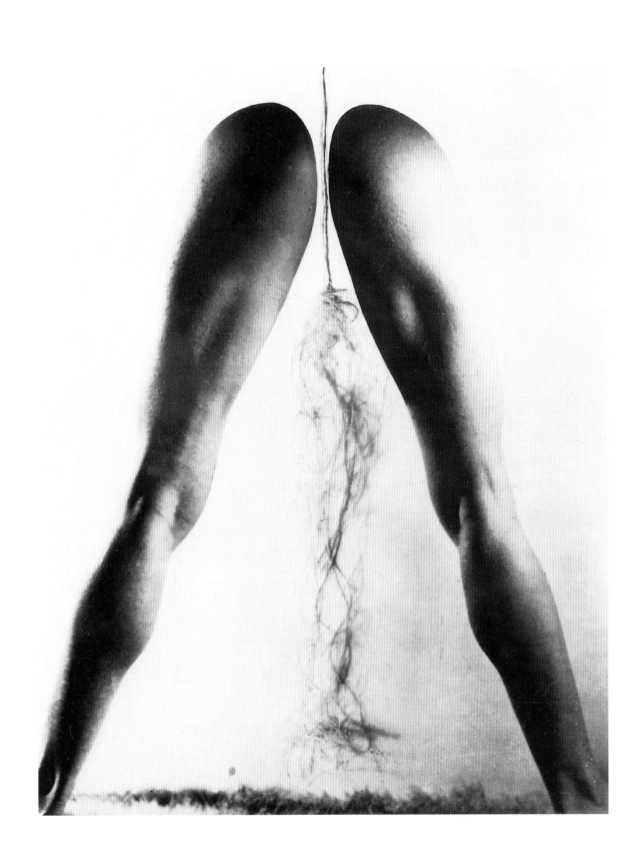

Below: Surrealist artist Marcel Jean's *Spectre of the Gardenia* of 1936 wears a strip of film around its neck made by Louis Chavance and featuring Dora Maar. Opposite: Dora Maar's *Forbidden Games*, a photomontage of 1935. The child voyeur peeping out from under the table adds a disturbing dimension to an otherwise preposterous satire on bourgeois respectability. The boy is taken from one of her Barcelona street photographs; the woman's body is that of a dancer at the Folies-Bergère, with a mannish, bespectacled head tacked on. The scene is played out in a heavy bourgeois turn-of-the-century interior.

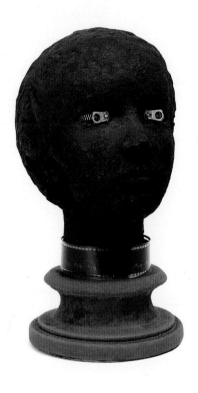

the most terrifying for neighbouring animals. But man does not have a simple architecture like the beasts, and it is not even possible to say where he begins.... The violent meaning of the mouth is conserved in a latent state: it suddenly regains the upper hand with a literally canni-balistic expression such as mouth of fire ... terror and atrocious suffer-ing transform the mouth into the organ of rending screams ... the overwhelmed individual throws back his head while frenetically stretching his neck so that the mouth becomes, as far as possible, a prolongation of the spinal column, in other words, it assumes the posi-tion it normally occupies in the constitution of animals. As if explosive impulses were to spurt directly out of the body through the mouth, in the form of screams.[20]

Such was the literary expression of the violently erotic games played in Bataille's company. But Dora Maar was no innocent ensnared in his world. She was a highly independent, unconventional, flamboyantly dressed young woman, fully in control of herself and aware of her magnificent talent as a photographer. She shared his appetites for mysticism and transgression. In the mid-1930s she produced a great deal of photography for erotic magazines.[21] Douglas Cooper described her as 'always spirited and provocative but already utterly self-possessed, aged twenty-six or so.'[22] Transgression clearly appealed to her. Her conceptually scandalous photographs are like so many dangerous experiments. In *Forbidden Games* the erotic thrill is intensified by the child voyeur watching on the sidelines, hiding under a table and witness to the scene. The riding lady keeps her spectacles on and her neck ribbon neatly in place as she perches atop a smartly suited man. The image invokes the old tale of Phyllis riding Aristotle, the wise philosopher mastered by his domineering wife, a favourite misogynist motif of Medieval and Renaissance art. Many of these photographs are heavy with transgressive erotic play, and with the ironies such consciousness exploits.

It was on the set of *Le Crime de Monsieur Lange*, in late 1935, that Paul Eluard first introduced Dora Maar to Pablo Picasso. Fifty-four years old, he was most likely dressed, as he usually was, in his 'worn old suit with its sagging pockets and baggy trousers, odd waistcoats worn over one or two sweaters and shirts with bent or crumpled collars...', his Basque beret and long scarf, his keys fastened to his belt and his money fastened inside his jacket pocket with a safety pin. By 1935 he was estranged from his first wife Olga Kokhlova and had recently fathered a daughter, Maya, by Marie-Thérèse Walter. He was to remain in close touch with Marie-Thérèse throughout his involvement with Dora; she was to be the private lover, Dora the public.

She vividly remembered their brief meeting on set; he did not. It would take a much more dramatic encounter for this startling young woman to catch his eye.

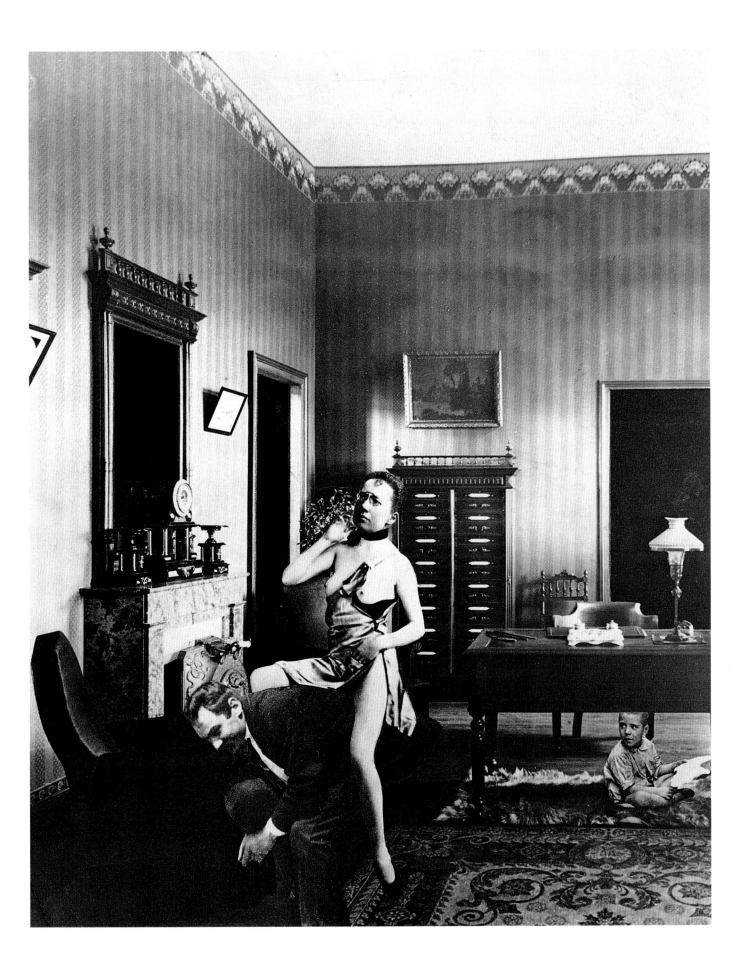

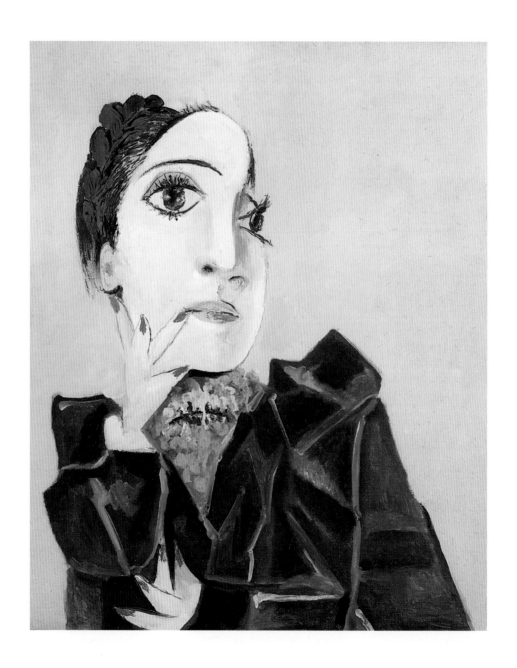

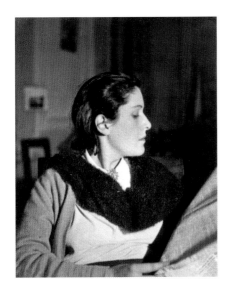

…but if the curve stirred up by the song hung from the end of the snail should wrap itself around biting the heart charming and colouring it and the bouquet of sea stars shrieking its distress in the cup the verbal cut of its gaze should awaken the tragic ratatouille of the ballet of flies in the curtain of flames boiling on the window ledge…
PABLO PICASSO, 7 SEPTEMBER 1936

By the mid-1930s, Dora Maar was a flamboyant presence in the Surrealist circle, renowned for her brightly painted fingernails and her fondness for the modish hats of Albouis and Elsa Schiaparelli. Picasso painted *Dora Maar with Green Fingernails* (opposite) in 1936 and photographed her in striking profile (above) in 1936 or 1937. Dora Maar was expert at creating an impression, and not always an elegant one. Marcel Jean recalled an occasion in 1936 when she arrived 'with her hair hanging loose about her face and shoulders, like that of a drowned woman. At the Surrealist table, everyone, or nearly everyone, exclaimed with admiration.'

During her love affair with Georges Bataille, Dora Maar had met André Breton, the spokesman, leader and seminal creative force of Surrealism. She was closely associated with the Surrealists for several years in the mid-1930s, signing many of their manifestos and sharing their views on the world, art and politics. With her taste for startling outfits and her drastically nonconformist behaviour, she was also very much seen as a Surrealist.[1] Between the years 1934 and 1937, she exhibited her Surrealist and documentary photographs in Tenerife, in London and at the Galerie de Beaune in Paris.

Breton was personally impressive and utterly self-assured. Brassaï's description is vivid:

> With his bright eyes, his straight nose, his artist's mane of hair starting far back on his forehead and descending in curls at the nape of his neck, he resembled an Oscar Wilde whom some sudden glandular substitution would have rendered more energetic, more masculine. His carriage, the port of his leonine head, his impassive and grave visage, almost severe, his sober, measured, and extremely slow gestures, gave him the authority of a born leader, born to fascinate and reign, but also to condemn and strike. If Eluard reminded me of Apollo, Breton seemed to me Jupiter in person.[2]

Surrealism was the more organized and rule-oriented successor to Dada's madcap explosion. Its guiding motto was 'lyric behaviour' or openness to chance, a state of constant expectation. One of its defining techniques was automatic writing, described in the first Manifesto of 1924 as the 'Dictation of thought, without any control by reason and beyond any aesthetic or moral concern'.[3] The Surrealist group acted as a group; nominations for membership and expulsions were treated with great seriousness. Former members and outside observers made numerous attacks on its dogmatic 'infallibility' and on Breton, its 'Pope'.

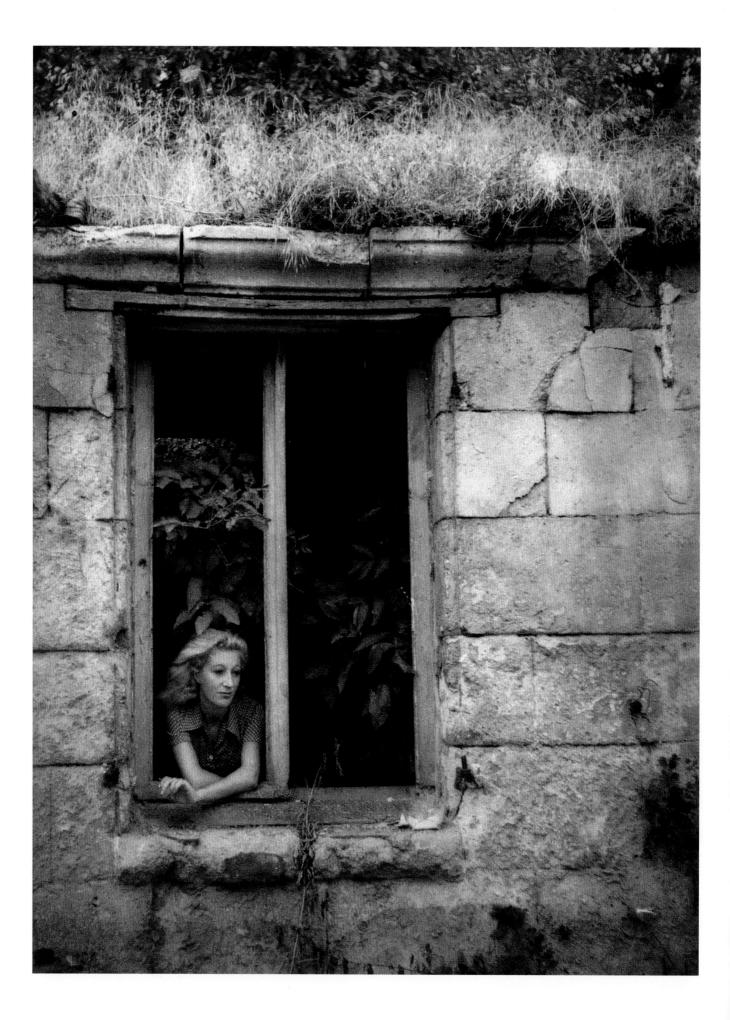

Yet the collective spirit to which all the signatories bore enthusiastic witness was one of Surrealism's great points; it thrived on being an authentic movement, with a real leader.

The group acted as one – as a jury, as a forum for discussion and as a political entity. The opposition of an individual to the group invoked grave and ritualistic consequences. Yves Bonnefoy tells of Giacometti's expulsion: he was called in before a jury of the entire membership, asked to recant or defend himself, and then excommunicated, as if from a church.[4] The ritual was undertaken with high seriousness, although it could turn into farce. Here is Georges Hugnet's account of the group's trial of Salvador Dali for 'counter-revolutionary acts tending to glorify fascism', held at exactly 9pm on 5 February 1934 in Breton's apartment:

> Paintings by Duchamp, Chirico, Miro and others cover the walls and hang above a graduated bookcase, of very artistic effect and apparently designed by the master of the house, on which Gothic novels, Surrealist objects, wild objects, and found objects stand side by side. In this atmosphere, already opalized by cigarette smoke, the Surrealists are grouped by personal affinity. Dali makes a spectacular entrance, dressed in a large camel-hair coat that floats around his body, stumbling and tripping over his untied shoelaces. He is preceded by Gala [his wife], who has the glare of a cornered rat….[5]

Dali, saying he was ill, kept a thermometer in his mouth throughout the proceedings; he was laden with sweaters which he peeled off one by one. He defended himself loudly and persistently, raving about his dreams and the glories of Hitler and Nazism, until finally he dropped to his knees and reached for Breton's hand to kiss it. Breton withdrew it hastily, but the evening ended without judgment.

There were no women present when Surrealism was launched in 1924, nor do any appear in formal line-ups before 1934. But Leonora Carrington, Léonor Fini, Valentine Hugo, Jacqueline Lamba, Dora Maar, Lee Miller, Valentine Penrose, Alice Rahon and Remedios Varo all figure in many informal snapshots. As Whitney Chadwick explains:

> [Theirs] is the story of a group of women who dared to renounce the conventions of their upbringing, who attempted to find some consonance between their ideas and their lives, and who embarked on the difficult path to artistic maturity at a time when few role models existed for women in the visual arts and there was little encouragement for women to establish professional identities for themselves. Young, beautiful, and rebellious, they became an embodiment of their age and a herald for the future, as they explored more fully than any group of women before them the interior sources of woman's creative imagination.[6]

Dora Maar was acquainted with all of these remarkable women. Most interesting among them is Jacqueline Lamba, her best friend in the 1930s. The future wife of Breton, Lamba was a painter whose work met a tragic fate. In 1941 she and Breton fled Paris for New York in the face of the Nazi advance. She returned in 1954, by then divorced, to find that most of what she had stored in the apartment at 42 rue Fontaine had mysteriously disappeared. Later she herself destroyed many of her surviving Surrealist works in New York.[7]

A Surrealist action in front of Breton's Gradiva Gallery on the rue de Seine, photographed by Dora Maar in *c.* 1935. Gradiva, a fictional character written about by Freud, was the archetypal Surrealist muse, whose free spirit and imagination enabled the artist to access the unconscious sources of his inspiration. In the entrance to the gallery was a pair of silhouettes, male and female, designed by Marcel Duchamp, while the fascia paid tribute to the muses of the Surrealist circle in the 1930s, including Dora Maar.

Breton's first meeting with Jacqueline Lamba was not just a great event in his life, but a defining Surrealist moment. It happened on 29 May 1934. At the daily meeting of the Surrealists in the Café de la Place Blanche, his attention was suddenly seized by a beautiful blonde who entered in a blaze of glory. Seating herself at a nearby table, she began to write: 'this illusion she gave of moving about, in broad daylight, within the gleam of a lamp. I had already seen her here two or three times…. And I can certainly say that here, on the twenty-ninth of May 1934, this woman was *scandalously* beautiful.' Could she have been writing to him?[8]

Jacqueline, then an aspiring painter, had met Dora Maar when they were both studying at the Ecole des Arts Décoratifs. She was now earning her living as a nude underwater dancer at the Coliseum on rue Rochechouart, and was determined to meet the charismatic Breton. She found out where the Surrealists met from Dora Maar. 'I was,' said Dora Maar, 'closely linked with Jacqueline. She asked me: "where are these famous Surrealists?" I told her about the Café de la Place Blanche.' Jacqueline visited the café several times, staring at Breton until he finally noticed her.

The sudden magic of their encounter was the ultimate Surrealist experience. That night, after her evening's swimming performance, Jacqueline met him once more. As she told Dora, and as Breton later wrote in *L'Amour fou (Mad Love)* (1937), they walked through Les Halles to the Tour Saint-Jacques. These were both places that Breton had described in earlier poems. In '*Vigilance*' of *c.* 1932 he had envisaged 'the Tour Saint-Jacques swaying like a sunflower'. And in '*Tournesol*' ('Sunflower') of 1923:

> The traveller who crossed Les Halles at summer's fall
> Walked on tiptoe…
> Night's promises were kept at last

While they walked on this 'night of the sunflower…' Breton's words came back to him as predictions of his own future. Such omens shaped many a Surrealist encounter. Dora's own mad love for Picasso and his for her would begin with a similarly dramatic and portentous meeting. By the time Breton wrote about his encounter with Jacqueline Lamba in *Mad Love*, mingling the story with other writings, it had gained a quality of mystery and a vague sense of impermanence. It is the culmination of a description of a series of women who are loved one after the other, each as the other, in a dazzling and dazzled state of grace. 'They are the women he has loved, who have loved him, some for years, others for one day. How dark it is!'[9]

The Surrealist encounter was providential, miraculous, or rather marvellous, and it was shared. It formed a community of perception conducive to artistic creation. Two famous encounters, appropriately each in a café – the place of the collective – link Jacqueline and Dora Maar, who were to be intimate friends throughout the period. The women artists already had much in common: their friendship, their art and their scandalous beauty, one blonde, one dark. For each, their most profound love story began with a dramatic scene in a café: they stare and they are stared at, like a human found object meeting its mutual other. From then on, their own genius is seen in deep association with that of another: Breton or Picasso.

Dora Maar participated in Surrealist demonstrations, convocations and café conversations with the same whole-hearted conviction she had given the ultraleftist

groups of *Masses* and *Contre-Attaque*. This was the time of the Comité du Vigilance des Intellectuels, a watchdog group for leftist intellectuals with which Dora Maar was in full accord. Along with all the other Surrealists, she signed the manifesto 'When the Surrealists Were Right' of August 1935. This concerned the 'International Congress for the Defence of Modern Culture',[10] known as the Congress of Paris, which had been held in March of that year. The issue it addressed was the impossibility of determining what 'culture' might be in a capitalist society, and the urgency of retaining individual freedom. Breton's 'Political Position of Today's Art' of June 1935 concludes with the famous words that have ever since represented the spirit of Surrealism: against propagandistic writing, he said, 'We maintain that the activity of interpreting the world must continue to be linked with the activity of changing the world…. "Transform the world," Marx said; "change life," said Rimbaud. These two watchwords are one for us.'[11] Coming after the First Manifesto of 1924, with its youthful blaze of excitement about the techniques of automatism that would unleash the unconscious creative spirit from its rational habits, and the Second Manifesto of 1930, with its fulmination against those who would care about anything so bourgeois as 'the position they occupy *in the world*', this more politically oriented manifesto of 1935 created the sort of excitement that greatly appealed to Dora Maar.

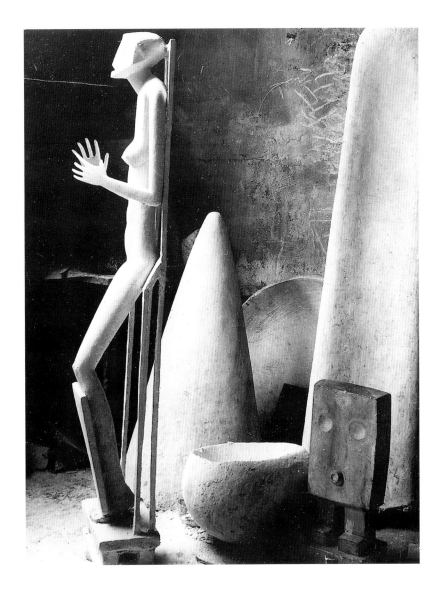

Alberto Giacometti's *Invisible Object (Hands Holding a Void)* of 1934–35, photographed in his studio by Dora Maar. This figure holds in its hands the expectation of an object, like an encounter yet to happen. For Breton it represented 'the desire to love and to be loved in search of its real human object, in its painful ignorance.' The first edition of *Mad Love* included one of Dora Maar's photographs of this piece, alongside remarkable Surrealist photographs by Brassaï, Henri Cartier-Bresson, Rogi André and Man Ray.

Nusch Eluard was a favourite model of both Man Ray and Dora Maar. Man Ray's frontispiece to Paul Eluard's controversial book of love poems *Facile* shows her slight body. The portrait of Nusch (opposite left) was by Dora Maar in *c.* 1935; the photograph of Paul Eluard kissing Nusch's forehead (opposite right) was by Man Ray in 1936 or 1937. Overleaf: The series of portraits of Nusch Eluard that Dora Maar produced between 1932 and 1935 are among her finest. They perfectly frame Nusch's fragile, ethereal beauty. Dora Maar's title for the version that she overlaid with a spider's web – *The Years Lie in Wait for You, c.* 1932–34 – took on unbearable poignancy on Nusch's shatteringly sudden death, little more than a decade later.

As she became increasingly familiar with their circle, Dora Maar also photographed the Surrealists themselves, particularly Paul Eluard, her close friend since the days of *Masses*, and his beautiful wife Nusch, the German-born Maria Benz. Paul and Nusch had married in late 1934 in a joint ceremony with André Breton and Jacqueline Lamba. Dora photographed her friend Jacqueline gracefully posed on a windowsill amid foliage, like the lovely mermaid Melusine, the patron goddess of Surrealism who flung herself with a cry from an open window when her husband spied on her (p. 58). She photographed the painter Yves Tanguy with his wild hair (he was a close friend of her and Jacqueline) and the Surrealist poet René Crevel, leaning on a wicker chair with backlighting to stress his angelic features (pp. 66–67). He was to commit suicide at the time of the Congress of Paris, in despair at Breton's homophobia and at the atmosphere of repression that hung over the event as communication between the Surrealists and the Congress of Writers failed. To his body he had attached a sign that read 'Disgust'. Dora's friend the Surrealist painter Léonor Fini posed for a series of provocative portraits (pp. 68–69). One image shows her in black stockings on a bed and another, even more dramatic, with her bare shoulders and almost bare breasts spilling out of her black dress, framed against the lush texture of a velvet curtain, as if in a theatre: like Jean-Louis Barrault, like Dora, Léonor Fini was drama itself. A black cat nestled between her parted legs looks drowsily towards the floor, while Léonor stares straight at the camera, a modern Olympia.

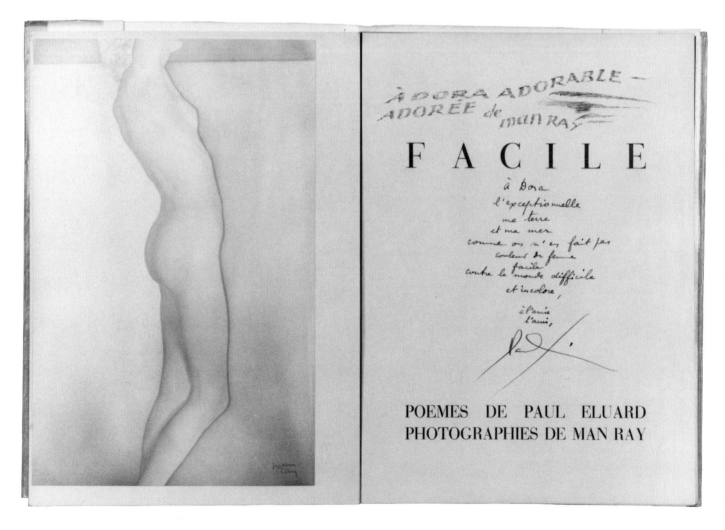

LIFE AMONG THE SURREALISTS

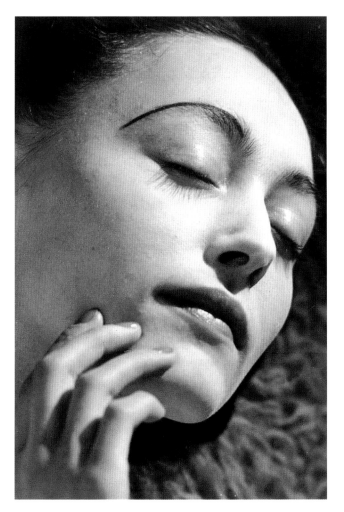
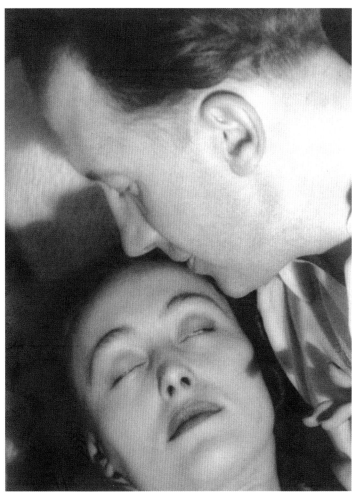

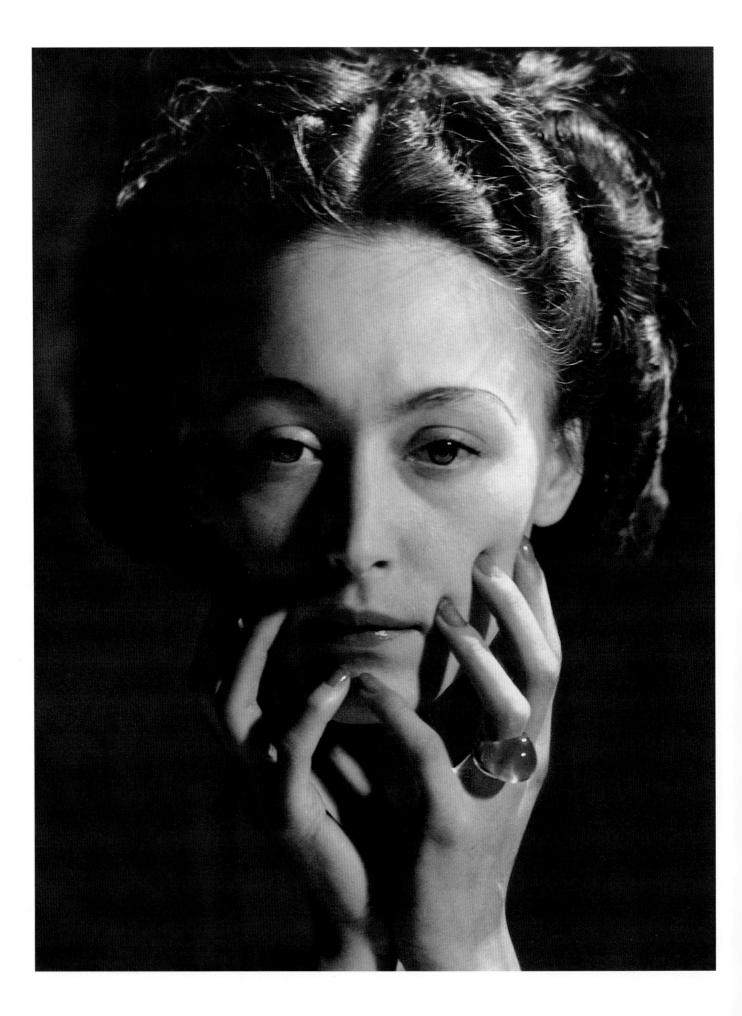

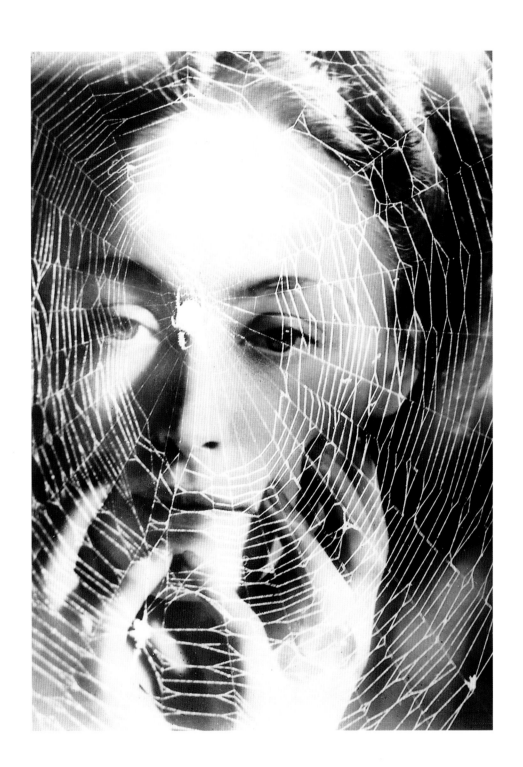

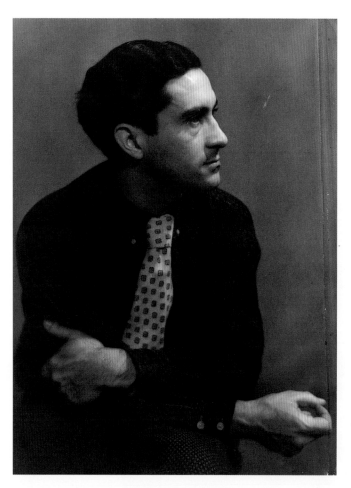

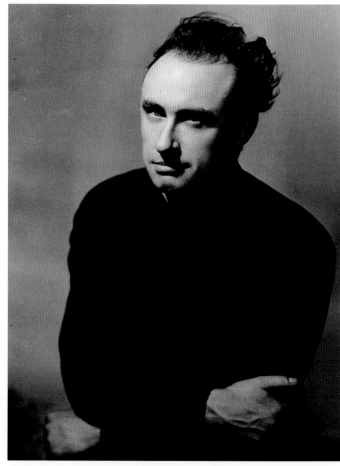

Georges Hugnet by Dora Maar, c. 1936.
Hugnet was a fiery-tempered Surrealist
poet and historian of Dada, outrageous
in speech and with a guttersnipe wit.
He was a friend of Gertrude Stein and
Virgil Thomson, who described him as
'small, truculent, and sentimental, a type
at once tough and tender.'

Yves Tanguy by Dora Maar, 1930s.
The wild-haired painter joined the
Surrealists after meeting André Breton
in 1925. In his art he created a fantasy
world – strange, lunar landscapes peopled
by amorphous beings. He emigrated to
the United States in 1939 with his wife,
the Surrealist painter Kay Sage.

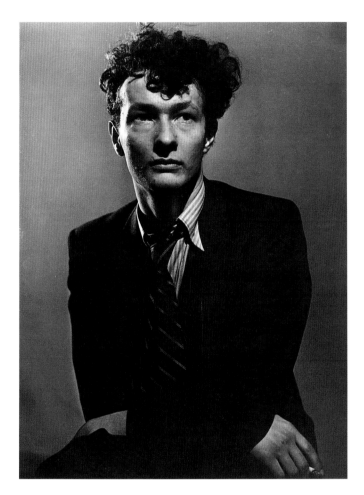

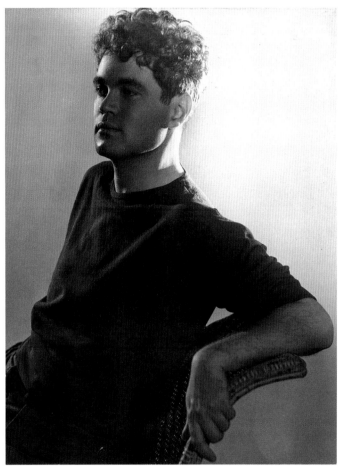

Jean-Louis Barrault by Dora Maar, 1930s. Actor and theatre director, Barrault met Dora Maar through the revolutionary group *Contre-Attaque*. He and his wife, actress Madeleine Renaud, were to be the leading figures in the postwar renaissance of French theatre, their company staging outstanding productions of plays by Paul Claudel and Samuel Beckett.

René Crevel by Dora Maar, 1930s. The brilliant Crevel was a poet, novelist and member of the Surrealist movement from its earliest days. He committed suicide in 1935, depressed by irreconcilable differences between the Communists and the Surrealists, and also by the atmosphere of homophobia that reigned over the movement.

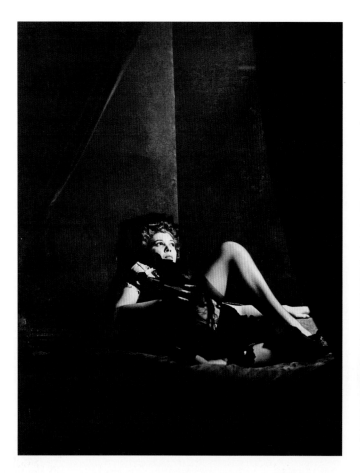
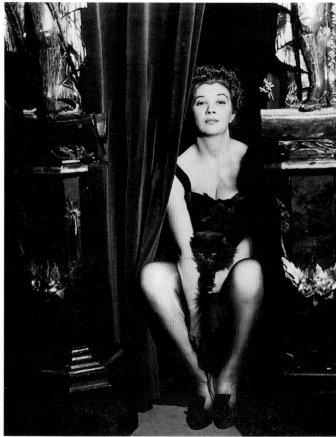

Léonor Fini photographed by Dora Maar
in *c*. 1936. Fini arrived in Paris from
Italy in 1936. She was a friend of Eluard,
Ernst and Magritte and was close to the
Surrealist circle. She showed her
paintings in some of their exhibitions,
though she never became a formal
member. Eroticism, theatricality and her
own image were all central to her work,
which pictured woman as autonomous,
beautiful and driven by passion.

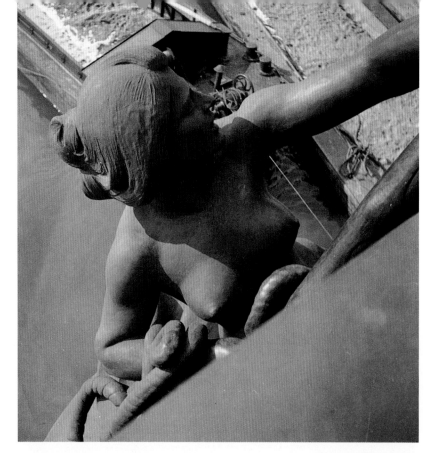

Sensuous, macabre, bizarre: Dora Maar's photographs of the mid-1930s show an increasingly Surrealist sensibility. This statue glimpsed over the edge of the *Pont Mirabeau* in Paris, 1932–34, is incongruously sensual, looking at first glance like a real nude. *Puppet Hooked on a Fence* of *c.* 1934 is more sinister and mysterious, while the lurid distortion of *Grotesque* (opposite) of *c.* 1935 shows an increasingly experimental approach.

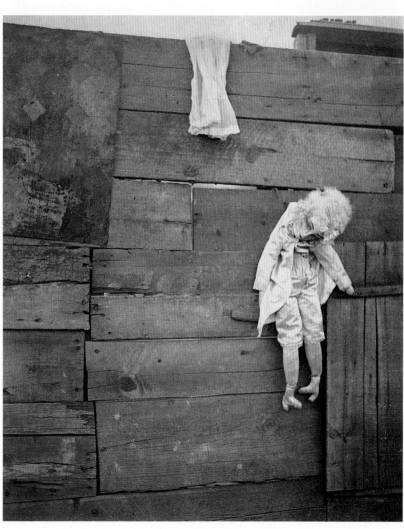

Dora Maar's photography had shown incipient Surrealist tendencies since the early 1930s. Her *Grotesque* of 1935, with the extraordinary distension of the mouth, laughs through its teeth at all our absurdities. Her eye was always attuned to the peculiar, the *insolite* of everyday life, deliberate or unconscious. She photographed street life and its oddities with a characteristically Surrealist sensibility: the hand of a palmist's sign beckoning passers-by (p. 40), a strikingly sensual, bare-breasted statue glimpsed over the edge of the Pont Mirabeau, or a puppet hanging limply on the side of a fence in Barcelona. This delight in street life was increased by her reading of the founding texts of literary Surrealism, especially Robert Desnos's *La Liberté ou l'amour! (Freedom or Love!)* of 1928, with its celebration of the street posters of Bébé Cadum, whose grin advertised a soap, and Bibendum Michelin, the man made out of tyres; and Louis Aragon's *Le Paysan de Paris (Paris Peasant)* of 1924, with its discovery of marvels in everyday locations such as the glassed-in arcade of shops, full of curiosity for the attentive stroller. The flowing style in which Aragon invoked this sense of the quotidian *merveilleux* was so poetic as to make the entire book a poem in prose. He called upon the transforming power of the unexpected: 'for each person there is one image to find that will disturb the whole universe.' So do Dora Maar's images disturb and reveal.

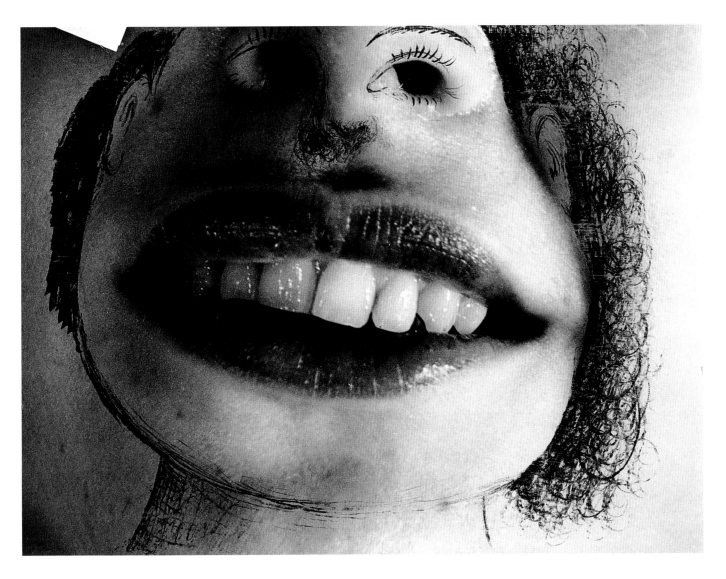

Dora Maar's Surrealist compositions frequently place enigmatic figures in desolate or disrupted architectural settings. Below: *Untitled, c.* 1936, in which a hauntingly misplaced figure lies asleep or dead as the tides rush in to its vaulted resting place. Below right and opposite: one of Dora Maar's most famous works, *29 rue d'Astorg, c.* 1936, both the original photomontage and one of several versions that she coloured by hand in pinks and yellows. With its stout legs, classical drapes and strangely phallic head, the statuette – which she claimed was an *objet-trouvé* – floats above the floor like an apparition in the distorted architecture of the cloister.

By the time she began to be closely associated with the Surrealist group, Dora Maar's photographic work had become a recognizable part of their enterprise. Her major pieces of the period 1935–36 show in their different ways the disquieting peculiarities so beloved of Surrealism, the *insolite* and strange ground of its discoveries and perceptions. The deformations of perspective of her photomontage *29 rue d'Astorg*, in which the statue's tiny unformed head is thrust right in front of us, are closely related to the tiny heads of Giorgio de Chirico's *Disquieting Muses*. Her manipulation of the negative imposed a dizzy spin on the architectural surround. In *The Simulator* (or *The Faker*), a boy's body hangs down from the vaulted ceiling of the vault of the Orangerie of Versailles (the figure of the boy taken from one of her street photographs). This image invokes a whole tradition of misrepresentation, of the tricks used by us and others against ourselves in a universe we do not choose. The background of the cloister lends a feeling of gothic terror to these strange perspectives. In an untitled photograph of 1936 (below left), water laps across the ground of a vault like the tides rushing in, menacing a sleeping – or dead – figure. In another untitled work of 1935 (p. 77) an unsmiling boy holds an upside-down body over his shoulder as if he were transporting a corpse, while in the background a female warrior stands in the curve of an arch, keeping guard over the unsettling scene. Incomplete arches lead into one another, dark and light, like a stage set for a play we would perhaps rather not be witnessing.

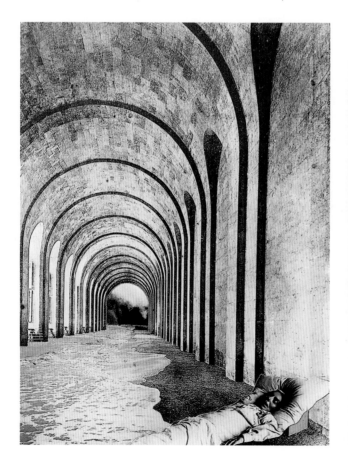

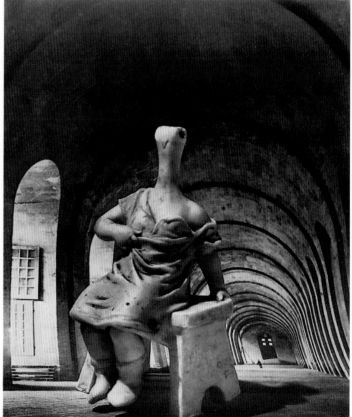

LIFE AMONG THE SURREALISTS

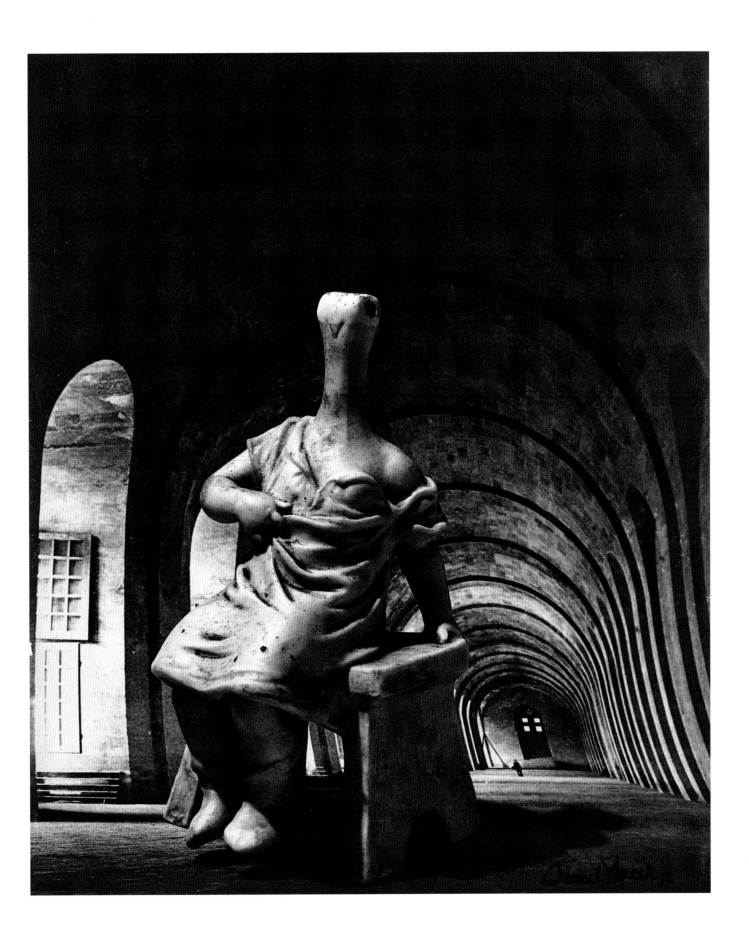

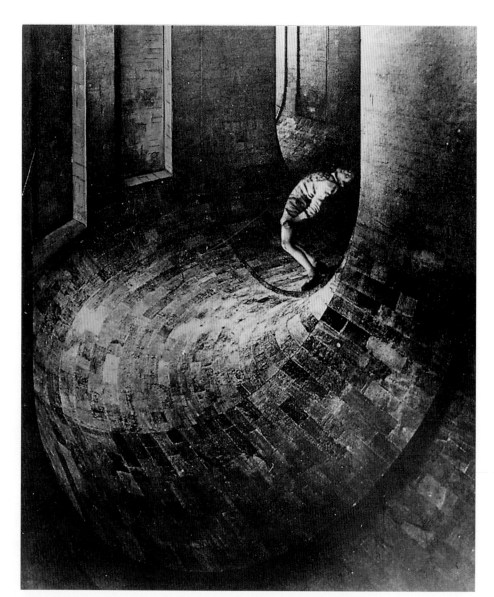

Dora Maar, *The Simulator*, 1936 (above right) and *Silence*, 1935–36 (opposite). In these photomontages she placed figures from her street photographs (such as the one above) into the upturned vaults of the Orangeries at Versailles to disturbing and mysterious effect.

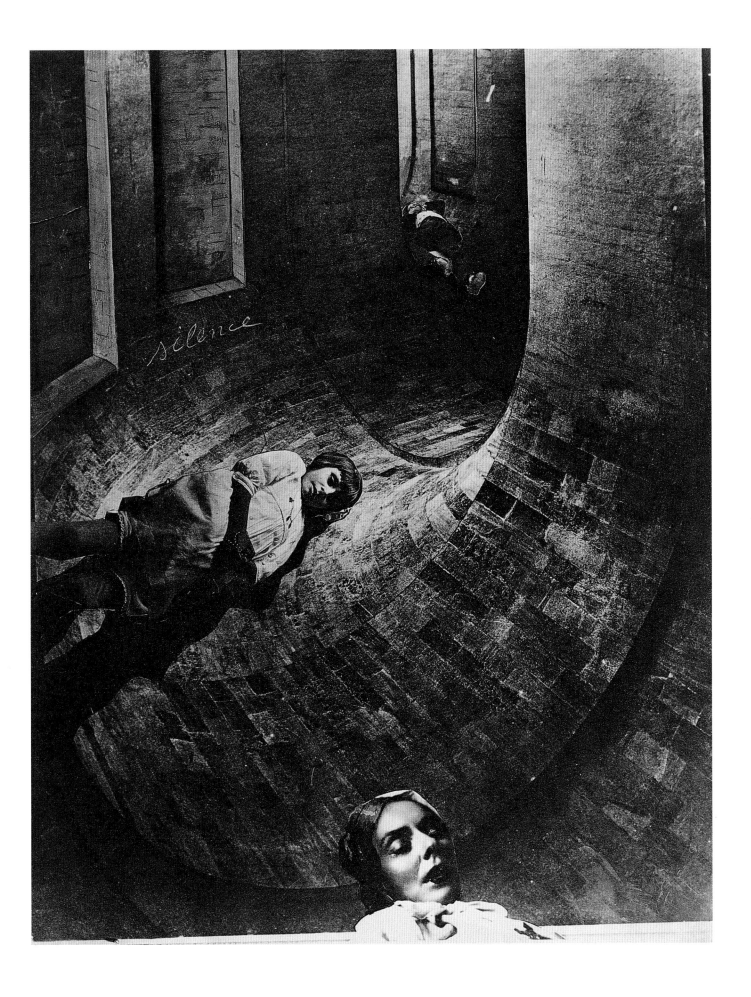

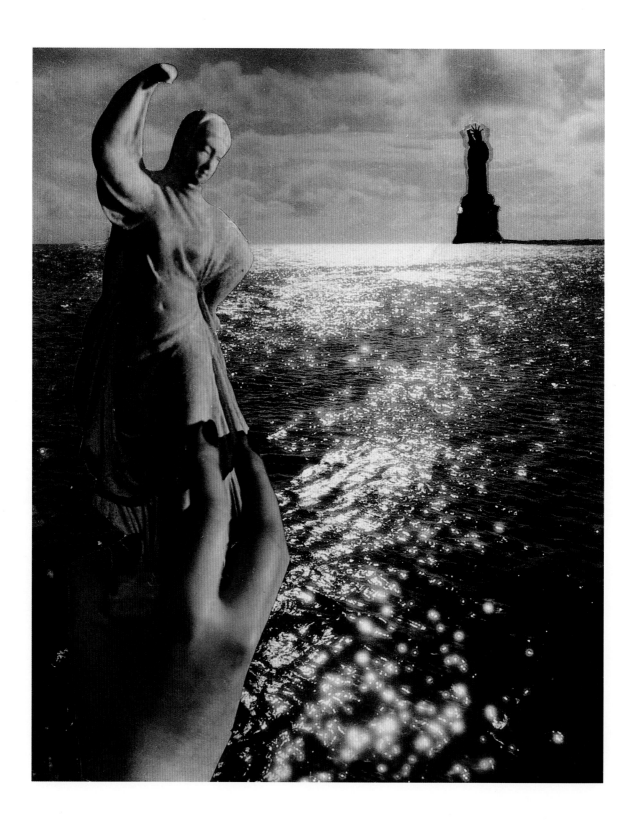

LIFE AMONG THE SURREALISTS

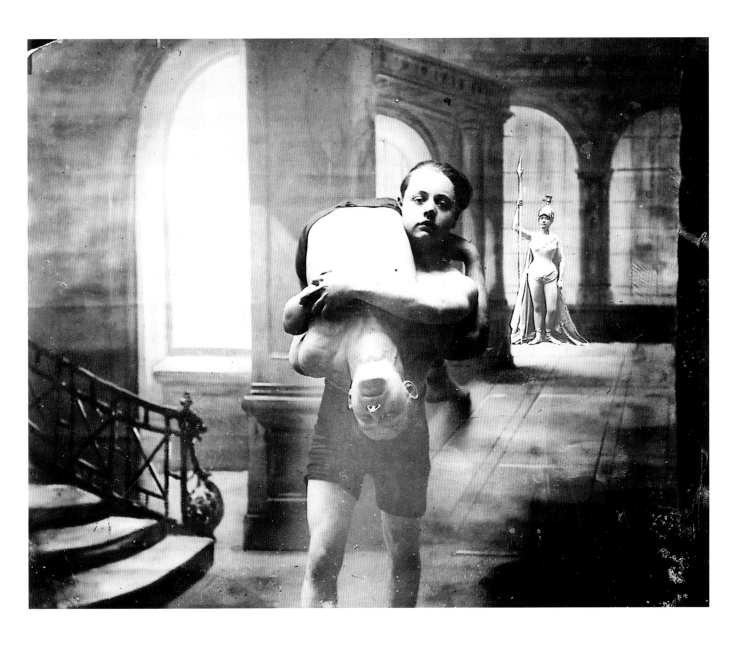

Opposite: Dora Maar, *Liberty, c.* 1935–36.
A female hand, probably Dora's own,
holds up a small figurine to the Statue
of Liberty across the glittering waters.
Above: *Untitled,* 1935. Rescue or
abduction? This ambiguous scene, with
its juxtaposition of the contemporary
and the mythic, has an ominous
atmosphere and a pervasive silence.

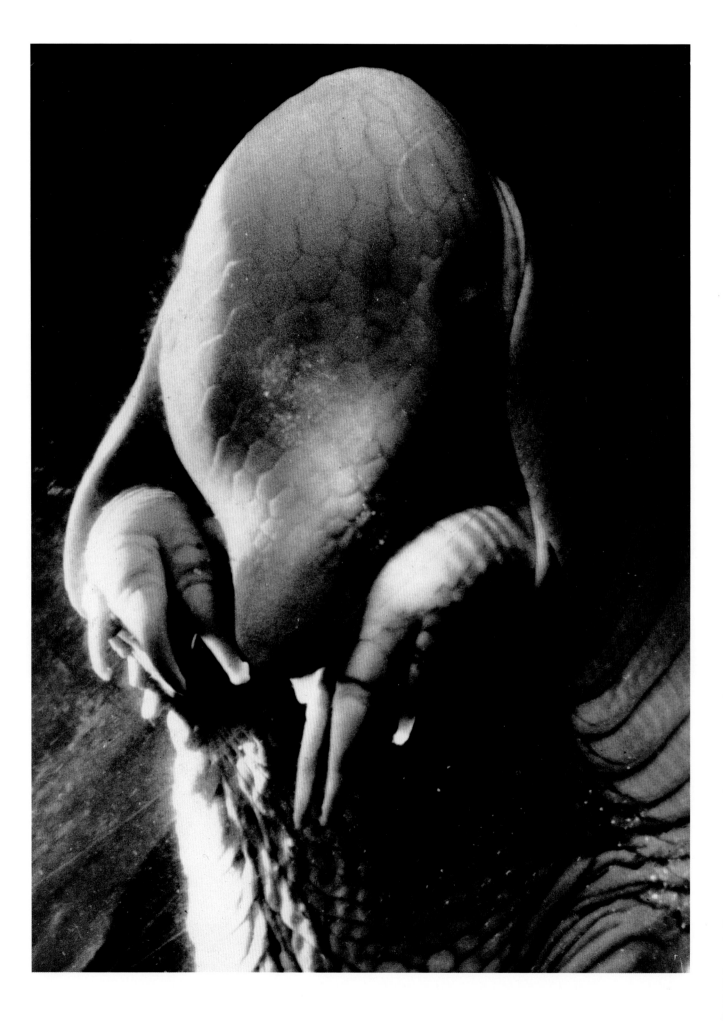

Monstrous, blind, and yet somehow imploring, Dora Maar's *Portrait of Ubu* of 1936 retains even now the mystery and hallucinatory power that made it an icon of the Surrealist movement. It is probably an armadillo foetus, but Dora Maar refused to confirm this, deliberately preserving its mystique.

At the time of these photographs Dora Maar was at the summit of her artistic fame. Her *Portrait of Ubu* was an icon of Surrealism, exhibited, widely circulated, and even included in a series of postcards. In May 1936 *Ubu* presided over the exhibition of Surrealist objects at Charles Ratton's Gallery as its semi-official mascot, and again at the 'International Surrealist Exhibition' in London later that year. It represents a foetus of a real animal, in all probability an armadillo, though no one can pronounce upon this now with certainty, and Dora Maar even at the end of her life was unwilling to say.[12] It is this air of mystery that conveys the particular lyric aura of Surrealism.

Dora Maar named the work after Alfred Jarry's 1895 play *Ubu*, a spoof written when he was a lycée student and a raging success ever since. Ubu was his physics teacher, 'a man, whence cowardice, filth, and so on…. If he resembles an animal, he particularly has a porcine face, a nose similar to the crocodile's upper jaw, and the totality of his cardboard caparison makes him overall brother to the most aesthetically horrible of all marine beasts, the sea louse.'[13] The peculiar fascination of the horrible and the undeveloped in Dora Maar's *Ubu* perfectly exemplifies one of the aims of Surrealism proclaimed by Breton in the First Manifesto: 'the systematic illumination of hidden places and progressive darkening of other places, the perceptual excursion into the midst of forbidden territory.'[14] It also represents Georges Bataille's conception of the '*informe*', the formless or as yet unformed which transgresses all boundaries and blurs distinctions between categories: human and vegetable, heroic and vulgar. This forbidden territory is both dangerous and erotic, and depends on the mingling of the monstrous and the exciting.[15]

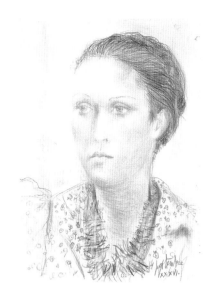

...the play of the pendulum of light sustains all the weight of the scaffolding of the sphere of the colours ground up roughly on the transparent curtain of the sensations originally unperceived...

PABLO PICASSO, 7 JANUARY 1940

Opposite: Pablo Picasso, *Dora Maar in a Yellow Scarf, her Head Leaning to the Side*, November 1936. Above: Pablo Picasso, *Dora Maar in a Polka-Dot Dress*, 14 September 1936. The polka-dot dress he gave Dora here is typically Spanish, and her hair is arranged in the traditional Andulusian style. His ability to talk with her in Spanish about events in Spain and elsewhere was one of the reasons Picasso was drawn to Dora Maar.

The erotic, the exaggerated and the elegant are interwoven in all the accounts of Dora Maar's meeting with Picasso in early 1936. Here is Jean-Paul Crespelle's version of the tale. Picasso is with his friend Paul Eluard at the Café des Deux Magots, where he notices a beautiful, intense-faced brunette seated at a neighbouring table:

> the young woman's serious face, lit up by pale blue eyes which looked all the paler because of her thick eyebrows; a sensitive uneasy face, with light and shade passing alternately over it. She kept driving a small pointed pen-knife between her fingers into the wood of the table. Sometimes she missed and a drop of blood appeared between the roses embroidered on her black gloves.... Picasso would ask Dora to give him the gloves and would lock them up in the show case he kept for his mementos.[1]

Asking Eluard to introduce them, Picasso addressed Dora in French, which he assumed to be her language; she replied in Spanish, which she knew to be his. (By some accounts, Picasso remarked to his sidekick Jaime Sabartès in Spanish upon her beauty; Dora heard, understood, smiled, and replied in Spanish.) They left together, and in the street Picasso asked for her gloves as a souvenir of their meeting.

The threat of Fascism was now increasingly felt. French intellectuals in the Communist and Socialist camps, as well as the Radicals, had joined forces with the Popular Front. It was a year since the suicide of René Crevel. It was less than a year since the birth of Picasso's daughter Maya by Marie-Thérèse Walter. He had kept them secret, hidden away, though he continued to see them, as he did his first wife Olga. The woman who led Jacqueline Lamba to André Breton was herself now a thoroughly flamboyant personality. Dora dressed in snappy clothing and eyecatching hats, and painted her nails different colours according to her mood.

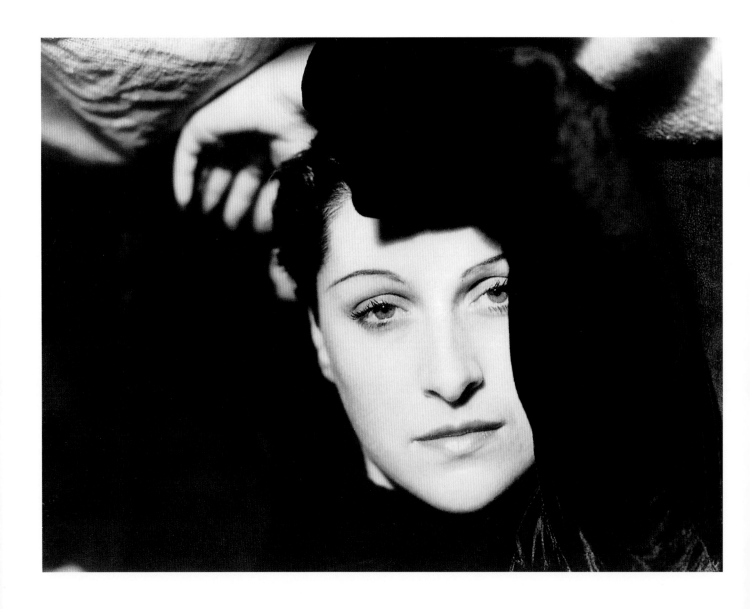

LOVE AND WAR

Having shot a few famous fashion photographs of hats, she delighted in wearing them herself. Her painting *Weeping Woman in a Red Hat* (see p. 129) shows one of these famous hats, flattish, with a blue flower nestling among red hills of felt above her green nose: she was colourful not only in Picasso's portraits but in her being and in her self-depiction.

The three main ingredients of the encounter – her knife, her fingers and her gloves – are like the elements of a Surrealist still-life. They also have a fetishistic value. Some versions of the fable have blood spurting freely, some have it spotting the gloves, while some simply have a drop or two visible. There hovers about the meeting an odour of perversity and spying, of observer and observed, prey and victim, and sado-masochistic delight in blood ritual. As it is recounted and re-recounted, the incident feels like a blood sport or a bull fight.[2] Picasso was fascinated by Dora's gratuitous act of self-mutilation, playing with a knife as one would with fire. His attraction to danger was a marked element in his being. It would be expressed in the torturous imagery with which he surrounded some of his images of Dora – uncomfortable chairs, angles sharp as blades, insects and spiders and horns. And just as Picasso kept the bloodied glove, Dora Maar treasured a trace of his dried blood among her souvenirs, along with other talismans, for their fascination with the shedding of one another's blood was mutual. To Dora Maar Picasso seemed to be both an anarchist and a believer. He was as haunted by death as she by the rituals and mystery of religion. They each had what Bernard Minoret calls a Spanish soul, excessive, dramatic and given to extremes, like Saint Teresa; '*mourir de ne pas mourir*', to die of not dying, an expression that might have been tailor-made for Dora Maar.[3]

The drama was set up: the short painter was deeply moved by a dark, tall, powerfully mysterious woman given to strange acts. According to some accounts, Picasso left town immediately after meeting Dora – the Spanish genius fleeing the young French photographer with her black-haired beauty and disturbing behaviour, who speaks his language and who dares to play with violence. In the words of Jean-Charles Gâteau, Picasso:

> felt a sudden and violent attraction to a young and beautiful photographer…. Dora Maar, radiant, with her ebony hair, her blue-green eyes, her controlled gestures, fascinated him. She still lived with her parents, but behind her haughty and enigmatic attitude you could see a spontaneity restrained, a fiery temperament ready to be carried away, mad impulses ready to be unleashed. She withstood without batting an eye Picasso's stare, and he was the one to flee.[4]

Whether or not Picasso fled, he and Dora were to meet again.[5] Picasso drove down to Cannes in July with his chauffeur in his sleek Hispano-Suiza car. Paul and Nusch Eluard had also gone south to stay at the Hôtel des Algues in Saint-Raphael. On 24 July they moved to Mougins, a little village above Cannes, into a villa lent them by relatives of Man Ray, the Sauvard-Wilums. Here Picasso came to visit them and their mutual friends Roland and Valentine Penrose (with whom he was in a car crash, not serious but memorable). The poet René Char was also staying, as were Christian and Yvonne Zervos, publishers of the magazine *Cahiers d'Art*, where Picasso's poems and Dora Maar's photographs of *Guernica* would first be published.

Man Ray's portrait of Dora Maar, taken in 1936, suggests the sphinx-like sophistication of this woman who lured Picasso by her solitary games with a penknife across the Café des Deux Magots.

On 4 August the Eluards and Picasso went to Les Salins in Saint-Tropez, a house owned by the writer Lise Deharme, society hostess and part of the Surrealist group. In the words of James Lord, Deharme possessed 'charm and a comfortable fortune,' a 'desire to deserve attention', and a salon that was an 'all-duty, avant-garde, *dernier cri* Madame Verdurin.'[6] Breton himself had pined after her for a period. He kept on his desk at 42 rue Fontaine a bronze cast of a pale blue glove that she once left behind there, and which haunts the pages of his *Nadja*. She remained his 'lady of the glove' – perhaps because she never gave in to his advances.

Staying with Deharme in August 1936 was her good friend Dora Maar. Her house was close to the sea, and Picasso, after visiting there, walked back with Dora along the beach to Mougins. In a drawing of 1 August 1936, he showed a young and diminutive Dora, bag in hand, opening a door onto the naked, bearded patriarch, a dog on his lap. The hierarchy is strongly marked: the newcomer and the priapic old painter. The old hound, Elft, would soon be retired to the Château de Boisgeloup in Gisors, Normandy, and succeeded by the Afghan hound Kazbek.[7] According to Picasso's biographer John Richardson, a close friend of Dora's until she died, Dora perceived that when the woman in his life changed, virtually everything else changed too: 'the style that epitomized the new companion, the house or apartment they shared, the poet who served as a supplementary muse, the *tertulia* (group of friends) that provided the understanding and support he craved, and the dog that rarely left his side.' Richardson called this 'Dora's law'.[8]

After a reasonable lapse of time, discreetly allowed the new couple, the Eluards went to find them on 15 August at the villa of the Sauvard-Wilums. The numerous paintings and drawings Picasso made of Dora Maar in this period show her as a being constantly in transformation: she becomes a bird, a water nymph, she takes on horns or then the features of flowers. It was hot in the south of France, and the noise of the cicadas made a pleasant background to sleep by. Each day the group of friends would dip in the sea, sun on the sand, prepare and consume their simple food, talk politics over the meal, and play cards in their spare moments in the afternoon.[9] After lunch, they would all take a nap – all but Picasso, who was always working at his art. In September he was granted the directorship of the Prado as an honour by the Spanish Republican government. All was going well, in love and work.

The sensuality of the summer light and heat is superbly rendered by some of the poems in honour of Dora that Picasso jotted down in Mougins. They are written in the Surrealist vein. Encouraged by Breton, Picasso had begun writing poems in 1934 when he reached a dry period in his art. They are good examples of automatic writing, many startling in their juxtapositions and visuality. Breton translated some of Picasso's Spanish poems into French for *Cahiers d'Art*, and lauded them in the essay 'Picasso Poet'.[10] Were they not listed with Picasso's name, one might well take them for typical Surrealist productions: they delight in the same kind of poker-faced irony, freeform lyricism, and concatenation of elements and moods as Breton's own creations.

> …good evening sir good evening madam and good evening children
> small and large damasked and striped in sugar and in marshmallow
> dressed in blue black and lilac mechanisms unsavoury and cold…

Above: Pablo Picasso, *Dora Maar in a Double-Breasted Jacket*, 20 October 1936. Opposite: Pablo Picasso, *Dora Maar and Classical Figure*, 1 August 1936. In Picasso's vision, Dora is the timid young model, diminutive and modestly covered as she enters the mythic domain of her towering, classically bearded lover. This imaginary scene is the polar opposite of their real encounter, when Picasso was irresistibly drawn to the seductive and mysterious figure of Dora Maar.

Picasso was unceasingly fascinated by
Dora Maar's image in its many modes,
from reflective to anguished. Below:
A fleeting moment lost in thought, Dora's
head resting on her hand in a sketched
Portrait of Dora Maar of 28 January
1937. Opposite: *Adora* of 28 December
1938, a frank – and punning – expression
of the physicality of his love.

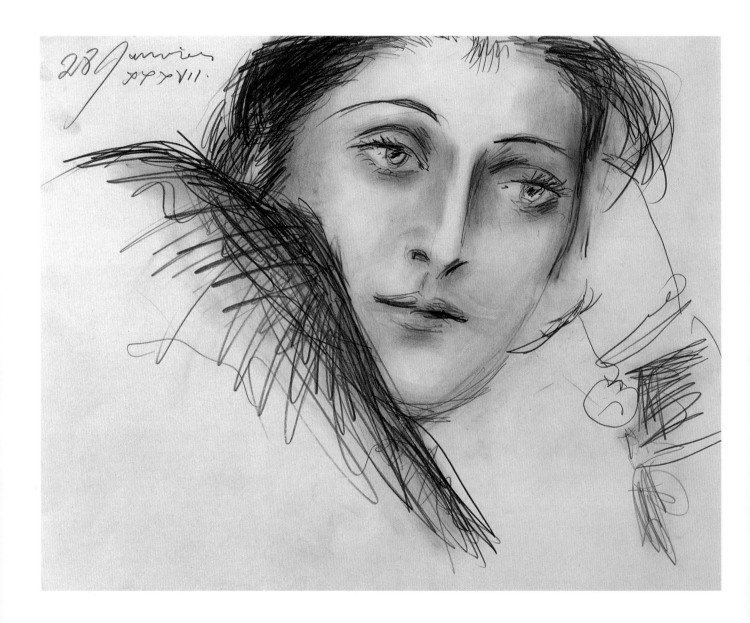

LOVE AND WAR

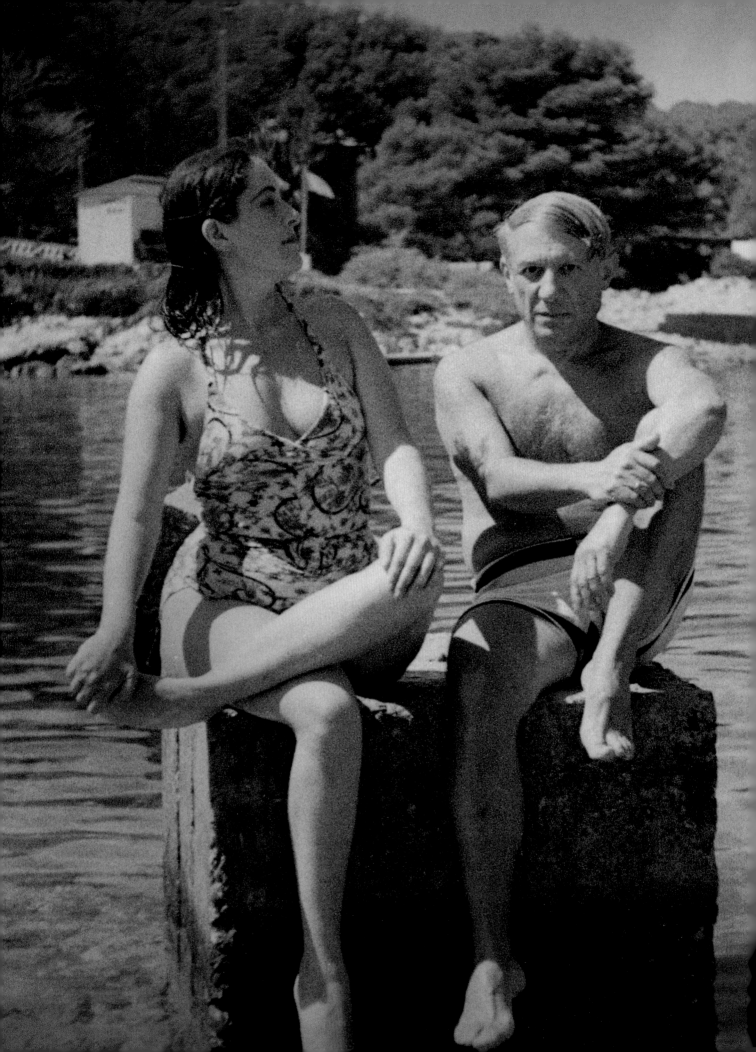

Picasso and Dora spent the summers
of 1936 and 1937 together in Mougins,
a hilltop village above Cannes. Roland
Penrose, who took this photograph,
joined them there both years. Picasso
was devastated by the outbreak of civil
war in Spain in July 1936, and found
consolation in his new companion.
Penrose recalled that he and Dora would
make 'long and mysterious excursions
by night along the coast'.

Dora's wind-tousled hair was still boyishly short in 1936, when Picasso made all three of these sketches. She eventually grew it longer, Spanish-style, at his request. Bird-woman (opposite) was one of the many incarnations Dora Maar's image underwent in Picasso's art. 'She was anything you wanted,' he told James Lord, 'a dog, a mouse, a bird, an idea, a thunderstorm. That's a great advantage when falling in love.'

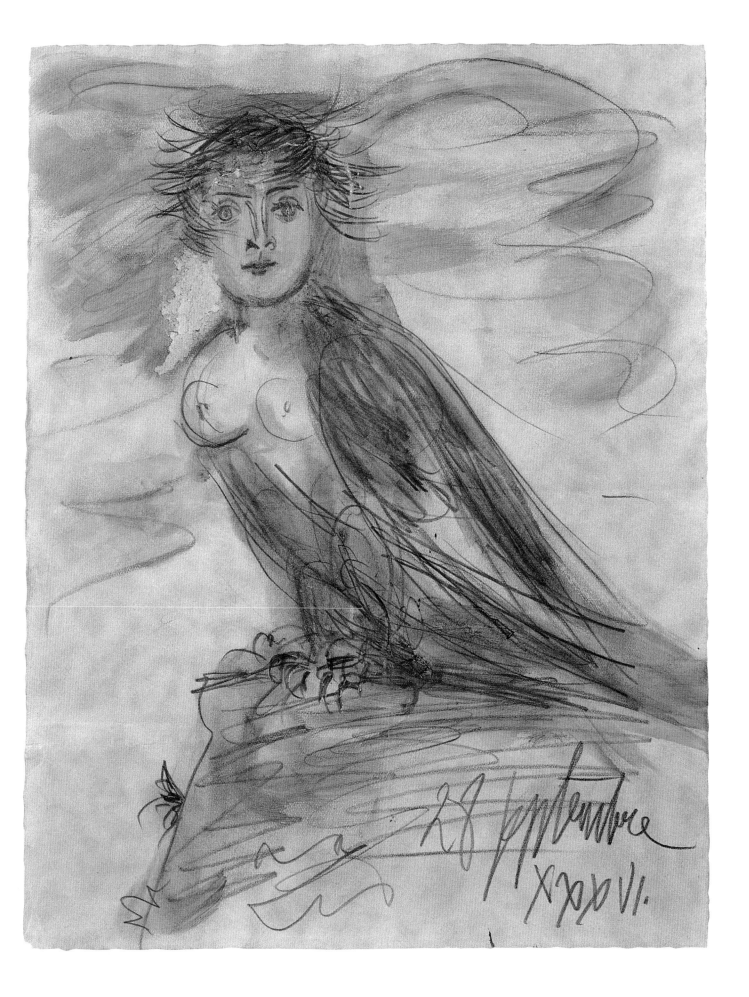

91

Right: Dora, Picasso and Kazbek, his Afghan hound, photographed on the beach by Man Ray. On 7 November 1936 Picasso reworked his simple pencil sketch of Dora (below) in pastel-coloured oils. *Dora Maar on the Beach* (opposite) shows a wide-eyed and tranquil Dora; it was clearly painted in tribute to the idyllic summer gone by. Overleaf: Picasso photographed by Dora Maar in 1936 or 1937 under the striping light of the bamboo awning at the Hôtel Vaste Horizon, and standing in the water holding up a piece of wreck like a sculpture, the tiny figure of a swimmer visible in the distance.

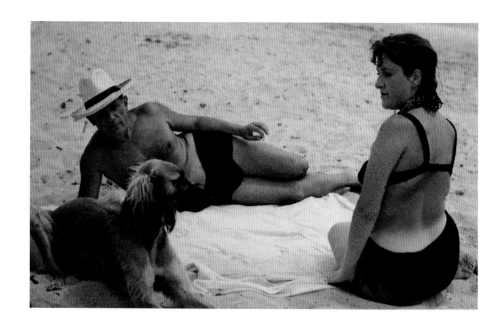

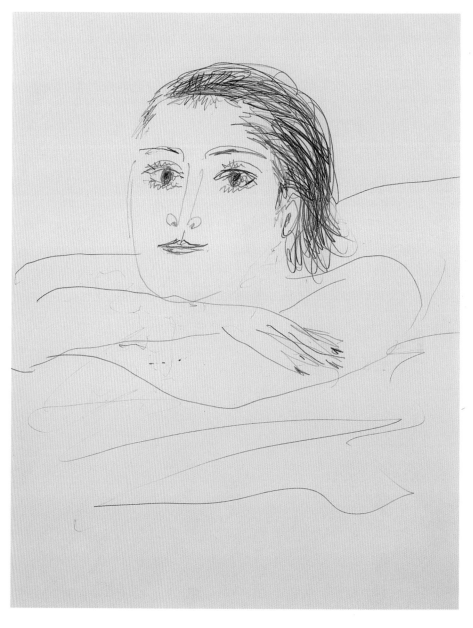

LOVE AND WAR

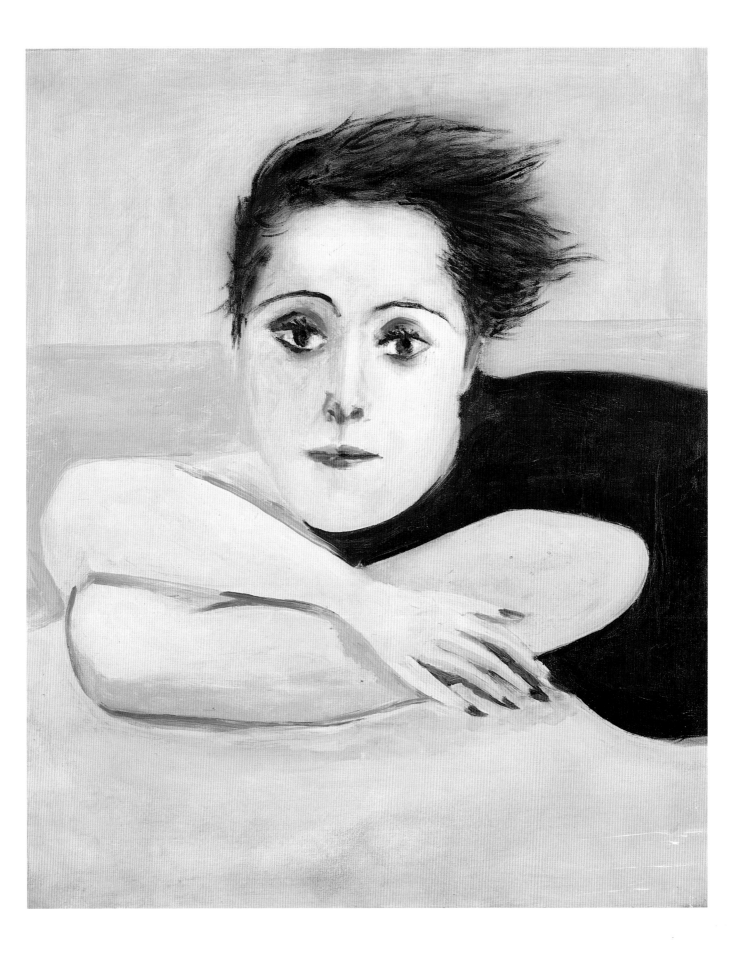

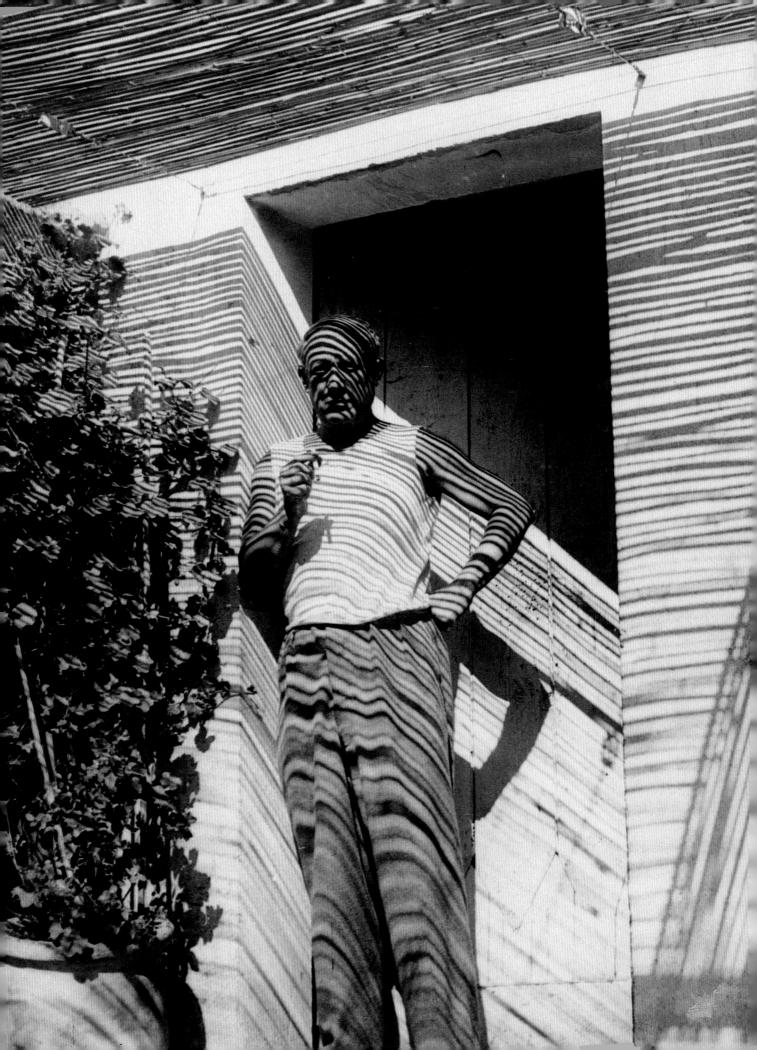

Breton's celebratory poem '*Union libre*' ('Free Union') of 1931 had enumerated on separate lines his lover's delights from head to toe and up again: the nape of her neck, her knees, her breasts, her buttocks, 'her eyes of water savoured in prison … her eyes of wood always under the axe/Her eyes at the level of water air earth and fire.'[11] Now Picasso celebrated the parts of his new mistress in the same fashion:

> Her great thighs…
> her hips
> her buttocks
> her arms
> her calves
> her hands
> her eyes
> her cheeks
> her hair
> her nose
> her throat
> her tears
>
> the planets the wide curtains drawn and the transparent sky hidden behind the grill —
> the oil lamps and the little bells of the sugared canaries between the figures —
> the milk bowl of feathers, snatched from every laugh undressing the nude from the weight of the arms taken away from the blooms of the vegetable garden —
> so many dead games hung from the branches of the meadow of the school pearled with song —
> lake lured with blood and thistles
> hollyhock played at gaming
> needles of liquid shadow and bouquets of crystal algae open to dance steps the moving colours shaken at the bottom of the spilled-out glass —
> to the lilac mask dressed with rain —

On 12 October 1936, Picasso wrote, and Dora Maar then copied in red ink, the line: 'Narcissus looking at himself in the broth of the pot au feu at two-thirty in the morning'. Narcissus he was, yet Dora Maar, transcribing his text in blood-coloured ink, was not merely a faithful echo but a collaborator, in poetry as in photography and painting. Making art and love at two-thirty in the morning and every other hour, they shared an intensity of creativity in these years that left its trace on these pages that he scrawled and she copied.

Pablo Picasso, *Dora and the Minotaur*, Mougins, 5 September 1936. The sovereign minotaur, dark and bestial, contrasts with Dora's sheer white flesh as his passion is consummated against flame-coloured skies. This was the unforgettable signature work in the 1999 exhibition 'From Celestina to Dora Maar' at the Picasso Museum in Paris.

Below: The exterior of Picasso's studio at 7 rue des Grands Augustins which Dora Maar located for him on their return to Paris in late 1936. As the former meeting place of *Contre-Attaque* and the setting for Balzac's story *The Unknown Masterpiece*, this historic building was laden with associations for both Picasso and Dora. Opposite: *Kazbek in the Grands-Augustins Studio*, photographed by Brassaï a few years later in 1944, the jumbled chimney pots and rooftops visible through the window.

In early 1937, at Dora Maar's suggestion, Picasso moved into a new studio at 7 rue des Grands Augustins. This attic at the top of an elegant seventeenth-century mansion was well known to her: it had previously been occupied by Jean-Louis Barrault, and she had frequented it along with other members of the October Group (to whom it was the 'Grenier Barrault'). *Contre-Attaque's* meetings, presided over by Bataille, had also been held there. Once home to the Dukes of Savoy, the building was all the more picturesque for being the fictional location of Balzac's *Le Chef d'oeuvre inconnu* (*The Unknown Masterpiece*). In this story, the painter Frenhofer becomes obsessed with the desire to represent the absolute upon his canvas. The more his obsession takes him over, the less recognizable is the subject of his painting. Eventually he destroys it and dies, to the despair of his friends Nicholas Poussin and François Porbus. Brassaï knew very well both Balzac's story and the steep dark staircase the fictional Poussin and Porbus had climbed, which he found 'still extremely striking in its resemblance'. He photographed the vast spaces of the studio, its rickety stairs, crumbling columns and views over brick chimneys and rooftops. Picasso, he recalled, was 'moved and stimulated' by the thought of becoming Frenhofer's successor. It was here, where the fictional 'unknown masterpiece' was painted, that he was very soon to create the masterpiece *Guernica*.[12]

According to Jean Cocteau, who was devoted to Picasso, the vast rooms of the rue des Grands Augustins were stuffed full of things. Picasso (like Dora) was a hoarder, who amassed:

> piles of booty, consisting of his own works and pictures by Matisse, Braque, Gris, the Douanier Rousseau, Modigliani and hundreds of others. The tables and chairs were littered with an amazing variety of objects: Negro masks, ceramics, twisted pieces of glass picked up in Martinique in the lava that engulfed Saint-Pierre, ancient bronzes, plaster casts, peculiar hats, de luxe books, reams of Holland paper and rice

paper, piles of reviews and unopened packets. Picasso kept everything he was given: bottles of eau de Cologne, bars of chocolate, loaves of bread, packets of cigarettes and boxes of matches, and even his old shoes, which were lined up under a table.... He had never thrown anything away, even hoarding useless household utensils, the old oil-lamp which lit the canvases of the Blue Period, a broken coffee-grinder ... he considered that anything that had come into his hands formed part of himself, contained a portion of himself, and that parting from it was equivalent to cutting off a pound of flesh.[13]

The atmosphere at the studio, Cocteau wrote, was regal: 'A regal disorder, a regal emptiness – haunted by the monsters he invents, who compose his universe.' Among these monsters was the double-natured Picasso himself: 'Picasso is a man and a woman deeply entwined. Like in his paintings. He's a living ménage. The Picasso ménage. Dora is a concubine with whom he is unfaithful to himself. From this ménage marvellous monsters are born.'[14]

Dora moved to an apartment at 6 rue de Savoie, just around the corner from the rue des Grands Augustins. Even so, she was never welcome in Picasso's studio unless invited. She would await Picasso's summons to lunch, dinner, or any other occasion he chose – or for him to come over unannounced. Nor did she ever live with Picasso in his apartment at 23 rue la Boétie. Years later, walking with Cocteau past 6 rue de Savoie, Picasso commented: 'In this house, Dora Maar died of boredom.'[15] But that was later. In 1937, the noble inheritance of aristocracy, art, ideas and politics gave the walls of the Grands-Augustins studio a feeling of excitement and creative continuity. In these fictionally historic and factually politicized rooms, with their accumulated energies and memories, two persons so imbued with the spirit of romanticism as Picasso and Dora Maar could work towards a collaborative depth of feeling.

In March 1936 Hitler's forces had marched unresisted into the Rhineland, and Nazi Germany continued to rearm. The French franc had been devalued, like the lira in Italy. In July 1936 General Franco had led a revolt against Spain's democratic government that led to the outbreak of civil war. Europe was divided in its sympathies and officially committed to non-intervention; in fact Nazi Germany and Fascist Italy sent increasing amounts of military aid to Franco, while only the Soviet Union actively supported the Republican cause. In February 1937 rightwing Spanish rebels took Málaga, Picasso's birthplace, with Italian aid, and Franco began a naval blockade. On Sunday 26 April, the defenceless Basque town of Guernica was devastated in a bombing attack by the German Condor Squadron.

That terrible event would receive its immortal image at the studio at 7 rue des Grands Augustins. Picasso had been approached at the beginning of the year by a delegation from the Spanish Republican government to paint a mural for the Spanish Pavilion in the 1937 Universal Exposition, due to open in Paris in May. He had agreed, but until now his sketches had been conventional and uninspired. The atrocity of Guernica gave him his theme.

Dora Maar captured with her camera each modification of *Guernica* as this epic painting took shape in May–June 1937. Her photographic record (opposite, pp. 104–5 and pp. 108–9) realized Picasso's longstanding ambition 'to preserve photographically, not the stages but the metamorphoses of a picture.' Upon it decades of scholarship have been founded. Art historians have traditionally identified seven distinct stages through which the painting passed before completion. Experts at the Parisian auction house PIASA, which sold Dora Maar's estate on her death, identified an additional two stages from the prints that were in her collection. These are the second version of the initial drawing, at the top of p. 104, and the image at the top of p. 105, which falls between the traditional States II and III.

LOVE AND WAR

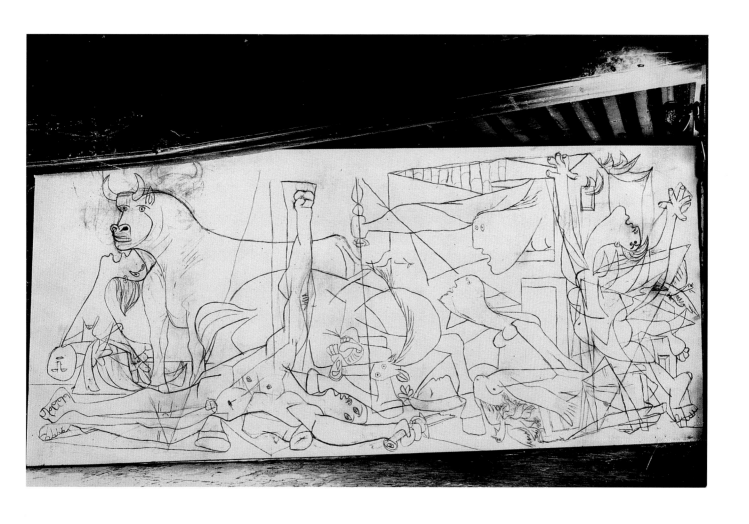

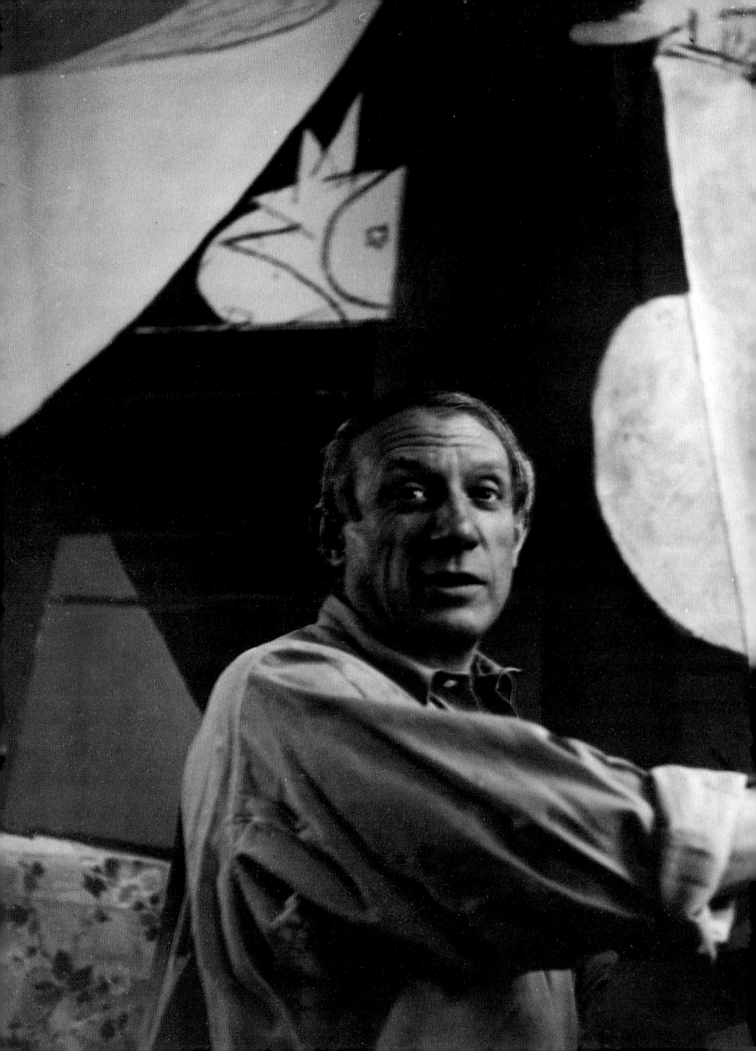

On Dora Maar's singularly expressive face Picasso could read every international event as in a newspaper. After years of involvement with the extreme left, her dismay at the continuing rise of Fascism was intense. She was the perfect photographer to capture the evolution of his painting. Brassaï, who had followed Picasso's work closely with his camera in the past, now stepped aside. During the Spanish Civil War it was Dora Maar who was Picasso's photographic witness and collaborator. She even painted some of the vertical strokes on the horse of *Guernica*, a minor but symbolic contribution that made this a collaborative endeavour in paint as in photography.[16] The huge mural – nearly eight metres wide – was completed in little more than a month. Day after day, Dora Maar photographed Picasso painting, from all angles, with a lover's intimacy and a passion as political as it was professional. She watched him stick pieces of wallpaper here and there as he pondered his composition and its tones, the way his father had stuck little pieces of paper on his canvases to emphasize the intensity of whites and blacks. As she wrote much later, in a journal entry of 14 October 1980:

> Collage as everyone knows was invented by Picasso
> This is what he told me
> His father in order to judge 'the scale of values'
> in a canvas he was painting used to pin a bit of white paper on the canvas.
> That's what gave Picasso the idea of collage.[17]

Dora Maar photographed his face illuminated by his impassioned working, his dark eyes burning with concentration and anger. She crouched down and took him standing high up on the ladder in a heroic position, just his head and brush showing over the top rung, and then mounted the ladder herself to take him in plunging perspective, paintbrush in his right hand, cigarette in his left. She stood in the doorway to catch him squatting under the high casement windows of the Grands-Augustins studio, with the light coming through the panes to strike his shirt, everything else deep in shadow.

Raymond Mason called *Guernica* 'the key to this century'. Its numerous commentators speak of the painting's massive simplicity – the nail-studded hoof, the furrowed palm of the hand, the woman's scream of anguish, the dead child, the dying horse, all illuminated by the lamp and the bare bulb – and of its austere mythmaking, archaic rather than modern, under a primitive enduring light. Picasso stated his objective in May 1937: 'The war in Spain is a war of reaction – against the people, against liberty. My whole life as an artist has been a continual struggle against reaction, and the death of art. In the pictures I'm now painting – which I shall call *Guernica* – and in all my recent work, I am expressing my horror of the military caste which is now plunging Spain into an ocean of misery and death.'[18] He famously said of this work: 'Painting is not done to decorate apartments. It is an instrument of war ... against brutality and darkness.' As his representations of Dora Maar's anguished face made of her image an enduring symbol, so the light he cast on the tragedy of this little Spanish town is a universal illumination beyond the particular.

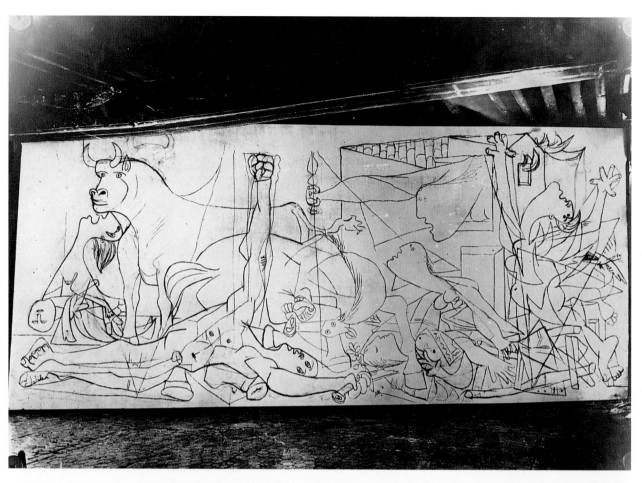

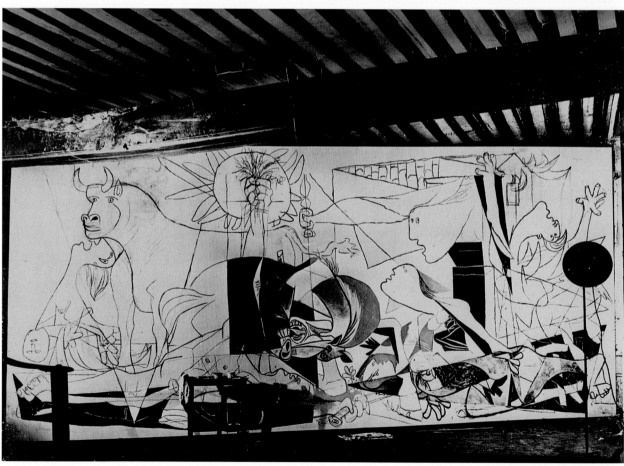

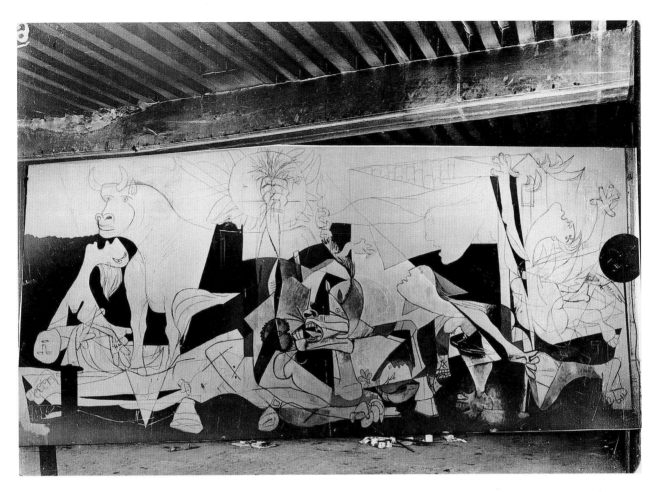

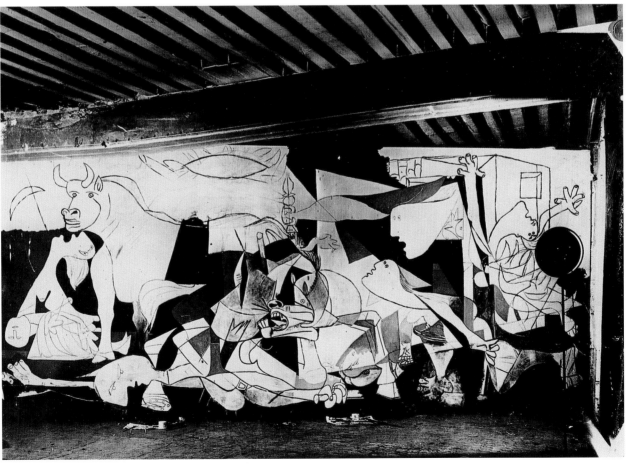

Dora Maar was the only photographer
allowed access to Picasso's studio at this
time, and Brassaï now stepped aside.
Her photographs of Picasso at work on
Guernica are a powerful testament to the
extraordinary passion and energy he
poured into the work. Her presence was
also part of its inspiration, for this was
a painting profoundly influenced by
photography: the multiple horrors in
a palette of greys evoke the shock
newsprint reports of the atrocity, while
the bare bulb suggests the flashbulb of
a camera, surveying the scene like an
electric eye.

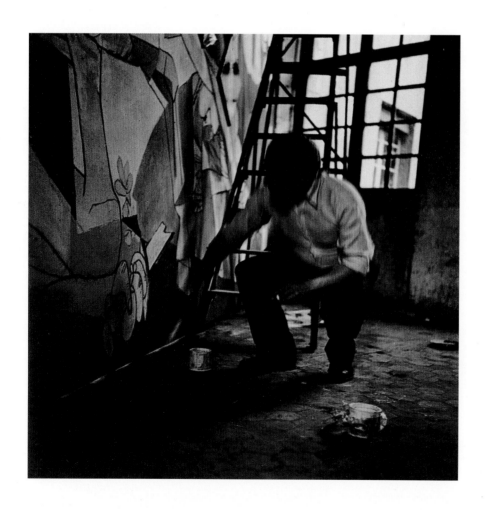

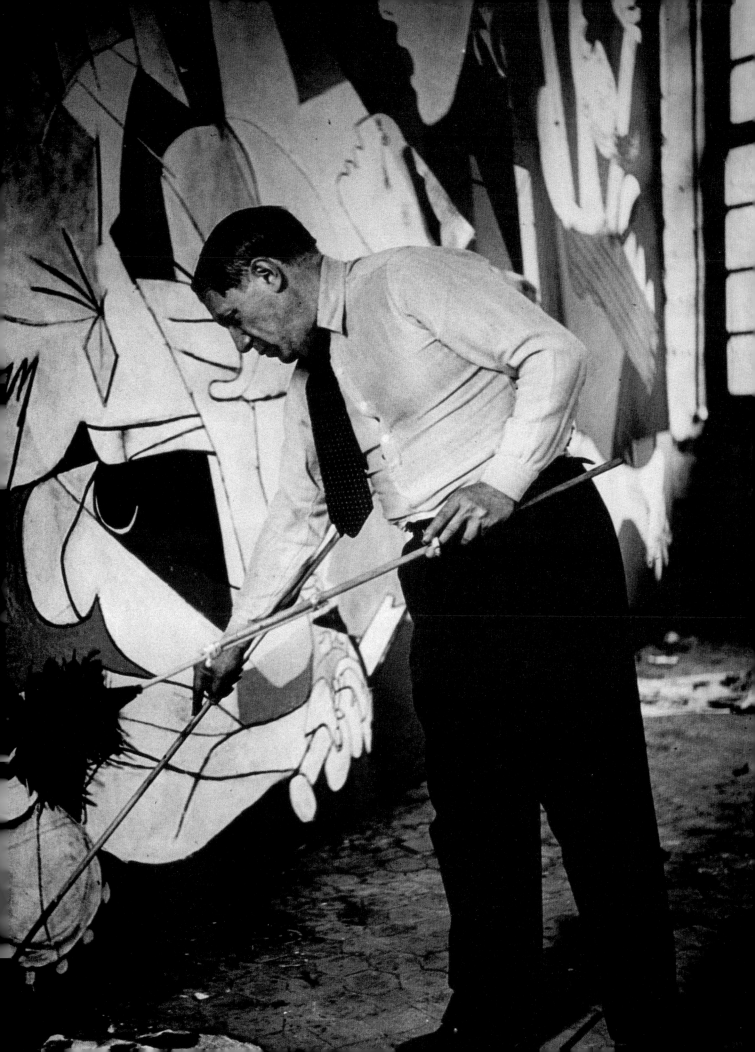

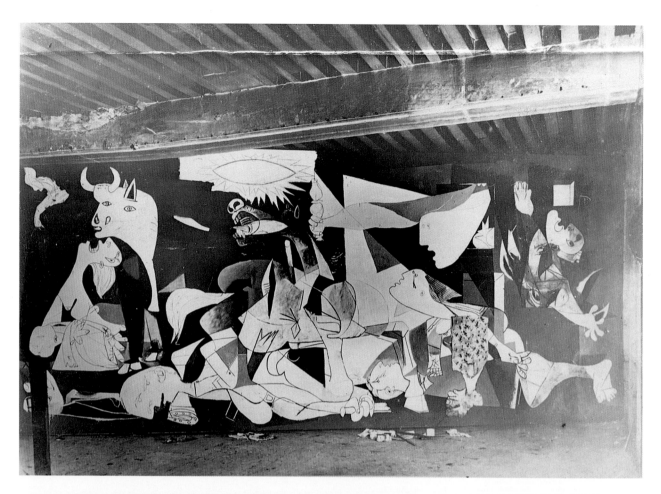

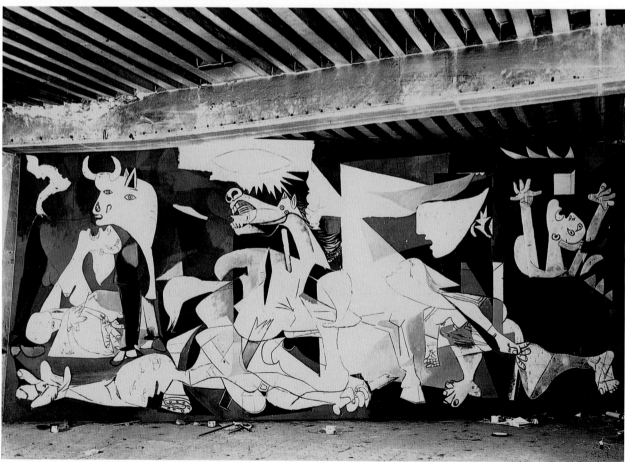

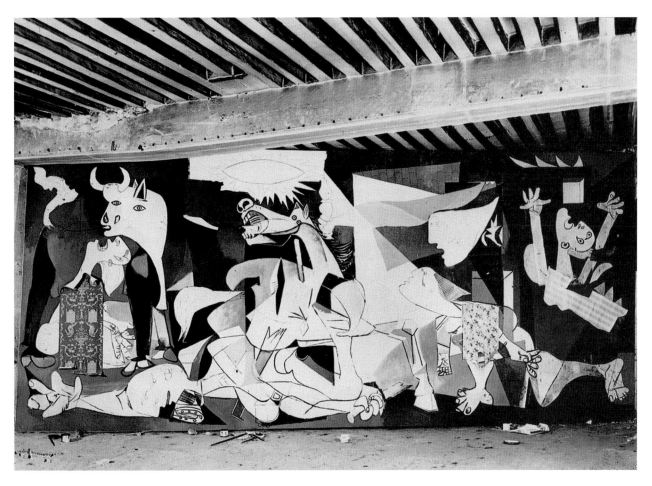

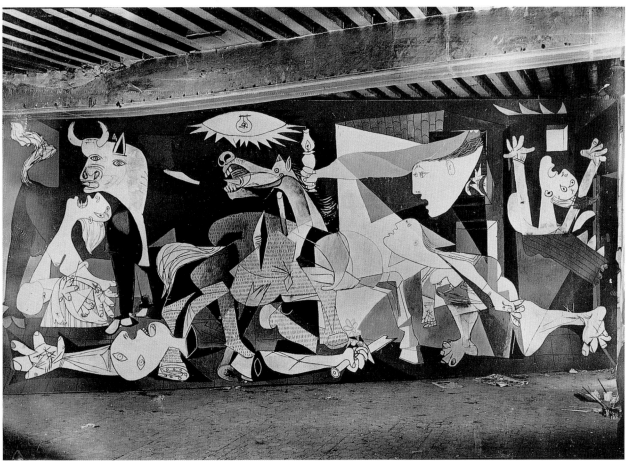

VICTORY AT GUERNICA
by Paul Eluard

1

Lovely world of cottages
Of mines and fields

2

Faces good in firelight good in frost
Refusing the night the wounds and blows

3

Faces good for everything
Now the void fixes you
Your death will serve as warning

4

Death the heart turned over

5

They made you pay your bread
Sky earth water sleep
And the misery
of your life

6

They said they wanted intelligence
They measured the strong judged the mad
Handed out alms split a cent in two
They greeted the corpses
They were polite

7

They persevere overdo they are not of our world

8

Women children keep the same treasure
Green springtime leaves and pure milk
Endurance
In their pure eyes

9

Women children keep the same treasure
In their eyes
Men defend them as they can

10

Women children keep the same red roses
In their eyes
They show their blood

11

Fear and courage to live and die
Death so hard and so simple

12

Men for whom this treasure was sung
Men for whom this treasure was wrecked

13

True men for whom despair
Nourishes hope's devouring ardour
Let us open the future's last bud

14

Pariahs the death earth and ugliness
Of our enemies have a colour
Grim as our night
We shall win out

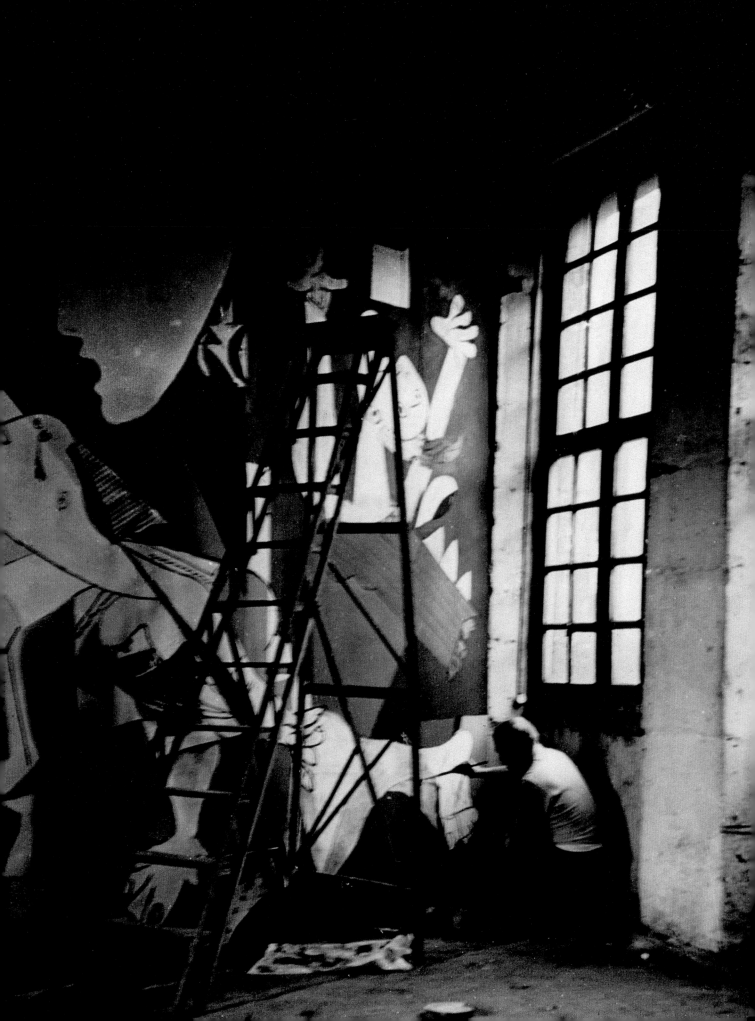

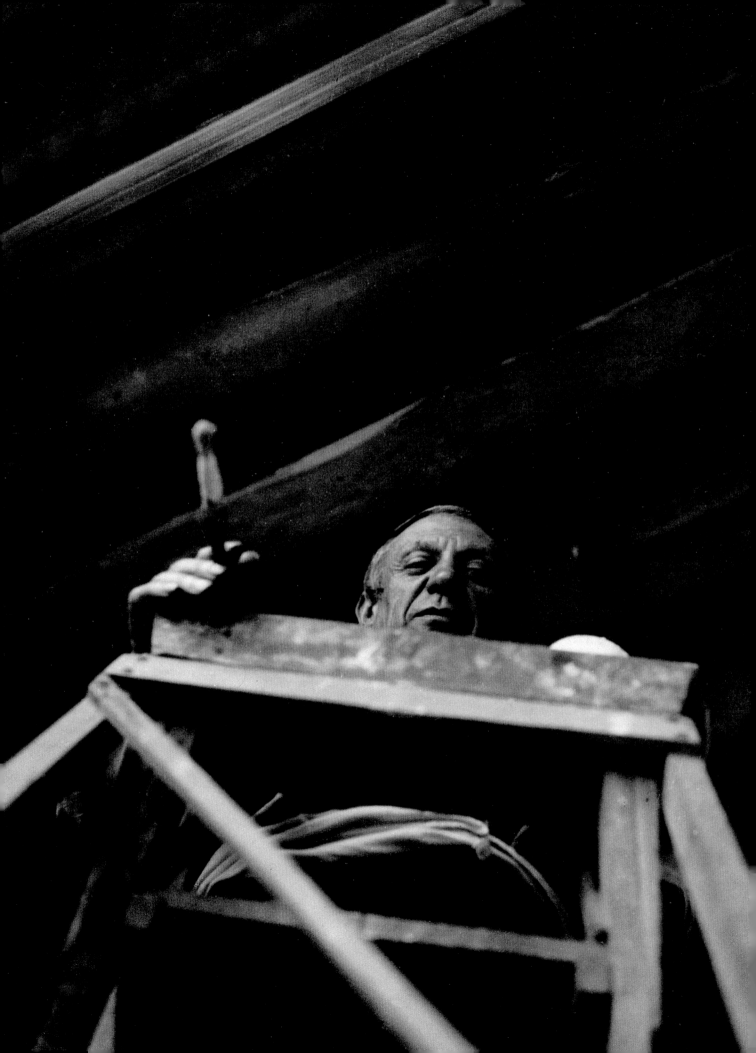

By mid-June, *Guernica* was installed in the Spanish Pavilion of the Universal Exposition. In that same month Picasso wrote a poem as brightly coloured in its cruelty as many of his paintings. Violence runs rampant outside and in, with all vision bloodied just from seeing the daily news reports. Time is now kept by 'hourglasses filled with eyes seen through the keyhole of the printer's letters.' There is no avoiding the sight or stench:

> inside the heart they are paving the village streets and the sand that runs out of the hourglasses wounded in the forehead, dropping from the windows well-suited to drying the blood spurting forth from the astonished eyes peering through the keyholes...

> an interior brilliantly lit freshly paved streaming with blood...

> the light paving with its blood the hourglasses of its eye keyholes wipes out with its feathers the smell of the bread soaking in urine...

That August, Paul Eluard wrote '*La Victoire de Guernica*', one of the strongest statements ever made against war and its terrors. He often said that it was worth living in the twentieth century just to have met Picasso.[19] He wrote in response not just to the Spanish tragedy but also to Picasso's painting, as Picasso had responded to Goya's *Tres de Mayo* about the horrors of war. These two productions, together with Dora Maar's dramatic photographs, form a monumental triptych of outcry against the unconscionable crime.

Picasso introduced Dora Maar's features into *Guernica* in the woman holding up a lamp, but also the memory of the woman with the lantern in his Minotaur series, based on Marie-Thérèse Walter.[20] It is ironic but fitting that Marie-Thérèse and Dora came into confrontation during the work's creation. Marie-Thérèse entered the studio one day, and began to insist that Dora leave. Françoise Gilot recorded the story, as recounted by Picasso:

> 'I have a child by this man. It's my place to be here with him,' said Marie-Thérèse. 'You can leave right now.' Dora said, 'I have as much reason as you have to be here. I haven't borne him a child but I don't see what difference that makes.'

Picasso kept on painting, he told Françoise, while they kept on arguing.

> Finally, Marie-Thérèse turned to me and said, 'Make up your mind. Which one of us goes?' It was a hard decision to make. I liked them both, for different reasons: Marie-Thérèse because she was sweet and gentle and did whatever I wanted her to, and Dora because she was intelligent.... I told them they'd have to fight it out themselves. So they began to wrestle.[21]

Picasso remained tranquil in his art and enjoyed the squabble over him. Why not? The value of the object they fought over was incontestable. Like Dora's blood sport in the café, this woman-to-woman struggle had something of the Spanish bullfight about it. Picasso summed up the incident as 'one of my choicest memories', as if genius automatically pardoned cruelty.

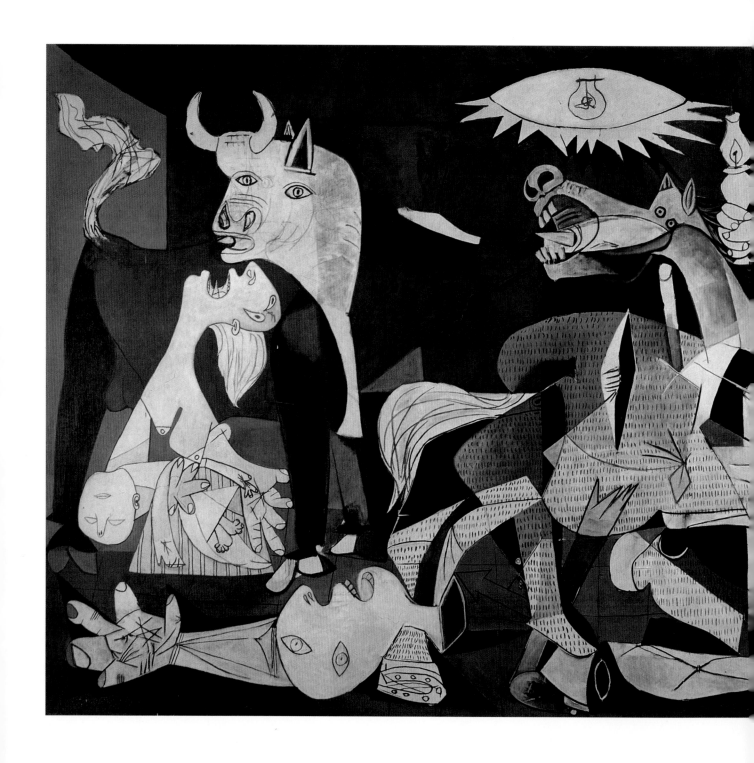

Pablo Picasso, *Guernica*, May–June 1937

Picasso pursued a number of experiments with photographic processes and materials at this time, some of them in collaboration with Dora Maar, whose skill in the darkroom was invaluable to him. Below: Picasso in collaboration with Dora Maar, *Young Girl in Front of a Beach Hut (The Bather at Dinard)*, 1936–37. On the left is the image that Picasso painted in oil on a glass plate; on the right is a print made from this on photographic paper. Opposite: Pablo Picasso, *Profile of a Woman (Weeping Woman)*, 16 July 1937. This is a cliché-film, an image etched onto exposed film with a drypoint.

Despite such tensions, Picasso and Dora were now immersed in an extraordinarily close collaboration as painter/photographer/lovers. Between 1936 and 1937, they created together a collection of photograms and prints using the cliché-verre technique, the transfer of a drawing onto light-sensitive paper. These drew on their combined talents: Picasso's artistry and Dora Maar's expertise in the darkroom. Picasso also returned to the 'photo-etchings' or cliché-films, engravings on photographic plates, that he had made five years earlier.[22] And it was in this studio, found for him by Dora, that Picasso painted so many portraits of her. Many of these paintings convey violence, even as she is seated, and are full of what Pierre Daix calls 'howling striations' that seem to explode into the larger canvas.[23] The angular chair on which his *Portrait of Dora in the Garden* is seated holds her as if in a trap (p. 125). Its knotted forms remained clear in Picasso's mind for years: in 1952 he came across someone who made equally uncomfortable chairs out of rope and string and purchased one enthusiastically in its memory. According to Françoise Gilot, Picasso explained his tortured rendering of Dora as an inevitability. Even though he claimed to have laughed with her more than with anyone else, 'I just couldn't get a portrait of her while she was laughing…. For years I painted her with tortured shapes. This was not because of sadism, but not because of any particular pleasure either. I was simply obeying a profound vision that had imposed itself on me. A profound reality.'[24]

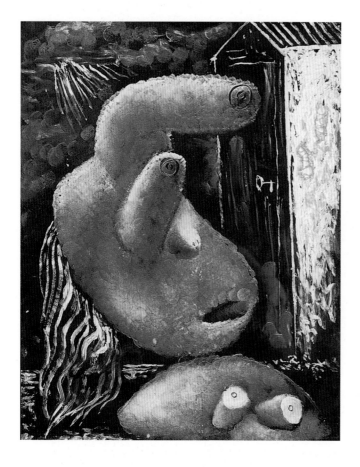 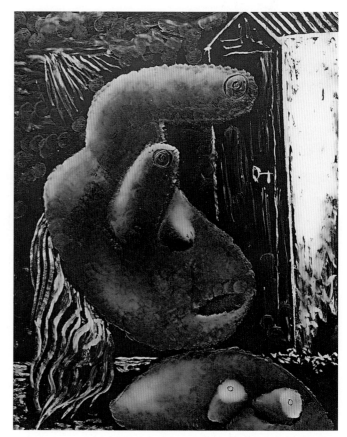

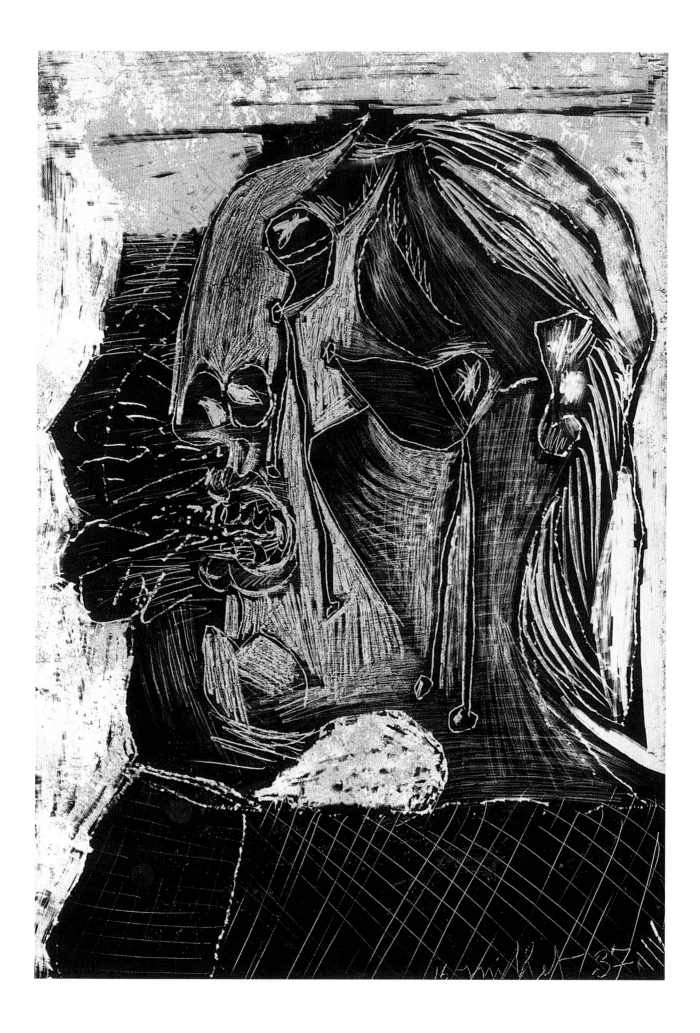

After photographing *Guernica*, Dora Maar
soon resumed painting herself. Picasso
believed that in every photographer there was
a painter, a true artist, awaiting expression,
and she may have heeded his encouragement.
The wide nostrils and all-seeing dark eyes of
these portraits of 1936 and 1937 are clearly
those of her lover. She was at this time as
absorbed by his image as he was by hers.

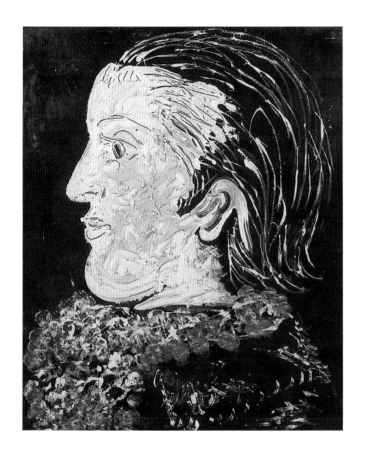

Another collaboration by Picasso and Dora
Maar in 1936–37. On the left is Picasso's
Profile of a Woman (Dora) painted in oil on
a glass plate; the fine lines were drawn into
the wet paint with a knife blade. Above is one
of a series of cliché-verre prints, *Woman in a
Mantilla*, whose effect was created by laying a
fragment of lace over the photographic paper.

Two pendants and a ring (centre) mounted with Picasso's tiny pencil drawings of Dora Maar. Opposite: Picasso's *Dora Maar Seated* of 1937. This poised and riotously colourful portrait strikes a very different note from Picasso's many anguished images of Dora from this period. Her ability to assume so many guises was an element of his fascination with Dora Maar.

Much about Dora Maar is troubling. For Picasso she had the '*mirada fuerte*' – that strong look, that brazen stare, which provokes unease. She elicited powerful, even exaggerated reactions. Bernard Minoret knew her well and respected her greatly. 'She took things and life seriously,' he said. 'Her great dignity and reserve meant that you were eager to join her on her own territory rather than seducing her onto yours … she would have been someone, a very strong personality, even if Picasso had never existed.'[25] Paul Eluard's poem '*Identités*', dedicated to her and illustrated with two of her still-life paintings, is about her contradictions. She is 'glory in full disdain', a 'body blooming' and a 'volcano of health' directly menaced by 'the axe beside the wound'. This ambivalent vision is typical of Surrealism and all too fitting for Dora. 'I see mortal … I see desolate': the poem seems almost to predict her future reclusion, with only her books open behind closed shutters both in Paris and in Provence:

> 'Identities'
> I see the fields the sea wrapped in an equal light
> There is no difference
> Between the sleeping sand
> The axe beside the wound
> The body blooming in a sheaf
> And the volcano of health
> …
> I see I read I forget
> The open book of my closed blinds.

The intensity of feeling vented by Dora Maar's hot-tempered personality leaps out at the viewer from the anguished features of her portraits of these years. Picasso portrayed her again and again as the *Weeping Woman* in 1937, or entrapped her insect-like image in dense networks of lines. He later told Françoise Gilot that he considered Dora 'a Kafkaesque personality'. Yet the portraits of this period are not all anguished. Roland Penrose picks up the brilliant colours in *Dora Maar Seated* of 1937: 'the painted fingernails prod gently into the flesh and hold back her hair, the blackness of which glistens with blues and greens … the two eyes, one of which is red and the other blue, are painted back on the same side of the face which is drawn in profile. They swim together in reds, pinks, greens, yellows and mauves, colours that are far too brilliant to be thought of usually as flesh tones, but which joyously convey the radiance of her youth.'[26] It is unfortunate, if inevitable, that the subsequent storms in their relationship and her life have so often been read back into the tormented portraits of these years. For besides turning her powerful features into an equally powerful lament against the cruelty of war, Picasso expressed in them optimism, energy and tenderness.

Another reason for refusing the reduction of Dora Maar's memory to 'the Weeping Woman' is the crucial fact that she drew upon her lover's imagery in her own representations of his work. This says a great deal about her strength. Her recovery of her image, the agency of her own art, have not been taken as seriously as they deserve. She was not simply 'imitating' Picasso, as has been said; she was too intelligent for that. Nor is she 'imitating' his portraits of her. She is collaborating in their representation of this tragedy, as she did in photographing his work.

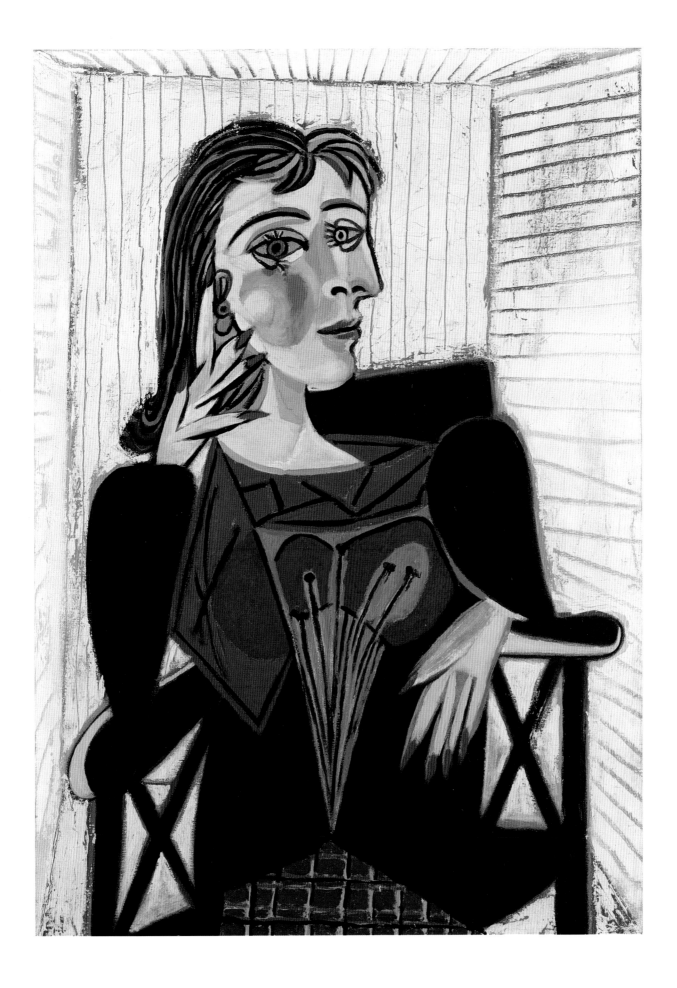

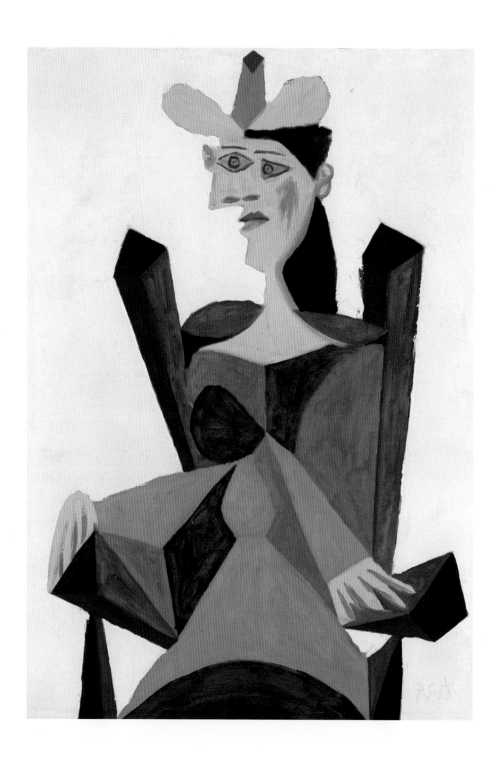

Above: Pablo Picasso, *Woman Seated on a Chair*,
7 May 1938. Opposite: Brassaï, *Picasso
Stacking up Portraits of Dora Maar*, 1939.
This photograph vividly conveys the almost
obsessive hold Dora's image had over him.

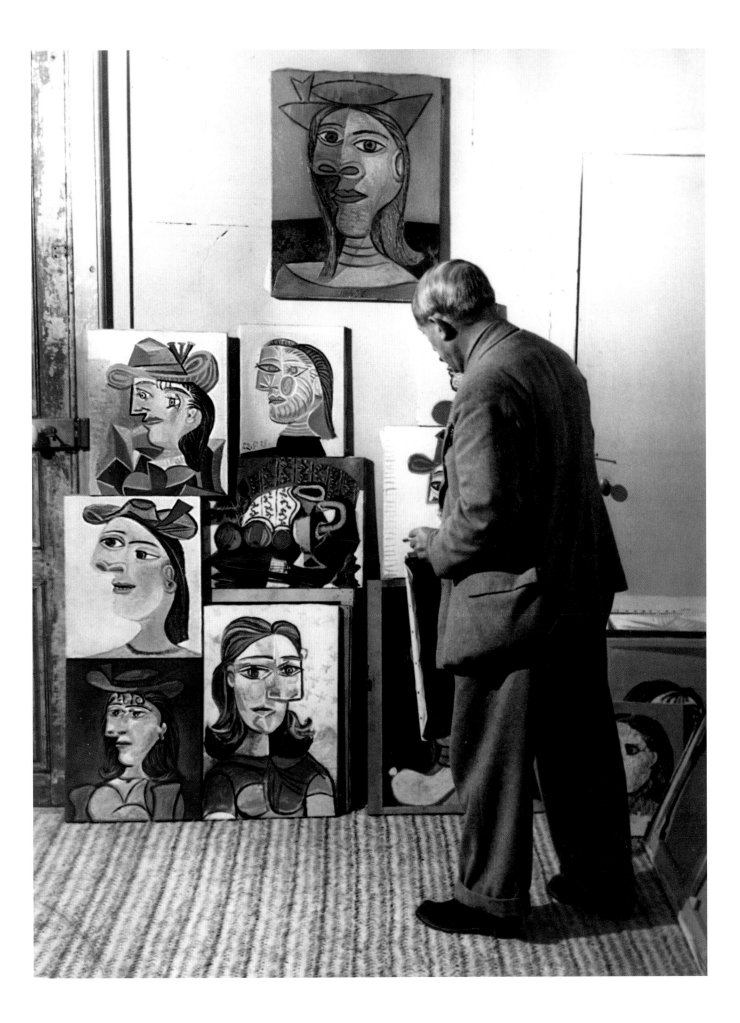

Above: Dora Maar preserved scores of
these tiny doodles that Picasso made
ceaselessly on matchboxes and cigarette
packets. Opposite: Pablo Picasso, *Portrait
of Dora in a Garden*, 10 December 1938.
Trapped by zig-zagging branches and the
angular forms of a wicker chair, the figure
of Dora Maar remains composed, beautiful
and identifiable. Picasso was so enchanted
by his imaginary torturing chair that when
he came across its like, fifteen years later,
he purchased it with delight.

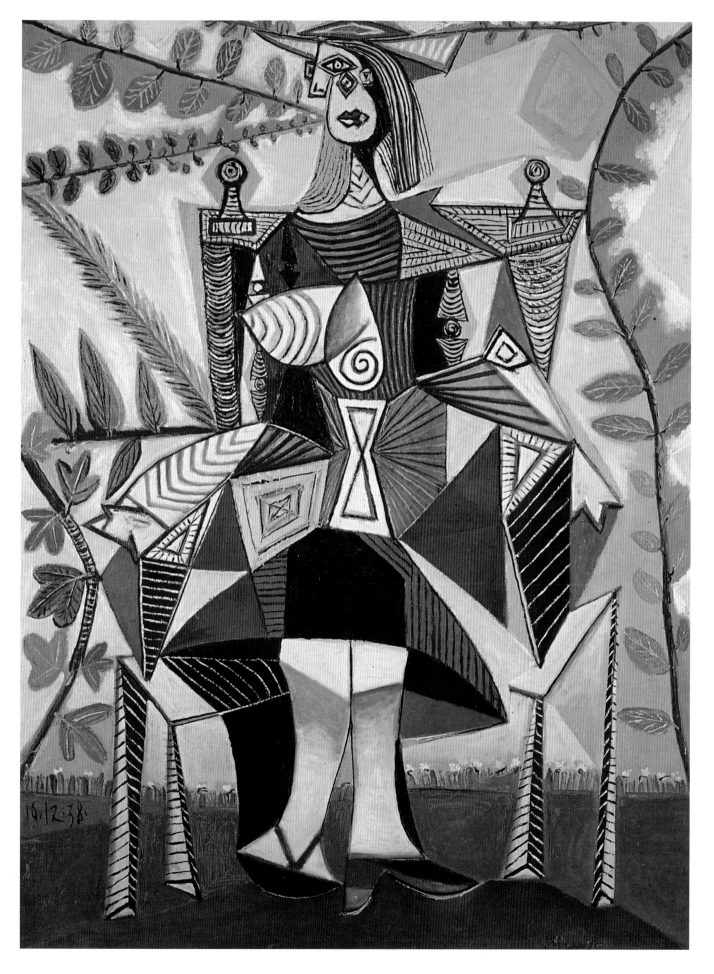

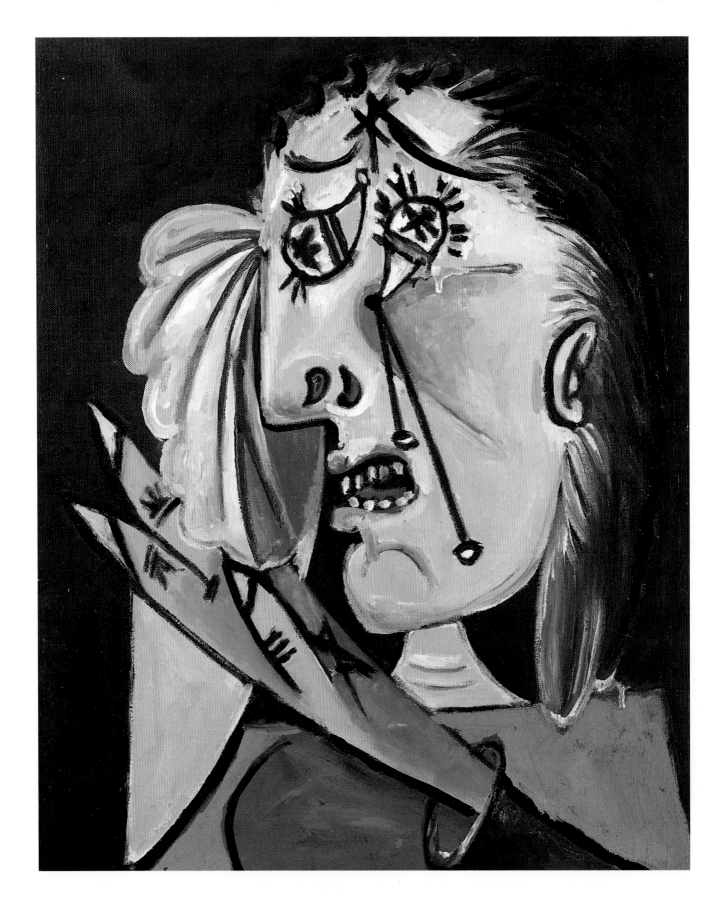

Pablo Picasso, *Weeping Woman*
(Study for Guernica), 22 June 1937

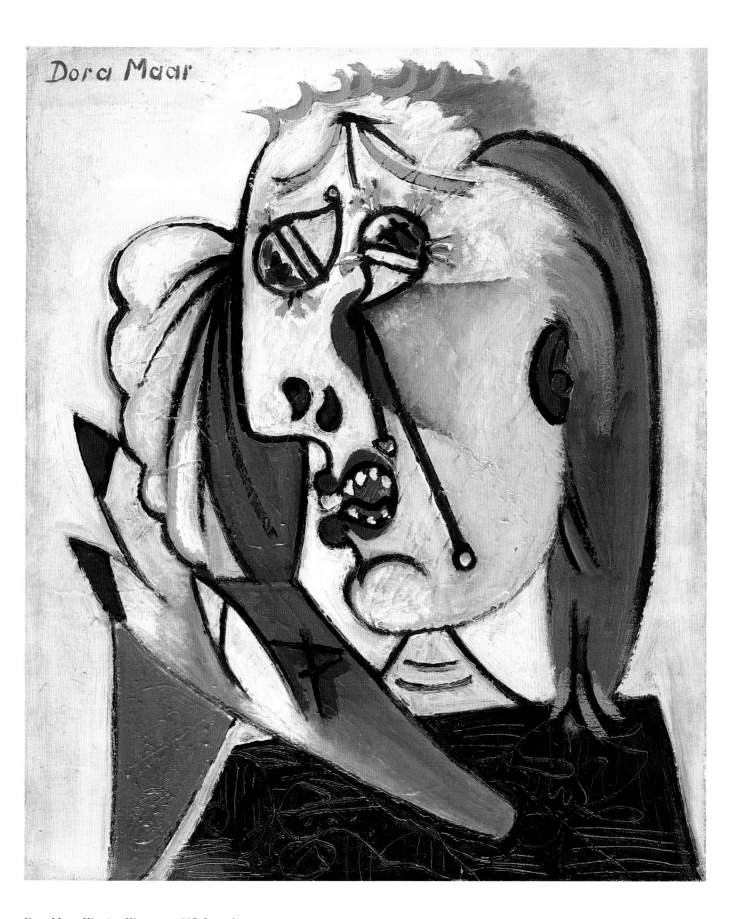

Dora Maar

Dora Maar, *Weeping Woman*, c. 1937. In each
case that Dora Maar reappropriated her
image, she made it doubly her own. 'I don't
give, I take,' Picasso would say to Françoise
Gilot. But Dora knew, here, how to take back.

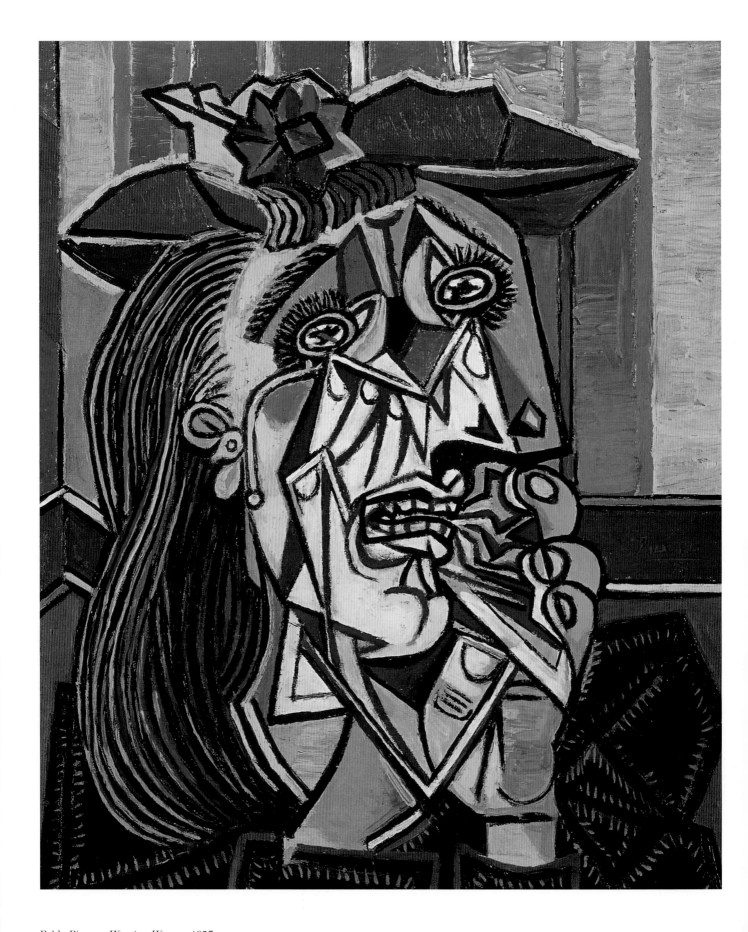

Pablo Picasso, *Weeping Woman*, 1937

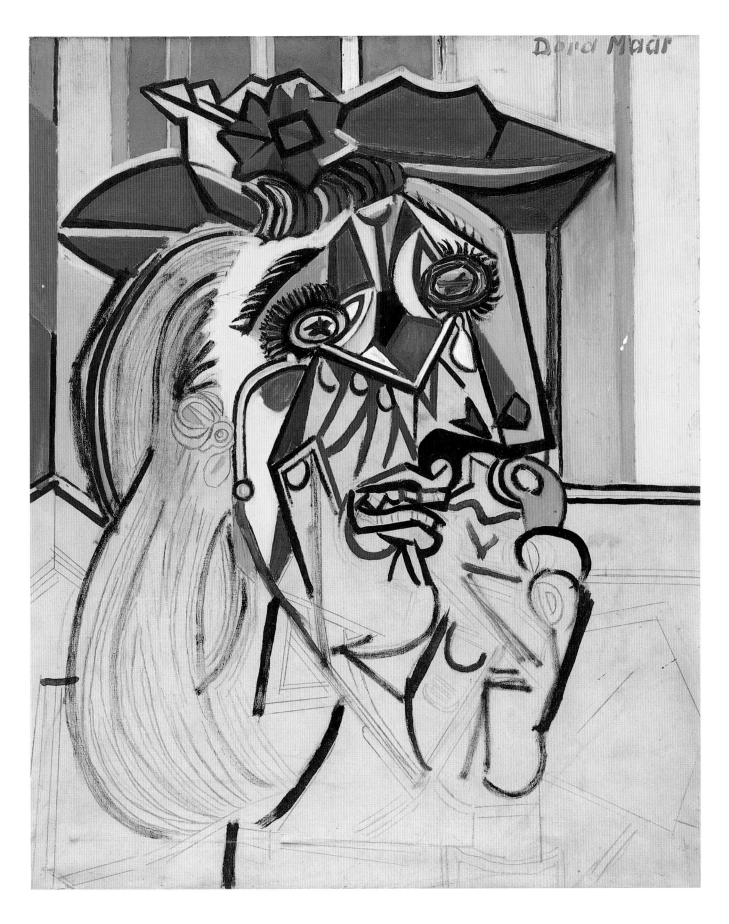

Dora Maar, *Weeping Woman in a Red Hat*,
c. 1937

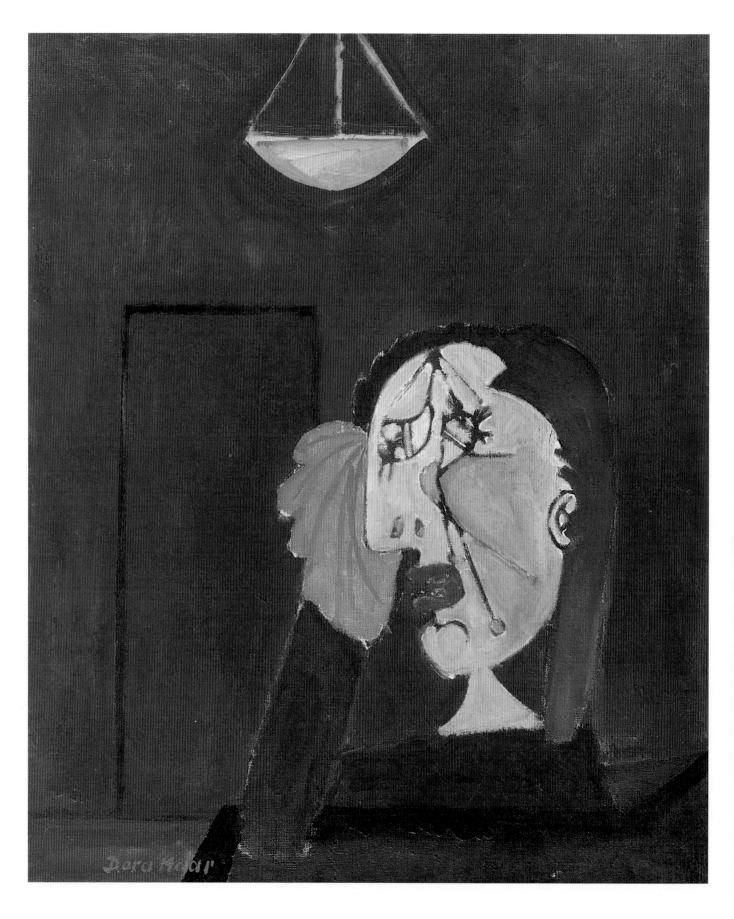

Dora Maar, *Weeping Woman on a Red Background*, c. 1937

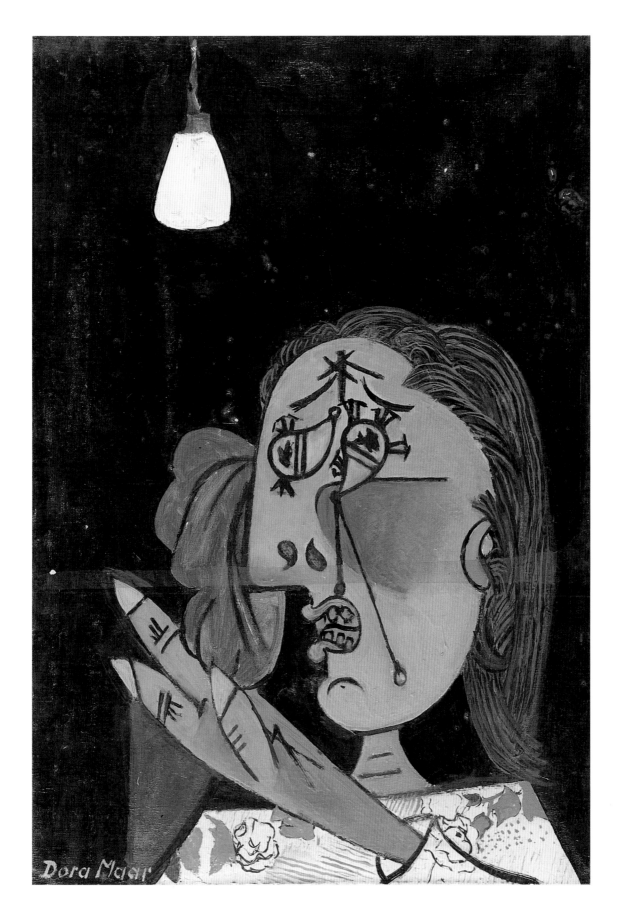

Dora Maar, *Weeping Woman Under
a Lamp*, c. 1937

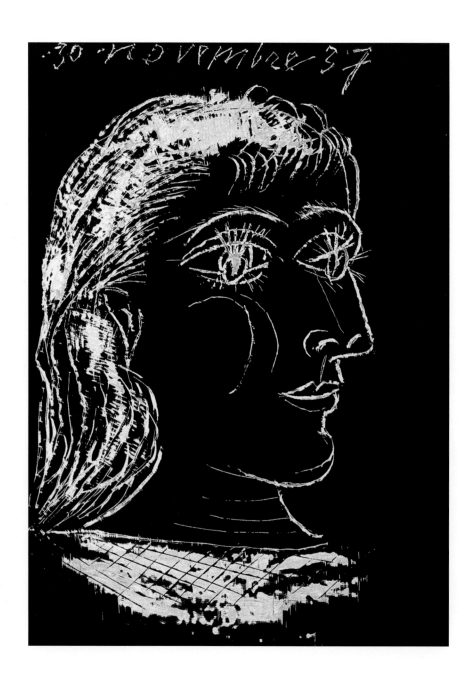

...memories already classified their certain identity pressed on all sides in a bonfire the play of the pendulum of light sustains all the weight of the scaffolding of the sphere of colours ground up roughly on the transparent curtain of the sensations originally unperceived...

PABLO PICASSO, 7 JANUARY 1940

Opposite: Pablo Picasso, *Profile of a Woman (Dora Maar)*, 30 November 1937. Like the work on p. 117, this was etched on exposed acetate film with a drypoint. Above: *Portrait of Dora Maar* by Lee Miller, who in the summer of 1937 accompanied Roland Penrose to join Picasso and his band in Mougins. Penrose photographed the sunny picnic overleaf, which features (clockwise from the centre) Nusch and Paul Eluard, Lee Miller, and Man Ray and his girlfriend Ady, a young dancer from Martinique.

After *Guernica*, Dora Maar returned in September 1937 with Picasso to Mougins, with the Eluards and for once without Picasso's secretary and confidant Jaime Sabartès, who had resented Dora Maar's appearance in Picasso's life alongside Marie-Thérèse, and let her know it. They stayed again at the Hôtel Vaste Horizon. Photographs of the time convey the radiant light of the south. As well as Paul and Nusch Eluard, they were joined by Jacqueline Lamba and André Breton, Roland Penrose and Lee Miller, Eileen Agar and her lover Joseph Bard, Man Ray and his mistress Ady, and Christian and Yvonne Zervos: the company was as warm as the Provençal sun.

In her witty recollections of that period, the Surrealist artist Eileen Agar recounts their practice of exchanging bedmates: 'It was Picasso who first came up with the idea of name-swapping. Eileen Agar became Dora Agar, Pablo Picasso became Don José Picasso,[1] Joseph Bard became Pablo Bard, Man Ray became Roland Ray. If you forgot what your name was for that day, you were fined one or two francs.' Paul Eluard enjoyed offering the beautiful Nusch to others, especially Picasso, who gladly accepted; her point of view has not come down to us.

Picasso, according to Marie-Thérèse Walter, enjoyed experimenting in all things sexual, including the coprophagous, and always wanted to learn something he hadn't yet tried.[2] Even so, he never ceased to put work above everything else. He differed from the others above all in his passion for his art in all its forms. After lunch, said Agar, when some of the Surrealists would say 'to bed, to bed', eyeing new partners, Picasso would say *'au travail, au travail'* — 'to work, to work', his constant idea.[3] Penrose recalled that he would appear each day at midday, announcing that he had painted another portrait. Most of these were of Dora, though he also painted Nusch, Lee Miller and Paul Eluard that summer.

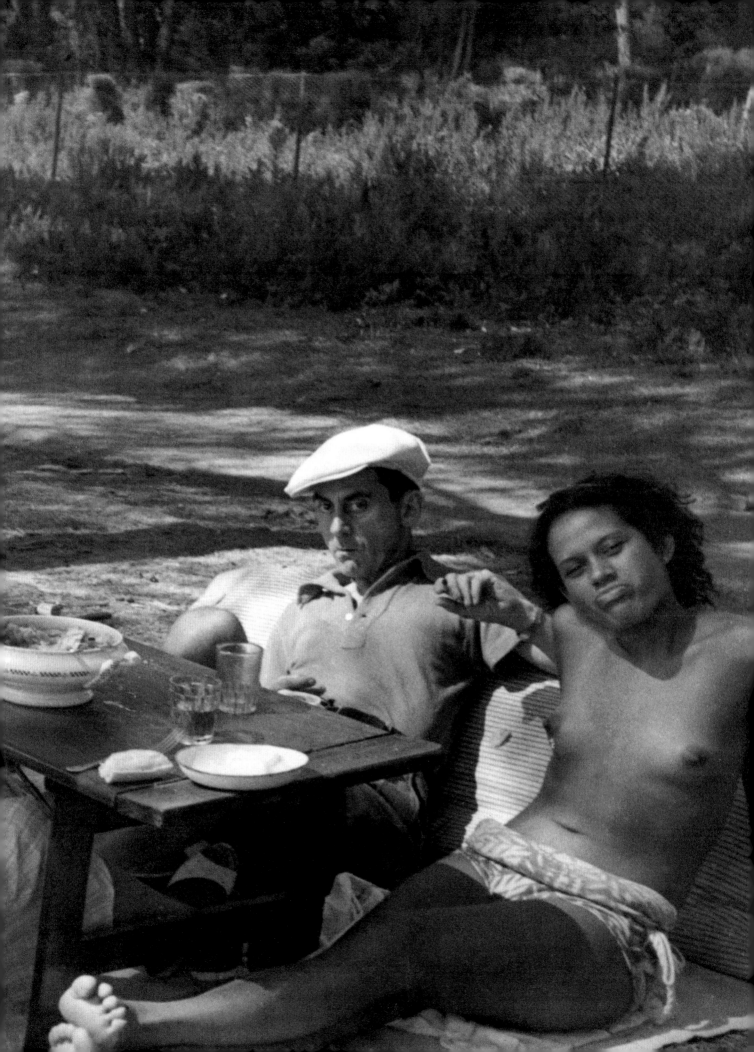

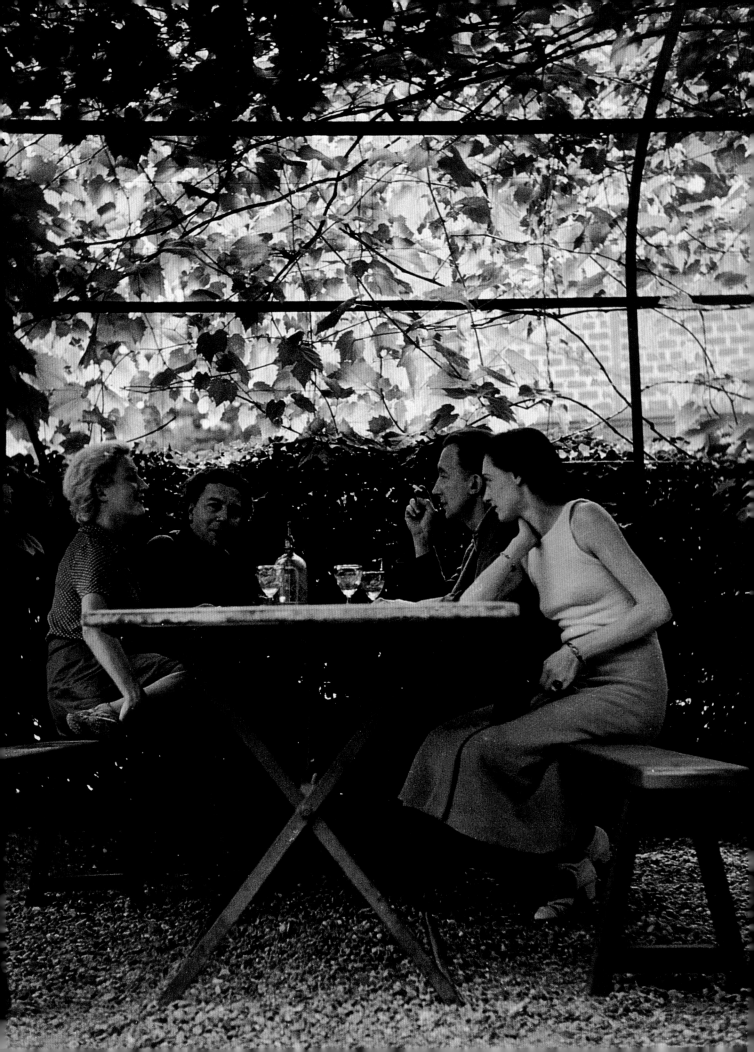

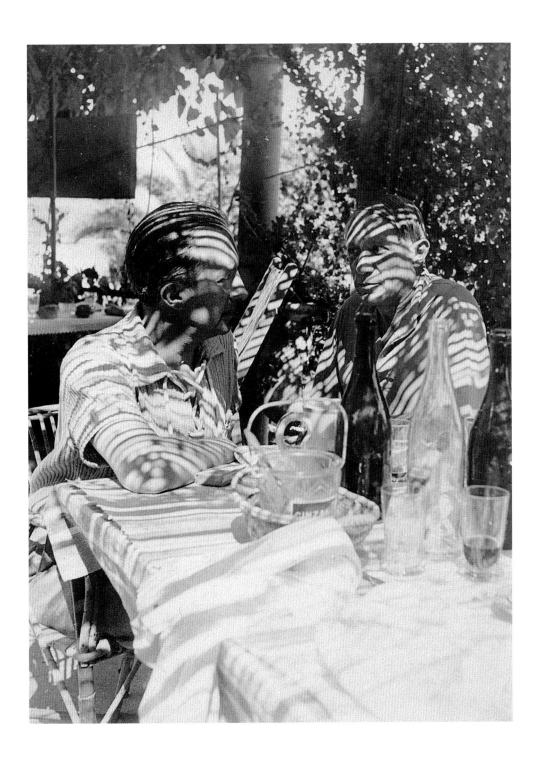

Opposite: Jacqueline Lamba, André Breton, and Paul
and Nusch Eluard, photographed by Dora Maar as they
shared an aperitif in the garden of the Hôtel Vaste
Horizon in Mougins. Above: Picasso and Eluard deep in
conversation at lunch under the striped shade of the
bamboo awning, photographed by Dora Maar. Roland
Penrose recalled that 'the presence of Picasso and Eluard
created a continuous play of wit, oscillating from bawdy
jokes to tragic or comic references to the precarious state
of our so-called democracy.'

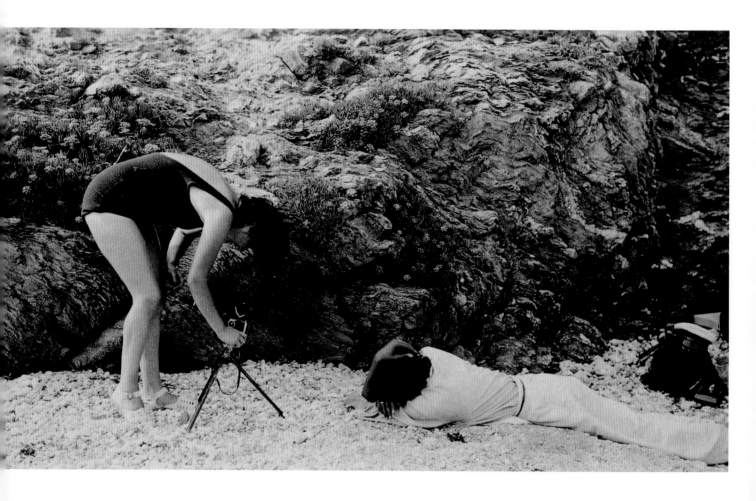

Dora Maar and Nusch Eluard in a photo-
session on the beach at Mougins in 1937.
The German-born Nusch (opposite, by Dora
Maar, and lying down in the anonymous
photograph above) was a lively spirit and
a fragile beauty whose acquaintances recalled
that she was always laughing. Dora had been
close friends with the couple since the mid-
1930s, before she became part of Picasso's life.

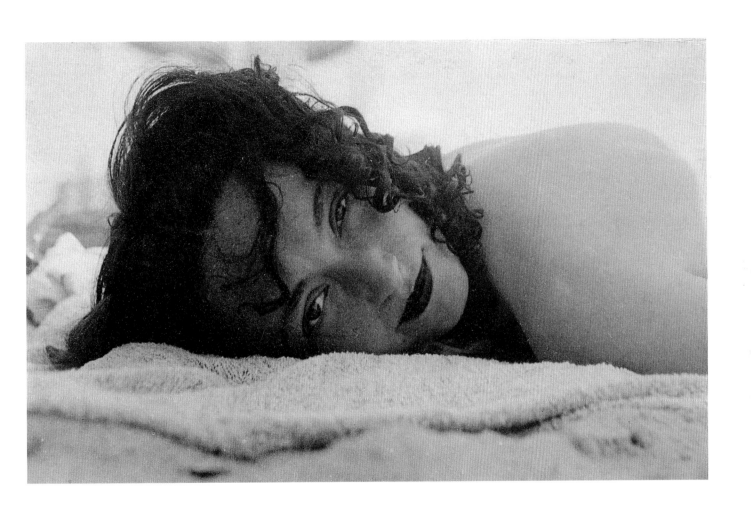

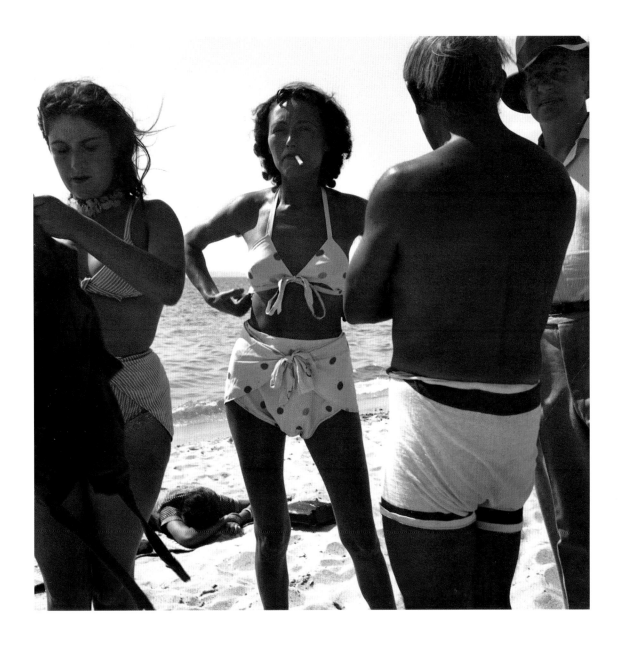

Picasso made many portraits of Nusch in
1936–37, including the delicate pencil sketch
opposite. He too was extremely fond of
Nusch, and most probably had an affair with
her at this time; he would not, he once said,
have wanted to insult his good friend Paul by
suggesting that his wife was undesirable.
Above: Dora, Nusch, Picasso and Paul Eluard
photographed by the British Surrealist artist
Eileen Agar, another member of the holiday
party who also documented the gaiety of
these times in her memoirs.

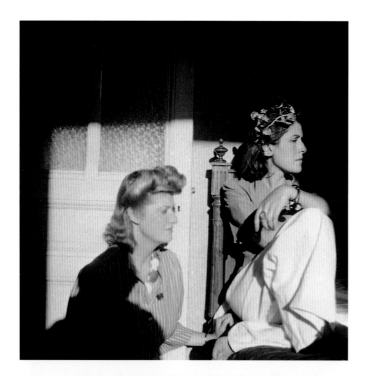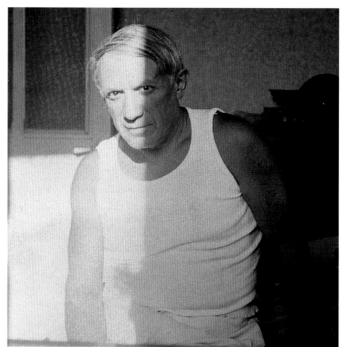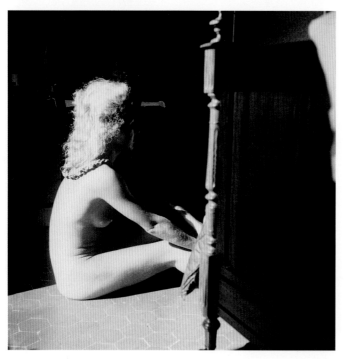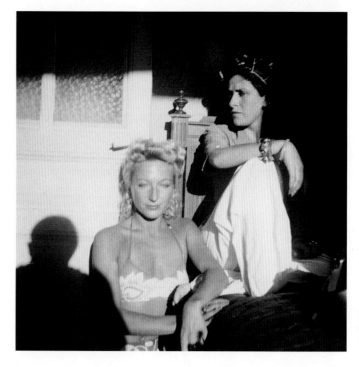

The play of light and shade intensifies
the intimacy of these bedroom scenes
photographed by Dora Maar and Picasso.
The photographer at top left and bottom right
is identified by his shadow; which of them
photographed Jacqueline Lamba, seated
naked on the floor, we can only guess. Dora's
crown of flowers also appeared in Picasso's
drawing of early 1937 (opposite).

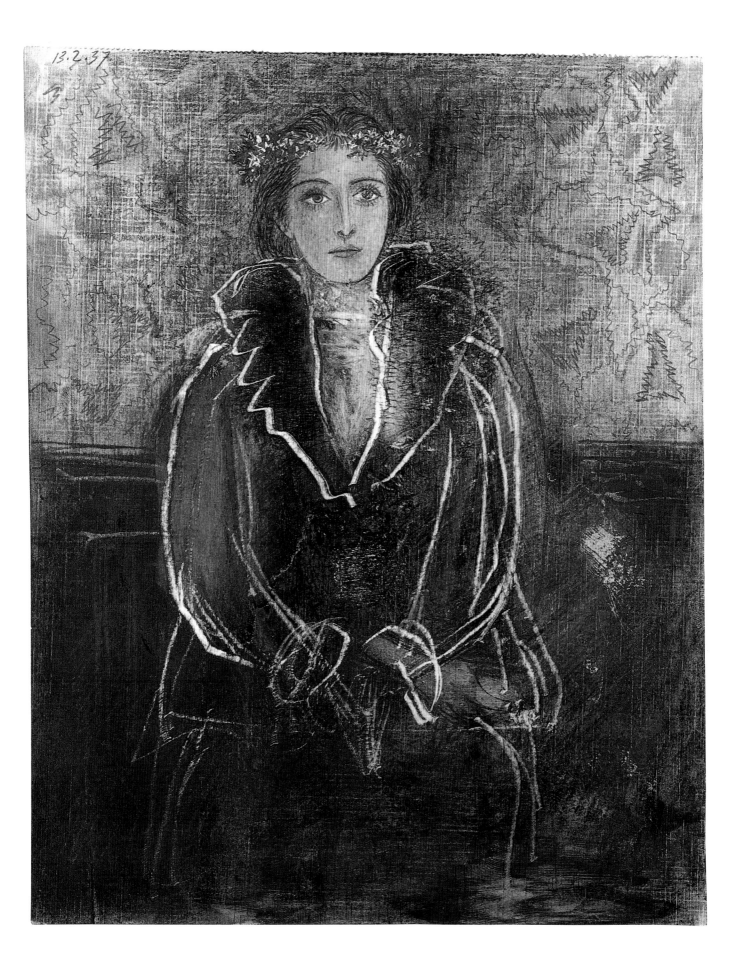

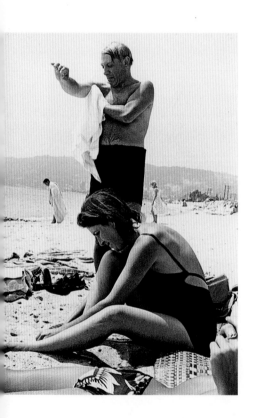

Below: Basking and bathing in the heat of the Midi, in an anonymous photograph from 1936 or 1937. Opposite: Picasso's identification with the minotaur – half man, half beast, all conquering – was not new, but in Dora Maar he found not just a conquest but an accomplice, as her photograph confirms. Overleaf: An afternoon in Antibes in 1937 at the home of Marie Cuttoli and her husband, who sit on the steps between Ady to the left and Picasso and Dora. Man Ray, who took the photograph, is seated in front. Cuttoli was a tapestry artist whose work was greatly admired by Picasso.

The poems Picasso wrote in Mougins in the autumn of that year are spontaneous and joyous records of the times he and Dora spent in harmony. 'You see,' he said to her, 'I am not always preoccupied with gloom.'[4]

> the walk at the end of the jetty
> behind the casino the gentleman
> so properly dressed so gentlemanly
> untrousered eating his
> french fries of turds
> graciously spits
> the pits of his
> olives in the gullet
> of the sea

A poem that Dora Maar composed on the same hotel stationery is heavily worked over, unlike Picasso's rapid scrawl. A phrase about dawn 'snatched from the fissures of death' hovers over her densely written lines, watered by 'tears of salt and birds'. Her sheet is a tumult of inspired madness:

> The little girl, her hands clasped around a stolen crust, dreams of the fissures of the night tears of salt and bird droppings. When a bed of roses stains the torn drapes, dragging of feet beating of wings mingling the furtive and awkward sighs with the learned cries of mutes the swindler will return to execute the farce his daily doings

Photographs of Picasso and Eluard in conversation at lunch under the bamboo at the Hôtel Vaste Horizon in 1937 (p. 137) convey a powerful feeling of intimacy in the summer light. You can almost smell the aromatic scents of Provence. Here the 'bande à Picasso' feels just right. The only element excluded from it was a monkey, which, as Dora recounts the story, they had acquired in Mougins earlier that year. It accompanied them everywhere – in the hotel, on the beach, at meals. But Kazbek was one thing, the monkey another, such a distraction that Dora became jealous and insisted they get rid of it.

She often won out. Marcel Duhamel says in his memoirs how 'cabocharde' – stubborn – she was. Georges Bataille also said she was 'inclined to storms – with thunder and lightning', the exact opposite of the tranquil Marie-Thérèse.[5] In Man Ray's group photograph seated on the steps with the Cuttolis at their villa in the Cap d'Antibes (overleaf) Dora Maar looks preoccupied, staring ahead, not really part of the group. There is no monkey in sight.

On their return to Paris in the autumn of 1937, Dora accompanied Picasso to the annual gathering of artists and writers held in Père-Lachaise Cemetery to commemorate the death of Guillaume Apollinaire. With Max Jacob and Pierre Reverdy, Apollinaire had been part of the avant-garde group of Cubists in the Bateau Lavoir, rue Ravignan, in the early 1900s. This annual memorial was to continue even through the years of war and occupation, but already in 1937 it was touched by the emerging international conflict: Picasso refused to shake the hand of Filippo Tomaso Marinetti, the Italian founder of Futurism, because of Fascist Italy's role in the increasingly grim atmosphere of prewar Europe.

POETRY IN PROVENCE

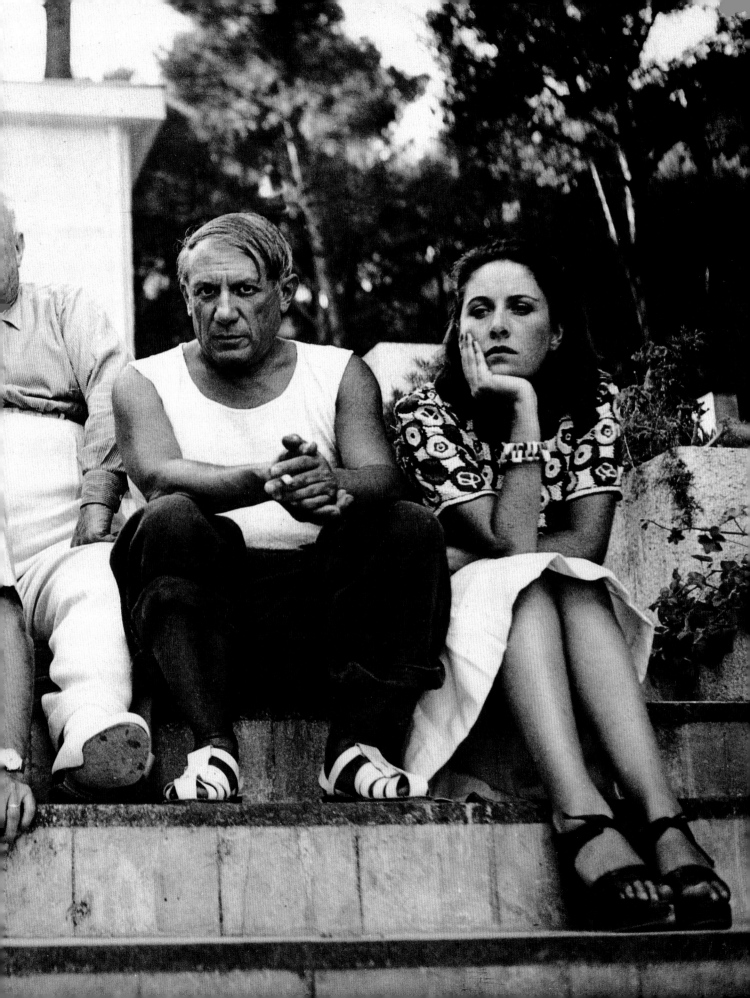

In July 1938, Picasso and Dora moved to the Côte d'Azur for the summer, taking the Train Bleu down south. Marie-Thérèse and Maya were established in the villa Gerbier de Joncs in Royan, a small fishing village far away on the Atlantic coast. Picasso and Dora rented a studio in Antibes that Man Ray had once used, high up on the third floor overlooking the sea. Their holiday was very soon interrupted by the news that the dealer Ambrose Vollard had been killed in his car when a piece of Aristide Maillol's sculpture fell onto him from the back seat. Picasso rushed to Paris for the funeral, and returned with Sabartès.

The Munich Agreement of September 1938 permitted German expansion to continue into Czechoslovakia. In November 1938, the month of the Kristallnacht pogrom in Germany, Picasso donated 100,000 francs to the Republican Spanish Aid Committee to buy milk for Spanish children: 'all Spaniards are Jews', he said. Britain, France and the United States officially recognized the government of Franco; the Spanish Civil War was over and the Republic was lost. In March 1939, Hitler's forces entered Prague. In September, Germany invaded Poland, and Britain and France finally declared war.

Dora was painting a great deal now, particularly experimental and stylized portraits of her lover and friends. Picasso had urged her to return to painting, announcing, perhaps believing, that in every photographer – including Man Ray himself – there was always a painter eager to be released. In his work, the darkening fate of Europe was increasingly in evidence. By January 1939 he was painting ox skulls picked up on the beach and the lambs' heads he fed to his dog Kazbek in these times of shortage: reminiscences and forebodings of death were everywhere. Kazbek's emaciated appearance led to comments, though it had even in good times. Picasso liked to call him the most misunderstood dog in the world, everyone thinking him underfed.[6] On his walks on the beach at Antibes and at Royan, Picasso had always 'stuffed his pockets full of pebbles, of roots bleached by the salt water, of pieces of glass and pottery worn smooth by the sea. When his pockets had given way he had taken to going for walks with a shopping basket in his hand', for he would make his sculptures from discarded or 'found' objects.[7] But increasingly now he picked up skulls, redolent of the atmosphere all around.

In August 1939, Jacqueline Lamba came to visit her good friend Dora Maar in Antibes, bringing her and Breton's daughter Aube. One of Picasso's largest and most impressive paintings, *Night Fishing at Antibes*, completed that month, shows the two friends as observers at the ancient scene of fishermen in this anciently-settled site. Timothy Hilton describes it as part of Picasso's 'New Mediterraneanism', finding in *Night Fishing* 'a queer mixture' of joy and 'thematic dignity', of the ancient and the contemporary, represented by the traditional fishermen and the 'quirky poetry' of the holiday makers: Dora and Jacqueline's bright dresses, Dora with her bicycle and ice cream cone.[8] Tripartite like *Guernica* in its composition, the painting also catches the mood of looming war in its explosions of light in the night sky and the fishermen's spears raining terror from above.

Picasso, anxious to protect his paintings, was also increasingly concerned about his status as a foreigner, especially since Max Ernst, a German, had been interned. At the end of August 1939, with the French government announcing a general mobilization, he returned to Paris with Dora, where he managed to obtain a residence permit from the Sûreté (the Criminal Investigation Department).

POETRY IN PROVENCE

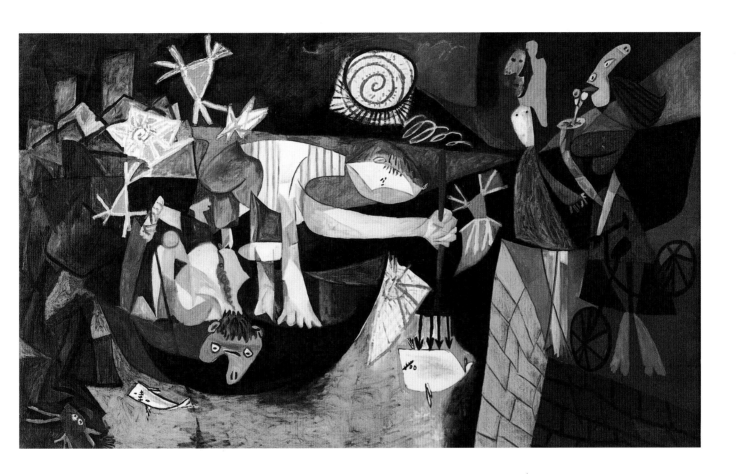

Opposite: Two pieces of bone and a
pebble, picked up on the beach by Picasso
and etched with a profile, the eye of an
eagle, and the impression of a fish. 'The
sea sculpts them so beautifully, gives
them such pure and full shapes, that only
a little effort is needed for us to make
them into works of art...' Picasso told
Penrose. Above: Pablo Picasso, *Night
Fishing at Antibes*, August 1939.
According to Penrose, there were troops
posted on the headlands of Antibes in the
summer of 1939; the war was now
imminent. Despite the apparently carefree
presence of Jacqueline Lamba and Dora,
Night Fishing is dominated by the savage,
violent figures of the fishermen hunting
down their prey.

Then he and Dora went to Royan, taking rooms at the Hôtel du Tigre, close to Marie-Thérèse and Maya. They were visited again by Jacqueline Lamba. After another trip to Paris, Picasso and Dora returned to the Hôtel du Tigre in September. In January 1940 Picasso took a studio by the sea in the villa Les Voiliers, rented from Mlle Andrée Rolland.

In December and early January 1939–40, with the shadow of war hanging over Europe, Picasso wrote a series of poems that have all the cruelty and sublime intensity of the many portraits of Dora Maar he did in this period. They refer to her presence in their multiple references to the apparatus of photography and painting: of line and drawing, angle and curve, canvas and camera, of projector and photographic plate, and, specifically, of the photograms he and Dora made together. The poems experiment with different rhythms of writing, subsumed under an 'overview of the canvas the direction wished for.' They feel not so much spontaneous as natural and personally directed. Mingling solitude with system, light with flame, colours with ashes, they have some of the great qualities of Surrealist writing and vision at their peak:

> 5 January 1940
> a pretty face even that of the beloved is only a flame of solitaire the symptom prefiguring the mass of tangled threads of a system to be built whatever the cost on the perspective levels of the so delicious perfume of the pile of shit that the colours of the projectors spread about in a sealed vessel at the temperature of roses that you have to draw with frozen ashes of its angles and its curves...

These are clearly the poems of someone concerned with the visual. The recurring 'symptom' is the equivalent of an image, caught up in the system of extreme rhythms and colours. These keep time to the alternating beat and direction, the alternation between pain and pleasure, in a deeply erotic framework of perception and expression:

> 6 January 1940
> a symptom ... so mingled with the net of coloured wires of a frequency more or less accelerated on the metronome of + or − sensational heat moving from well-being to pain force the forms of the floating crystals take in an overview of the canvas the direction wished for... the angle the curve essential to the game already won on the gambling table predicted by all the oracles already marked with red fire at the wished for place on the map...

These poems evoke all the dread and menace of the contemporary political atmosphere: 'sweats from the tambourine drop by drop the honey of the cheek afire of the house that sways above the black sheet unfolded by the eagle...'. They exude a terror but at the same time a coherence and harmony of elements that Françoise Gilot compared to a musical score. Dora Maar copied these poems in her own hand, often on hotel stationery. Like her friends Paul Eluard and André Breton, she found them extraordinary.[9]

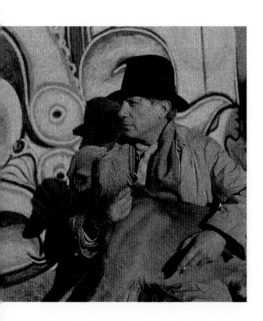

Above: Picasso photographed by Dora Maar in front of his painting *Reclining Nude, Marie-Thérèse*, the lover he continued to see throughout this period and the mother of his child Maya. Opposite: In this *Portrait of Pablo Picasso in a Black Hat*, 3 November 1939, Dora Maar borrowed his style to depict Picasso. By the onset of war, she was painting with energy and enthusiasm, no doubt, like Picasso, finding in her art solace and distraction from the frightening situation they found themselves in.

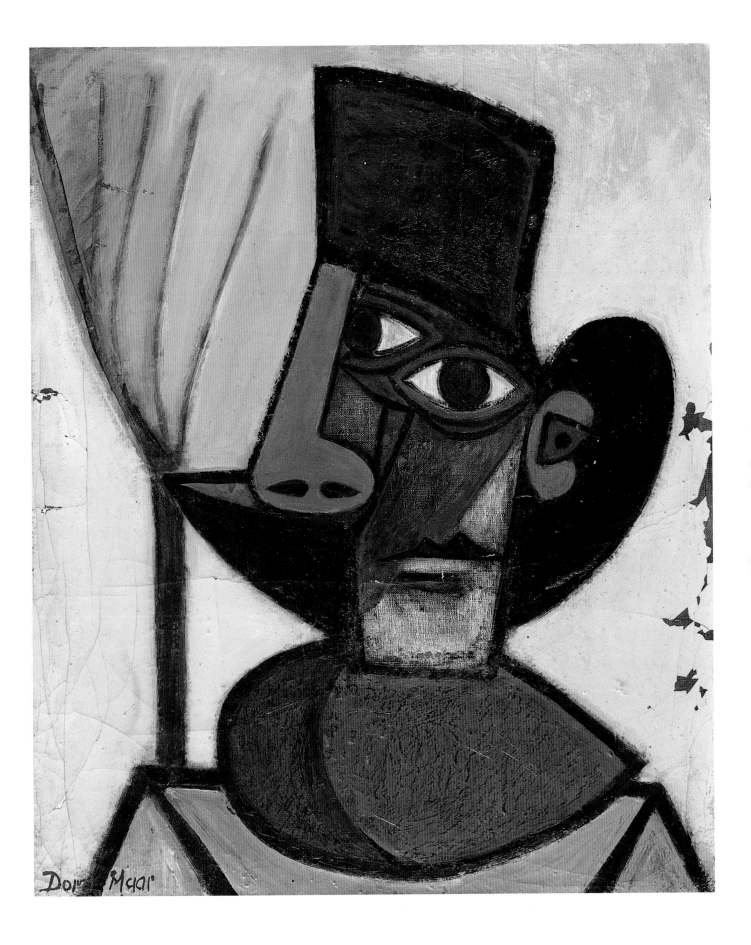

151

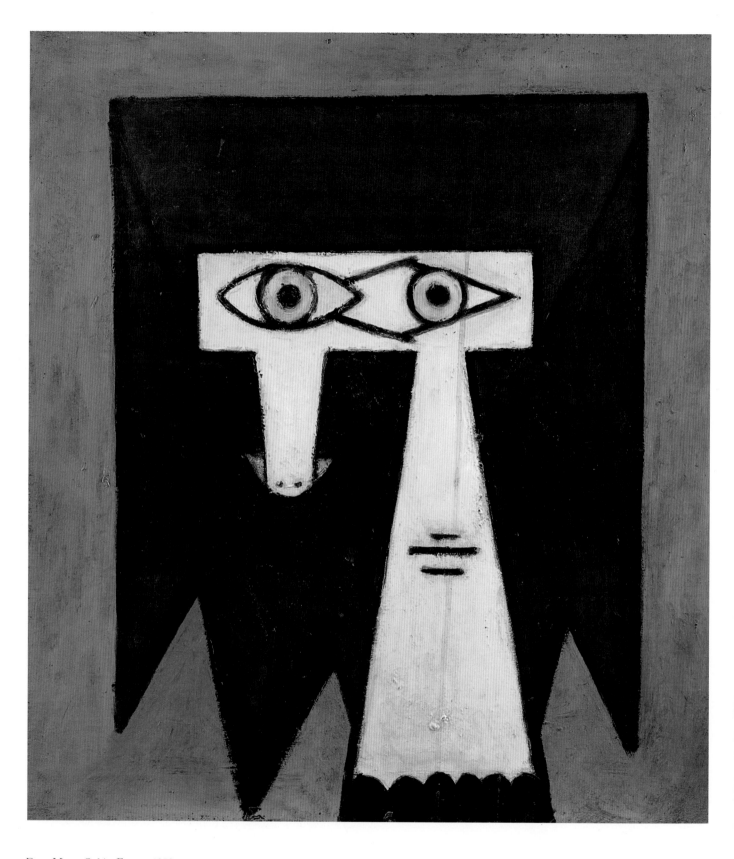

Dora Maar, *Cubist Face, c.* 1939

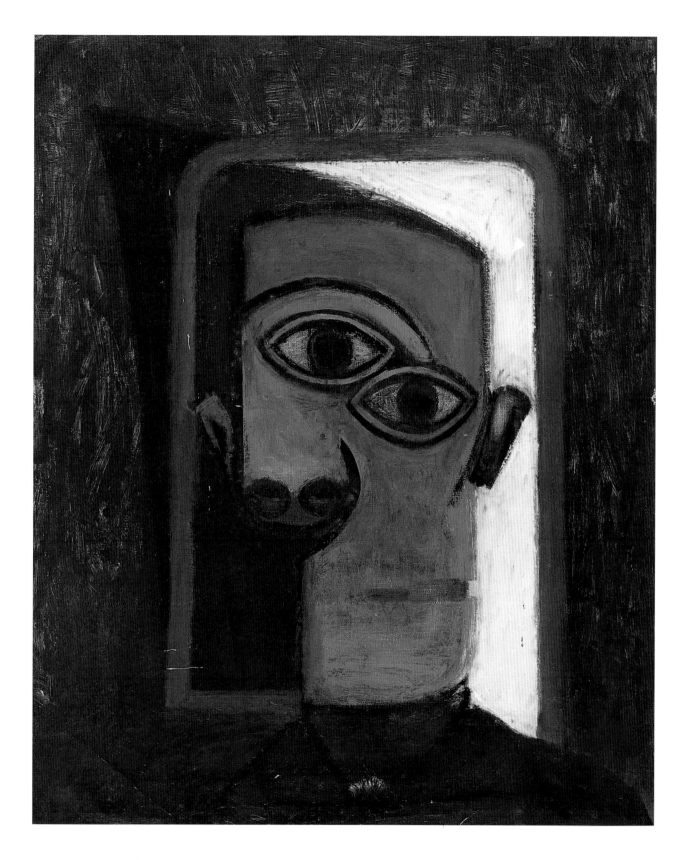

Dora Maar, *Portrait of Pablo Picasso in
a Mirror*, no date

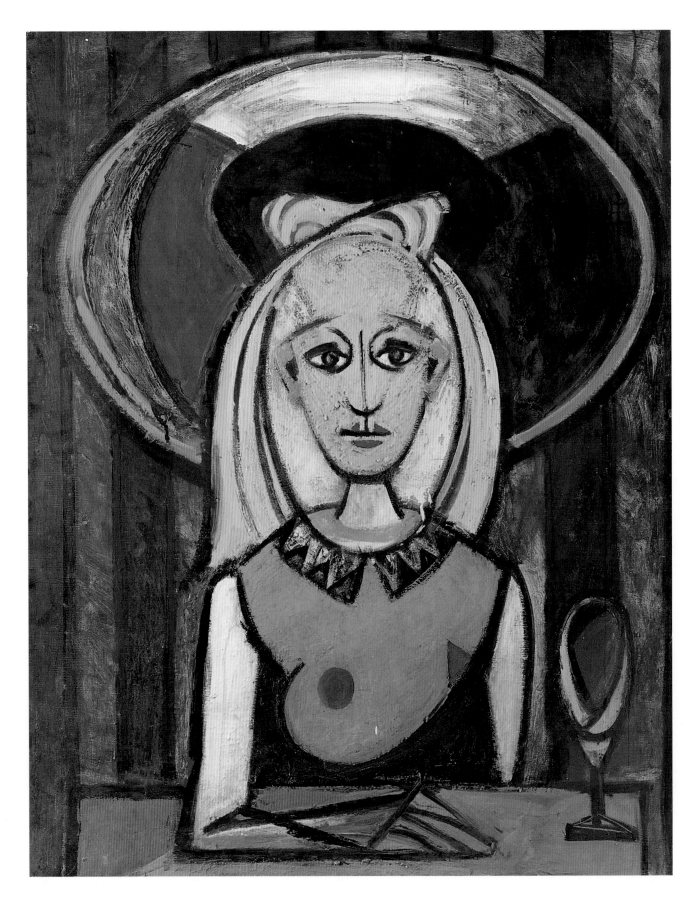

Dora Maar, *Portrait of Jacqueline Breton*,
no date

Dora Maar, *Man and Pink Tree*, January
1939

Occupation 1940–1944

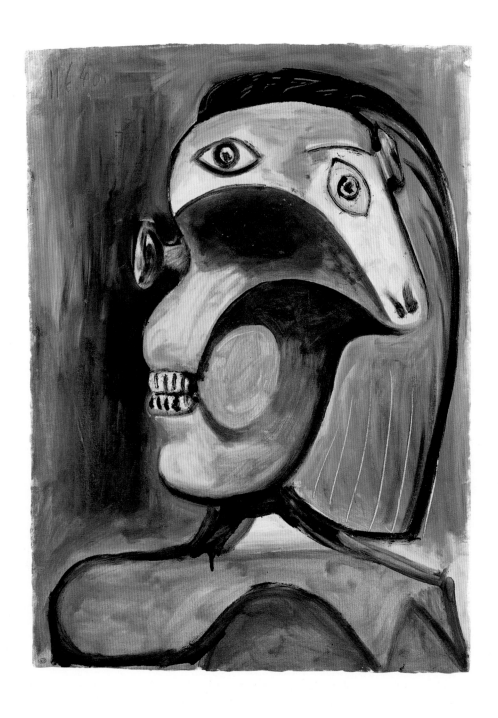

Chasuble of blood cast over the bare shoulders of the green wheat trembling between the dampened sheets symphony orchestra of strips of flesh hanging from the flowering trees of the ochre-painted wall flapping its great wings apple green and mauve white tearing its beak open against the windowpanes architectures of suet...

PABLO PICASSO, 13 MAY 1941

Opposite: Pablo Picasso, *Head of a Woman (Dora)*, 11 June 1940. This fleshless vision of death was painted in the dark days of France's defeat. Above: Dora Maar by Rogi André, 1941. Dora and Picasso lived in Paris throughout the Nazi occupation; it marked them both, but placed a greater strain on Dora's spirit.

On 3 June 1940, German planes bombed the airports of Paris. By 16 June France had been defeated. Nazi forces swiftly occupied three-fifths of France, leaving the remainder to be ruled by the collaborationist government of Marshal Philippe Pétain, based at Vichy. In October, the Vichy regime passed the Statut des Juifs, under which Jews lost civil rights and could be imprisoned arbitrarily. In this atmosphere, friendship and trust were more essential than ever. Picasso and Dora returned to Paris, in the occupied zone. Paul and Nusch Eluard were also there, and the friendship between the two couples remained strong. They celebrated the Eluards' new apartment in Paris at 35 rue de la Chapelle, and stayed up all night together on New Year's Eve of 1941.[1] *Guernica* had made Picasso an international symbol of resistance to Fascism, yet to the occupying Nazis his art was degenerate, and his opportunities to show it were severely limited, as were his materials.

André Breton and Jacqueline Lamba fled Paris, first staying with Pierre Mabille and his wife in Salon-de-Provence, then moving to Martigues, from where they wrote to their friend Dora Maar. This letter, dated 8 September 1940, demonstrates how close Jacqueline and Dora were. She writes of her sister Huguette, who would be left behind when she departed with André and Aube, hoping Dora can see to her safety and well-being. She has avoided telling Huguette that they are about to leave. The ever watchful police, stationed all about, are a dire presence. Jacqueline tells Dora to which bores *not* to give their address, and wonders if she and Picasso have seen their other Surrealist friends: Benjamin Péret and Remedios Varo. Jacqueline misses Dora's company, but must go with Breton to New York after taking the boat from Marseille. They are living in a tiny fisherman's shack 'of a great impoverished beauty' on the beach in Martigues, heated by open fires and lit by candles. The nearest shop is two kilometres away. Jacqueline is painting, as is Dora, and has just completed a watercolour; Breton has begun a magnificent long poem; their daughter Aube has done some drawings of Martigues. Jacqueline

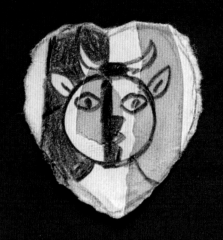
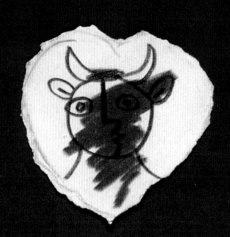
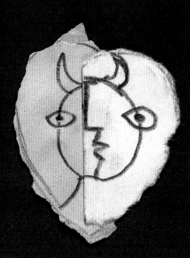
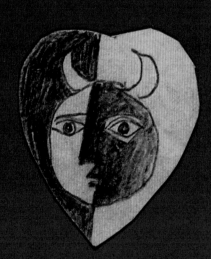
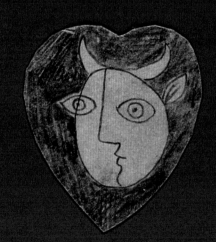
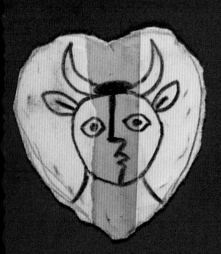

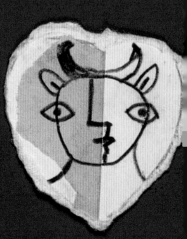

asks if Dora will pick out two or three things from her wardrobe for her. André then adds a note of his own: 'Very dear Dora, how sad we aren't around a table that we love. But there are only half-tables now. The History of Art would have every charm if we could all devote ourselves to it. Tell Picasso I am with him and you in my heart.'[2]

From Martigues they went to the Villa Bel Air in Marseille, at the invitation of the American Varian Fry and his Rescue Committee, which was stationed there to assist political and intellectual refugees in their flight from France and the Gestapo. Their presence attracted other Surrealists who together devised experiments and games, and produced the Jeu de Marseille, a Surrealist Tarot set. The Bretons went from there to Martinique, and finally to New York, with other refugees. Another letter from Jacqueline, sent from New York a year later on 13 September 1941, expresses again her pain at their separation, especially now that she is seriously working again. Her companionship with Dora had been richly enhanced by their shared passion for their work. In his unpublished conversations with Dora, Penrose recorded her recollections of Picasso's thoughts on intensity: 'One would follow ideas to their ultimate end with the greatest tenacity. Like a dog who picks up a scent and does not leave it until he has found his quarry and who is also always on the lookout for new tracks. One fails in life through lack of curiosity and lack of concentration.'[3] If Picasso was never lacking in either, nor was Dora, or Jacqueline, who writes:

> Now that 'I am working' in a completely serious way, to such an extent
> that I can't possibly understand how I could have managed to avoid it
> before – and that my life has become almost bearable, there is this new
> pain of living without you – without anyone, moreover, to replace you
> even temporarily…

Working is the only possible way for her to stand America, she says, and now at least they are going to live in a district where the houses are smaller, where theirs will have a skylight, and she will have her own room. She doesn't want to buy anything, in spite of the numerous artisans working on the street near them, because that might augur for their staying longer than she hopes. Her letter sheds her own kind of light, that of a woman painter, on the Surrealist scene in New York in these years. Besides Nicolas Calas and Gordon Onslow Ford, there is no one she and André enjoy. Yves Tanguy, now married to 'the Princess' Kay Sage (so-called after her previous marriage to an Italian prince), has alas ruined their relationship, for he:

Despite rations, curfews and the ominous presence of the Nazi forces, Picasso and Dora Maar were determined to stay put. With materials in short supply, Picasso now more than ever applied his ingenuity to everything around him, even making sculptures from the metal seats of abandoned bicycles. These heart-shaped fauns' heads (opposite), skulls and faun's head (above) were all made from cut and torn paper in c. 1943.

> …doesn't utter a word, that's to say he's never alone. You see just what
> it's like…. From the *Moulin de la Galette* to *Guernica* – you appear
> very often, I've spilled some bitter tears…. Mme Guggenheim is help-
> ing us to live – she is going to make a museum of her collection – she
> is in a rage over having nothing from the father of the 'demoiselles
> d'A'' that I finally saw with [Alfred] Barr, and that I adore.[4]

Peggy Guggenheim, says Jacqueline, finds everything too expensive, in spite of the protestations of André, her art counsellor. André is bored to death. Perhaps the Bretons will go to Mexico City to visit Frida Kahlo: anything! anything!

Below: This torn-paper figure with features burned with a cigarette end was made by Picasso in 1943. Opposite: Pablo Picasso, *Woman Dressing her Hair (Dora)* June 1940. Like *Head of a Woman* (p. 156), this painting was conceived in the days of France's defeat. Its gigantic, carcass-like figure is a supreme evocation of the sheer naked violence of war. It echoes the horror Cocteau expressed in his journal: 'Paris will be ruined. Rome was ruined. All will be ruined.'

The frustrations of life in occupied Paris were graver. During these years Picasso continued to work with a frenzy: paintings of Dora in hats and armchairs, busts of Dora and Nusch. Others took a more detached approach to this terrible time: Georges Bataille, questioned later about his feelings at seeing the Germans parade through Paris, simply responded: 'Oh you know, I have a historian's training. When they marched along the Champs-Elysées, I saw history passing by....' Lise Deharme jotted down her impressions of the period in a little black moleskin notebook. Bataille was admired by everyone, she said, even if: 'He is sometimes a bit tired, like a plant that has lived too long under a violent sun.'[5]

In May 1941 Picasso wrote of blood, not that of a beautiful young photographer stabbing herself between the fingers in a café, but this time of a more horrific kind. The war is nowhere more disturbingly present than in these poems. A thick cape dripping blood hangs heavy and oppressive; a swarm of bees sting themselves into the mass of dishevelled hair in the landscape stretched out in its suffering. A great bird's wings flap painfully, and its beak rips itself and all it touches. The essential matter of nature and of daily life is twisted, chained, dingy and torn, and even the flowers have deadly teeth:

> ...the plough's long tongue hanging out in the furrows sweating the leaden weight of the effort expended in the centre of the bouquet twisted by the chains of teeth of flowers ... the dress and its broken pleats, its rips, the wearing out of the stuff covered with spots the thousand and one hitches, its dinginess, the vermin...

Yet despite all, the poem rises into a lyric evocation of swan and ship and music. A languorous yawn of white feathers rises, not from any lake or ocean, but from a simple 'glass of water' so that finally:

> ...the tall candles aflame of the great ships resting on the rim of the well listen to the perfume of the rain breathing in the flute the fingers of green olives.

Picasso's vivid narration of an ironic and terrible ritual, dated 2 February (1941?), was dedicated 'ADORA', to Dora:

> The Meal
> the sheet rises from the bed and immediately its wheels, laughing uproariously, tear into shreds the skin of the bouquet ... the thread stretched so tight as to make it shriek through its toothless mouth out of the window falls a strange and very ceremonious soldier
> 1st course
> they bring the tears in piles of sand and crack them between the teeth of the men and women chosen among the most beautiful

In October 1941 Picasso cancelled the lease on his Royan apartment. That was also the month in which a group of artists including André Derain, Othon Friesz, André Dunoyer de Segonzac and Maurice Vlaminck made 'Le Voyage', an infamous journey to Germany, organized and invited by the German Ministry of Propaganda. They are sometimes said to have thought this would help free French prisoners in Germany, but the result was the blackening of their names.

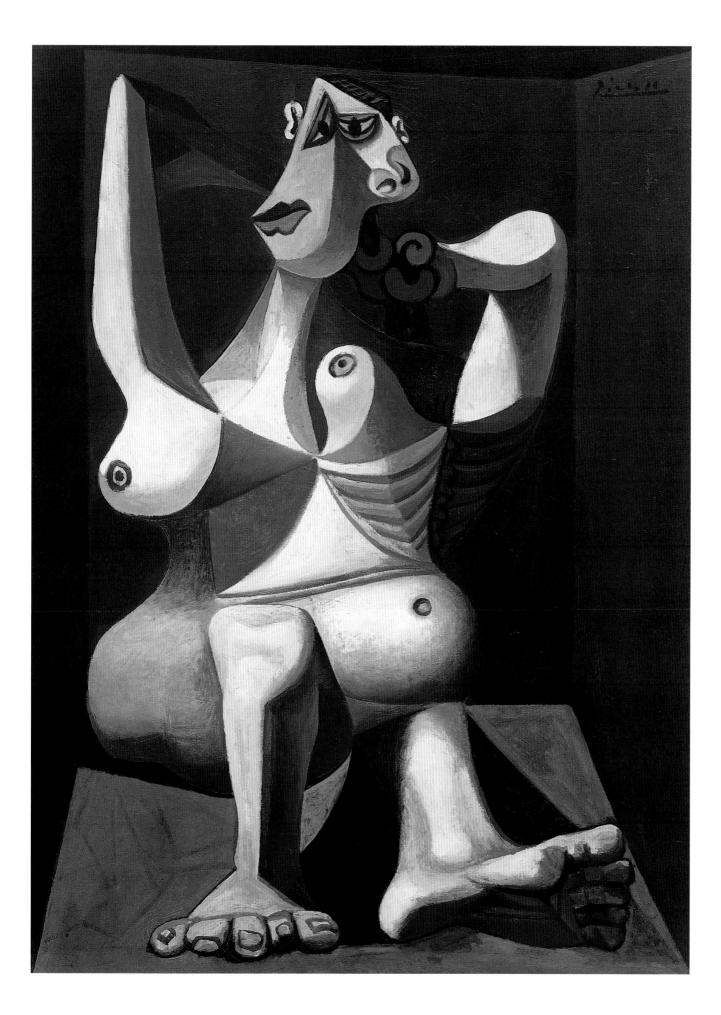

Below: Picasso made these tiny figures of a bird and a dancer from mineral-water bottle caps in 1943. Opposite: His *Blackbird*, also made in that year, consists simply of pieces of wood stuck together with plaster and mounted with wire. Such everyday, throwaway materials are characteristic of his wartime production, his ingeniously inventive spirit finding an outlet even in times of extreme deprivation.

In February and March of 1942, Dora Maar wrote this desperate poem, and typed it, scoring out much of the text. It reflects a growing discord between herself and Picasso. Vividly anticipating her own solitude, remaining motionless in her pride, she refuses to ask herself or anyone else for pity:

> Today it's another landscape in this Sunday at the end
> of the month of March 1942 in Paris the silence is
> so great that the songs of the tame birds are like little
> flames you can see. I am desperate
>
> But let it be

Brassaï recalled people huddling together to keep warm in the cafés of Paris in 1942. In spite of everything, this was a communal time. In the Brasserie Lipp, the clientèle consisted of senators, lawyers, authors and some film stars. A younger crowd frequented the Flore and the Deux Magots: poets and artists, avant-garde writers and film-makers gathered about Sartre and de Beauvoir, and Jacques Prévert and his 'gang'. Picasso was often present at the Flore, sporting his eternal trenchcoat with his wallet pinned inside the pocket, with Christian and Yvonne Zervos and the Braques. Monsieur Boubal, the Auvergnat proprietor of the Flore, would circle about, eternally smoking Gauloise cigarettes. Picasso would order (and not drink) a half-bottle of Evian water. Kazbek would beg sugar from all about, and Brassaï, with his photographer's eye, would gaze at Dora, at the 'grave, tense countenance of this girl with the pale eyes and the look that was so fixed and attentive it was sometimes disquieting.'

The theatre in Paris continued to some extent under the Occupation. Jean Cocteau, playwright and poet, had published a courageous address to young artists, asking them 'to defend, against your unworthy fellows among men, the domains of the Spirit.' Despite his official clearance of collaboration by the purge tribunal he emerged from the Occupation more seared by inward anguish than ever.[6] He saw his plays savaged by the press: performances of *Les Parents terribles* and *La Machine infernale* were halted by members of the audience throwing objects at the stage and hurling insults at Cocteau and his lover, the actor Jean Marais. Marais was involved in a fight with Alain Laubreaux, 'one of the most venomous of the occupation critics; and Cocteau was attacked and quite badly hurt on the Champs-Elysées' according to Brassaï.[7] Laubreaux was responsible for sending the great Surrealist poet Robert Desnos to the concentration camp at Fresnes. From there he was transferred to Auschwitz, Buchenwald, Flossenburg, Flôha, and eventually Terezina, where he died of typhus on 8 June 1945, just after the camp was liberated by Russian troops.

During wartime, materials for sculpture were not readily available, and Picasso was more than ever working with whatever came to hand: pieces of wood, bones, scraps of paper or cigarette packets. One exception to this was a monumental head of Dora Maar made in 1941. Picasso modelled at least two versions of this in plaster high up in his studio on the rue des Grands-Augustins. In the mid-1950s Picasso presented this piece, cast in bronze, as a memorial to the poet Guillaume Apollinaire (p. 212). It stood in the little Laurent Prache square, on the rue de l'Abbaye side of Saint-Germain-des-Prés in Paris, until 1997 or 1998, when it was stolen. Only the base now remains.

One day in 1942, at Picasso's invitation, Jean Cocteau came over to Dora's apartment and began to draw her in charcoal. 'The drawing is lovely and is very like her', he later recalled thinking.[8] But Picasso found the sketch and painted over it, as if to mark his exclusive possession of its subject. He dressed Dora in a green and orange striped blouse that she had never owned. Cocteau said nothing about this cover-up, but described Dora in this or another of Picasso's many portraits as possessing 'a monkey's eyes (but admirable), one nostril that pulls her lip slightly up to the left, a mouth like a torn flower.' Her spirit was crushed, but her dignity remained intact.

Some of Cocteau's artistic efforts met with less concealment. On 4 May 1942, in Dora's studio, he started to paint Paul Eluard, while – typically – Dora made coffee and Picasso drew 'wonderful things'. Eluard continued to pose, and Cocteau to observe him, through 3 June. They left happy with their joint effort of posing and painting, an effort Cocteau describes in his inimitable way: 'We leave thanking Dora like the proprietor of a whorehouse, two people who have just indulged in exhausting vices and gymnastics.'[9]

The political atmosphere remained grim, fuelled by accusations, denunciations and self-justifications. It inspired Sartre's influential play *Les Mouches (The Flies)* of 1943, based on the tale of Orestes and his revenge. About the Occupation and its effects, Picasso remarked despairingly to Cocteau: 'You'll see. Everything will go from bad to worse. It's all broken in us.'[10]

On 6 June 1942, the right-wing painter Vlaminck attacked Picasso in the collaborationist journal *Commedia*. Under cover of an analysis of Cubism, he accused Picasso's painting of 'an indescribable confusion', saying 'The only thing Picasso absolutely cannot do is a Picasso which is a Picasso' and comparing his work to the Talmud and the Kabala – clearly to his mind the ultimate insult. André Lhote answered Vlaminck on 13 June, and a war of words raged on with venom. Vlaminck's attack of course bore witness to Picasso's versatility, the flexibility of an artist who treated himself and others at times clownishly, at times grandly, and always as secondary to his painting. One has only a certain amount of energy, said Picasso, and many squander theirs on all sorts of small enterprises; his were devoted to one only, his painting.

From 10 June 1942 the Jews of France were obliged to wear the yellow star of David. On 16 July almost thirteen thousand Jews were rounded up by nine thousand French police into the Vélodrome d'Hiver, a sports arena in Paris. From there they were taken to the concentration camp at Drancy in northeastern Paris. On 11 November 1942, the Germans occupied southern France. On 10 December Hitler gave the order for all French Jews to be deported. Dora's Jewish parentage, if true, was overlooked, and no one gave her or her father away; nevertheless the fear and claustrophobia of this time must have been overwhelming.

The Parisian intelligentsia continued to meet. Picasso often lunched with Dora and his friends at the Catalan on the rue des Grands Augustins, which they had named in honour of its owner from French Catalonia, Monsieur Arnau, who had access to black-market supplies. In November 1943, they were found eating Chateaubriand steaks on a 'meatless day'. They were fined, and the Catalan was closed down for a month. Lise Deharme tells of being allowed only one meat ticket a week, and how the very leaves of the chestnut trees became appetizing.[11]

Above: Dora Maar by Rogi André, 1941. Opposite: Pablo Picasso, *Portrait of Dora Maar*, 9 October 1942. This was Picasso's last full portrait of Dora. Her features are intact but they look bruised by emotion. Cocteau and Dora Maar both told the story of this painting, Cocteau in his memoirs and Dora to James Lord. Cocteau came over to paint Dora's portrait at Picasso's invitation. Picasso proclaimed the result a masterpiece, but as soon as Cocteau left started adding touches until eventually, some days later, it was entirely transformed. This reworking coincided with the death of Dora's mother. She and Dora were arguing fiercely on the telephone one night when suddenly Mme Markovitch fell silent. It was past curfew; when they found her the next morning she was dead, the phone still in her hand.

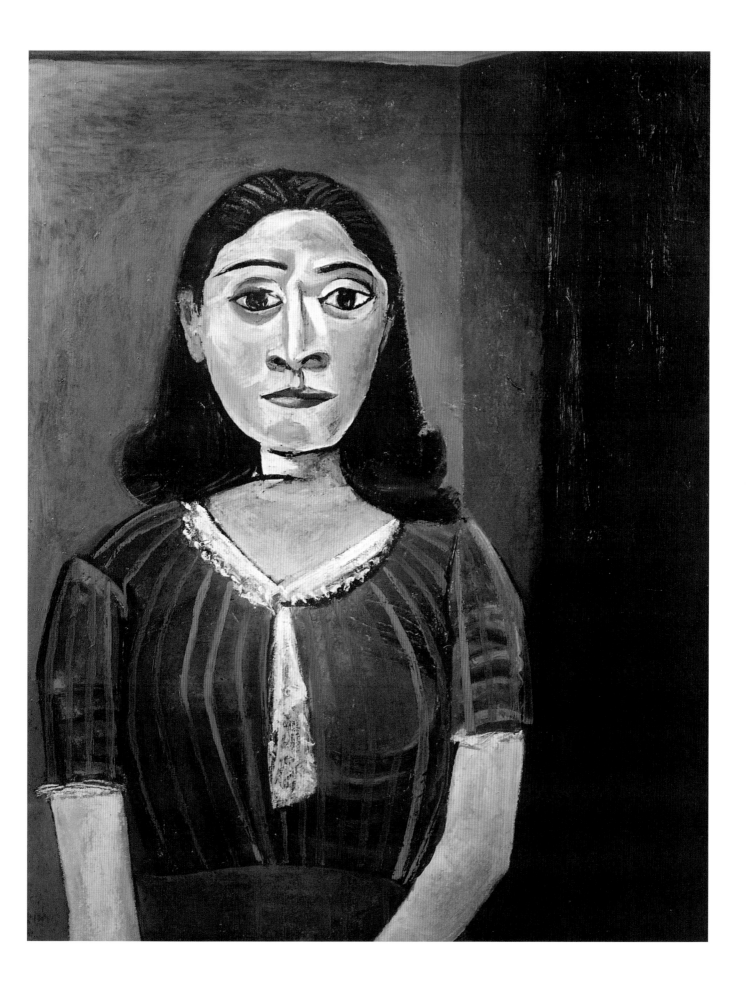

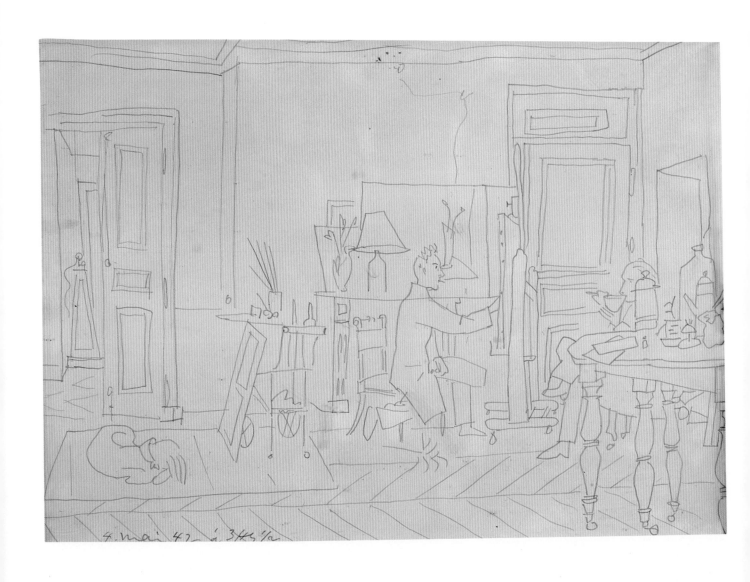

4. mai 42 à 3h5 1/2

Opposite: Picasso's 1942 drawing of *Dora Maar's Studio* on the rue de Savoie depicts Cocteau making a portrait of Eluard, probably the drawing above. The faithful Kazbek is shown sleeping at bottom left. Dora Maar had photographed Cocteau some years before, in *c.* 1935. Despite this amicable scene, their mutual friendship with Picasso did not enable the Communist Eluard and the right-leaning Cocteau to overcome their political differences.

In late 1942 Picasso made a set of engravings for an edition of Buffon's *Histoire naturelle* that was printed by the publisher Fabiani. This is the title page of a copy he presented to Dora, showing her as bird-woman and inscribed with an affectionate pun in Catalan to his '*rebufona*', his sweetheart.

But Deharme recalled brighter moments amid this hardship: 'Life regains a primitive meaning; people use their hands, their feet, their inventive spirit…. They find all those things again which are only available in calm, depth, and leisurely strolls.'[12]

In January 1943 Picasso gave Dora a copy of Buffon's *Histoire naturelle*, for which he had made a set of engravings. On the title page he drew Dora as a bird and dedicated the book in Catalan to his sweetheart Dora Maar: '*Per Dora Maar tan rebufona*'. This affectionate, punning inscription combines not only woman, bird and author, but the play of temper and teasing humour typical of Picasso.

By 1944 trouble was brewing all around. On 24 February the poet and painter Max Jacob was dragged away by the police as he was attending Mass at the Benedictine abbey of Saint-Benoît-sur-Loire. Picasso had been extremely close to the complex Jacob in earlier years, and he and Dora had visited him at the abbey. Jewish by birth, Jacob had converted to Catholicism after seeing two visions of Christ, and had become an oblate at the abbey. He died in Drancy in northeastern Paris of pneumonia on 5 March, just as he was about to be deported to Germany.

Picasso remained intensely loyal to his memory. Cocteau tells how Christian Bérard wore Jacob's trousers one day to visit Picasso, who recognized them at once from their knees, worn thin by so much kneeling at the altar. Picasso turned pale at this 'repugnant frivolity' and gasped 'that's the height of disrespect'. Preceded by Dora, who had felt the storm coming on, he rushed out of the room and slammed the door. Pierre Colle, who had saved the trousers and passed them on, was banished ever after from Picasso's house.[13]

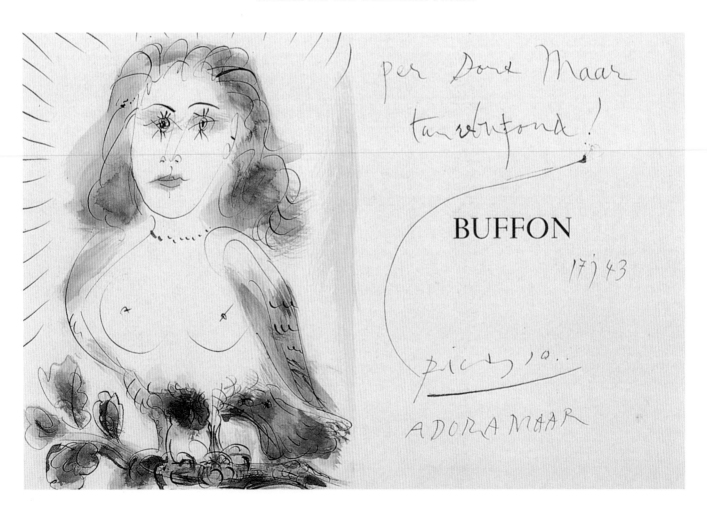

A funeral mass was said for Jacob, which was attended by Picasso and Cocteau along with Braque, Derain, Eluard, Pierre Reverdy and André Salmon (whose hand Picasso refused to shake because of Salmon's support of Franco and the pieces he had written for the pro-Franco journal *Le Petit Parisien*). The next November, Michel Leiris presented a *Homage to Max Jacob* at the Théâtre des Mathurins, which Picasso attended. Robert Desnos was also arrested in February 1944 and would die in Terezina a year later. These two remarkable poets who met similar fates remain much read and revered.

Picasso had written the now celebrated play *Le Désir attrapé par la queue (Desire Caught by the Tail)* over four cold January days in 1941 in the unheated studio of the rue des Grands Augustins. Some of its lines have an authentic Bretonian Surrealist flavour: 'Dazzling traces of spines sketched with hatched blows into the naked barking flesh in flames discovery immobile and perfumed'. In March 1944, a group of Saint-Germain intellectuals put on a fiesta: Dora Maar staged a pantomime bullfight, Sartre directed an orchestra, the Surrealist writer Georges Limbour cut up a ham, Bataille and Raymond Queneau enacted a duel with bottles.[14] And on 19 March at the apartment of Michel and Louise Leiris, *Desire Caught by the Tail* was finally performed. It clearly reflects the shortages of the Occupation and its pinched atmosphere: the fact that Picasso and his friends lunched at the black-market–supplied Catalan scarcely shielded them from the realities of life around them. In the play, both Big Foot the poet and his friend Onion are in love with the Tart, who has Thin Anguish and Fat Anguish for friends. She is deeply alluring ('I light the candles of sin with the match of her charms') and is marked as a painter: 'the roses of her fingers smell of turpentine'.[15] Some of the characteristics of the Tart are based on Dora, though she played the part of Thin Anguish. Albert Camus directed, and the other actors included Sartre and de Beauvoir, Germaine Hugnet, Raymond Queneau and Sylvia Bataille (by now married to Lacan). With the exceptions of Eluard, who was working for the Resistance, and Zervos, who was away fighting, the audience included all of the major intellectual and artistic figures of occupied France.

The relationship between Picasso and Dora Maar was by now under severe strain. In May 1943, while dining at the Catalan, Picasso met Françoise Gilot, twenty years younger than Dora and forty years younger than him. She was tall, slender, beautiful. Dora's state of mind became increasingly unstable as her jealousy mounted. Dora had shared Picasso with Marie-Thérèse and their daughter Maya for years, a sharing that was never simple. He would insinuate that she was unfeminine, that her sterility – rarely spoken of, but possibly an element in her complicated personality – was the opposite of Marie-Thérèse's gentle and curvaceous fertility.

In his portraits, Picasso would sometimes deliberately confuse their representation, crowning Dora with Marie-Thérèse's flowers, or dressing Marie-Thérèse in a costume more fitting for Dora. He also painted them together, in a double portrait. Worst of all, he bought them identical dresses and then switched the labels on the boxes so that each would know she was not the only one. Early in his affair with Françoise he told her that '"for me, there are only two kinds of women – goddesses and doormats." And [she wrote] whenever he thought I might be feeling too much like a goddess, he did his best to turn me into a doormat. One day when I went to see

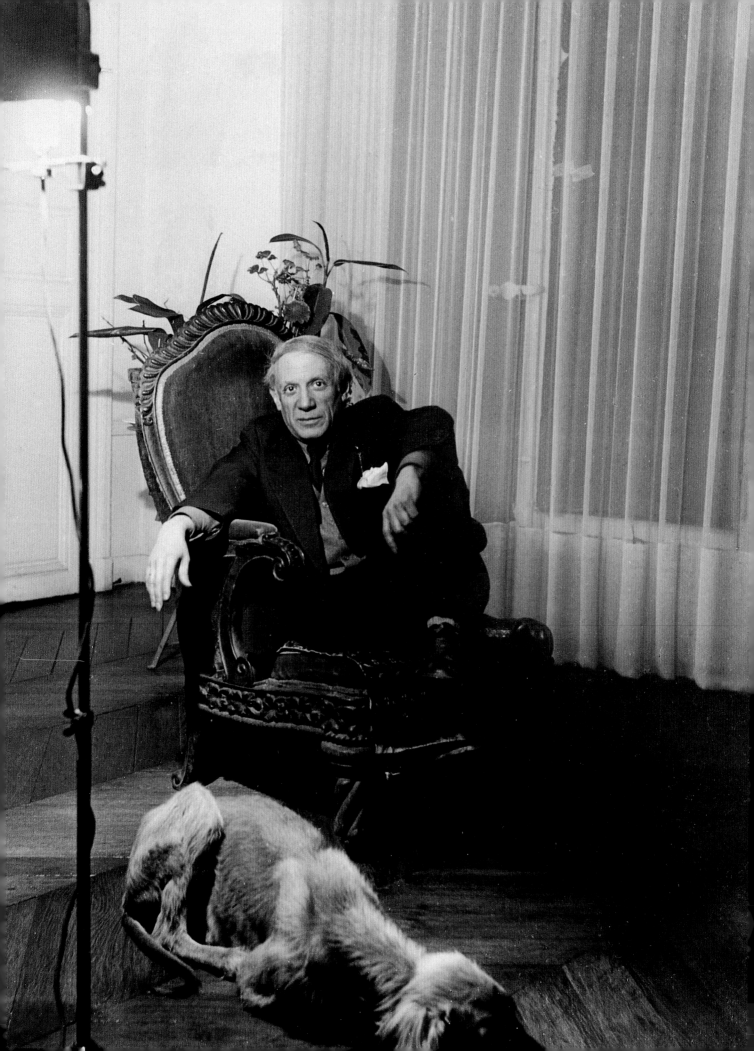

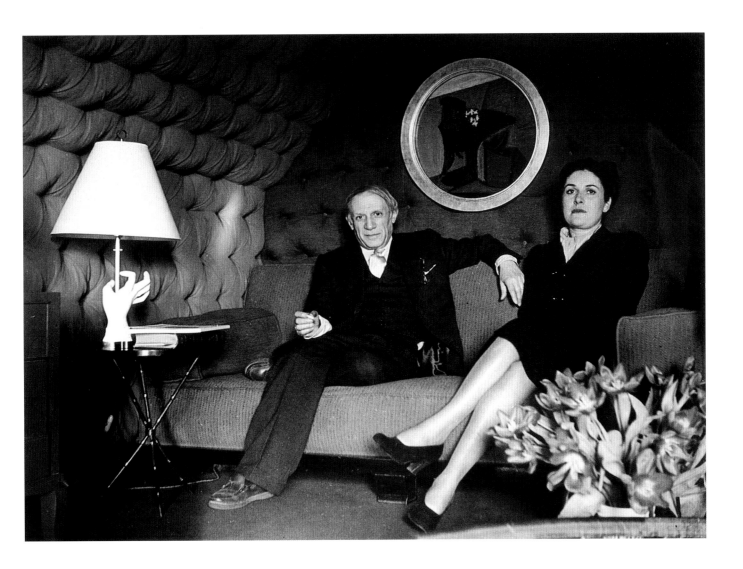

Opposite: Picasso in the drawing room
of Dora Maar's apartment on the rue de
Savoie with the ever-present Kazbek at
his feet, photographed by Dora Maar in
c. 1942. Above: A snapshot preserved by
Dora of herself with Picasso in a curious
padded interior in the 1940s. The
painting above them may well be hers.

him we were looking at the dust dancing in a ray of sunshine that slanted in
through one of the high windows: "Nobody has any real importance for me. As far
as I'm concerned, other people are like those little grains of dust floating in the
sunlight. It takes only a push of the broom and out they go.'"[16]

Since *Guernica* Dora Maar had given up photography for painting. As she
divested herself of her photographic equipment – projectors, curtains, spotlights –
it ended up not far away from her studio, in Picasso's own. Dora's spotlight was
used to illuminate his paintings during the Occupation, while her backdrops were
used as blackout curtains for his studio.

Perhaps her renewed enthusiasm for painting came about through painting
those few strokes in *Guernica*; perhaps her proximity to a painter of genius inspired
her anew. The intense focus she applied to an alarm clock or the stalk of a plant in
her still lifes of this period owed much to the teachings of Sougez and the *Neue
Sachlichkeit* or New Objectivity, which advocated absolute concentration on a single
object, sometimes in unbearable, suffocating close-up. All the same, her submission
to what seems to have been Picasso's wish proves now a great sacrifice of her talent
and her individuality. She was intensely conscious of this, once saying about their
relationship 'I wasn't Picasso's mistress, he was just my master.'[17]

One positive effect of her renunciation of photography was the renewal of
her friendship with that other photographer of genius, Brassaï: 'strangely, as she

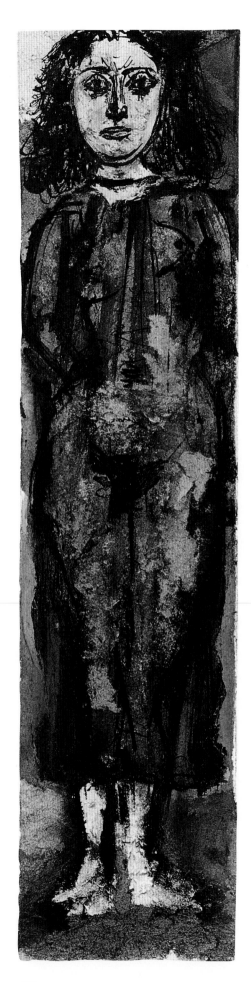

gave up photography to concentrate on painting … she also changed her attitude: professional jealousy shaken off, there was no longer any obstacle to our friendship….'[18]

When Dora Maar's still lifes were exhibited at the Jeanne Bucher Gallery in 1944, Brassaï insisted that one fact deserved 'underlining – she has managed to keep herself free of Picasso's formidable influence. Her still lifes – a loaf of bread, a pitcher or jug – are extremely austere and recall nothing of her friend's colours or any of the periods of his work.'[19] The paintings were severe, and severely focused on a minimal object. To Françoise Gilot, herself a painter, 'they may have reflected, in a measure, her community of spirit with Picasso, but they brought to that a feeling that was entirely different. The work was not derivative; there was nothing sharp or angular about her forms.' Gilot considered that she excelled in a chiaroscuro that was missing in his work, and in the painting of ordinary objects: 'a lamp or an alarm clock or a piece of bread… [they] made you feel she wasn't so much interested in them as in their solitude, the terrible solitude and void that surrounded everything in that penumbra.'[20]

Dora Maar – proud, beautiful, jealous – stayed in touch with her friends even in these most difficult days. The Surrealist painter and her longtime friend André Masson wrote to her of his distress at missing her 1944 show: his invitation had been sent to the country. 'Dear Friend,' he wrote, 'A student informed me that you were having an exhibition at Jeanne Bucher's. I rushed over right away, distressed not to have been able to celebrate you on the day of the opening. The exhibition had finished. But all the same I was able to see most of the canvases from it; I liked them a lot, especially the cage.'[21]

Picasso's painting and poetry were nourished throughout this period by Dora Maar's personality and temperament, her intelligence, and her willingness to participate in a romance 'à l'Espagnol' – dramatic and stormy, so unlike the calm waters of his relations with Marie-Thérèse. And conversely, his violence and lyricism – which André Breton so admired and through which Dora Maar loved him – nourished hers. Having been so intense, the relationship was now deteriorating. Picasso and Dora continued to see each other until 1946, but by then a final separation was inevitable.

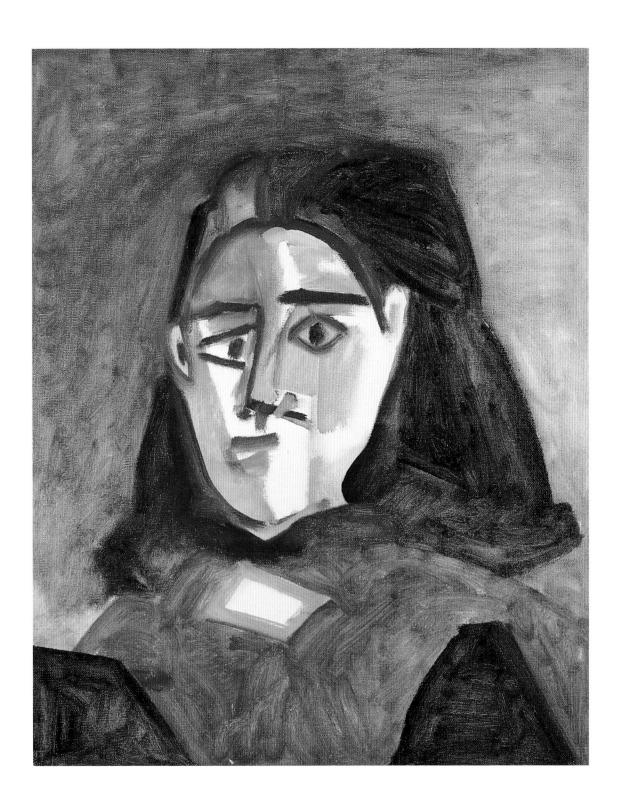

Opposite: Pablo Picasso, *Dora en déshabillé*,
2 April 1943. Above: Pablo Picasso, *Dora
Maar in a Mauve Shawl*, 26 April 1942.
These harsh depictions show her as cold
and angry – or maybe just hurt. Her
passionate nature reacted badly to Picasso's
involvement with Françoise Gilot, which
began in 1943 and spelled the end for Dora.

Dora Maar painted angular still lifes in this period, focusing an unflinching gaze on an often solitary object. These works – such as *Alarm Clock* of 9 August 1940 (below) and *Composition with Alarm Clock* of 20 April 1943 (opposite) – have a purity and freedom from sentiment that recall the aesthetics of the New Photography. She had many exhibitions of her paintings in the mid-1940s. Right: This shoe box decorated by Picasso with anthropomorphic alarm clocks in 1940–42 was one of the innumerable pieces of ephemera by which she treasured his memory until her death.

175

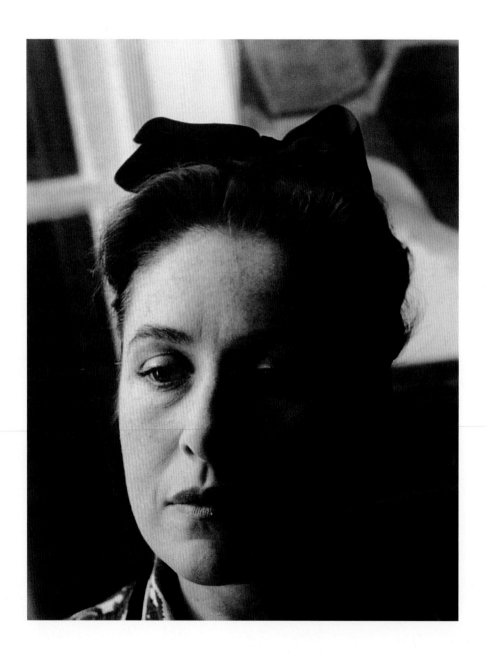

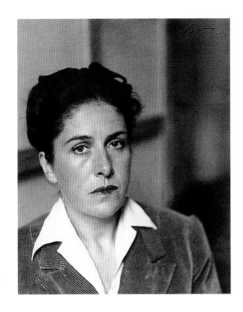

I walk alone in a vast landscape
It is fine weather – But there is no sun. No hour.
For a long time now no friend no passer-by. I walk alone. I speak alone.
DORA MAAR, 23 MAY 1946

Dora Maar's poems of the 1930s and 1940s are a clear reflection of her emotional life, as are those written in her later years. She constantly reread and retranscribed (and sometimes redated) them. They were the private reality behind the proud exterior. Towards the end of her life she also spent much of her time reworking her old photographs, always rethinking, replacing, reframing and resizing. Her poetry expresses the anguish that Picasso depicted in her face; here the presentation is her own, and its strength depends entirely upon her own personality as a woman and a poet:

> I rested in the arms of my arms
> I slept no longer
> It was summer night winter day
> An eternal shiver of thoughts
> Fear love Fear love
> Close the window open the window

Friends had warned Dora that she should protect herself against Picasso the satanic genius, her 'demon lover', as people called him; but she had her pride, her stubbornness and her originality. To the art critic Edouard Jaguer she was 'a strange, bizarre, ambiguous, even frightening person' whose force of character was such as to refute everything said about her. Her courage was so far holding up, and she heeded no counsel.

> Absurd advice
> Satisfaction like a dream
> terror
> And fatigue
> A great courage mocked

Opposite: Dora Maar by Ina Bandy, late 1930s. Above: Dora Maar by Izis, 1946. The end of the war and her renewed success as a painter brought some relief for Dora Maar, but still the slow agony of her split with Picasso contributed to a devastating depression and breakdown in 1946–47, to which her poems of these years bear witness.

Above: Anonymous portrait of Dora Maar – possibly a self-portrait – from the 1940s. Opposite: Dora Maar photographed by Izis in 1946, supremely poised and elegant, smoking a cigarette in a golden holder. Both images are tinged with melancholy and loneliness. In one poem she wrote: 'Facing the mirror I question myself/About the night to come/Let the time pass/Let me withdraw/Let the mirror be empty /For always'.

On Armistice Day, 11 November 1944, there were celebrations everywhere. In December, the American writer James Lord first sought out Picasso, hoping for a portrait of himself. He met Dora at lunch. She held out a gloved hand, pride and stylish accoutrements intact. Her gaze, says Lord, 'possessed remarkable radiance but could also be very hard. I observed that she was beautiful, with a strong, straight nose, perfect scarlet lips, the chin firm, the jaw a trifle heavy and the more forceful for being so, rich chestnut hair drawn smoothly back, and eyelashes like the furred antennae of moths.' Before lighting her Gauloise, taken from Picasso's blue packet, she took out her gold cigarette holder, 'a slender tube several inches long like a tiny trumpet, with a black Bakelite mouthpiece and a flaring bell, into which she studiedly inserted the end of her cigarette. She had remarkably beautiful hands, the fingers exceptionally slender and graceful, with long, pointed, scarlet nails. Having set the cigarette into its holder, she placed the mouthpiece between her teeth and must have clenched them, because the holder jutted upward at an acute angle from her lips. Then she sat there, staring straight in front of her, moving not a muscle with the unlighted cigarette projecting into space.' Picasso asked for a cigarette lighter; she answered that it must have been lost. Picasso shouted at her in Spanish and rapped his knuckles on the table loudly. 'But he appeared supremely indifferent to everyone but Dora, whose own indifference to Picasso's tirade was evidently absolute, as she simply sat there, the unlit cigarette immobile in front of her face.'[1]

The atmosphere following the Armistice was ambiguous. Lise Deharme described how: 'Everyone hates everyone and they all argue…. On the evening of this victory so dearly bought, the most celebrated collaborators were drinking, feasting, toasting each other while an entire population was dancing on an empty stomach. The jeeps were covered with clusters of tipsy females. I went out rarely, too upset.'[2] Dora Maar was more gravely upset by Picasso's continuing affair with Françoise Gilot. Deharme noted in her journal on 27 May 1945 the terrible grief Dora Maar's condition was causing among her friends.[3] Even in the dark years of the early forties, when, after dining at the Brasserie Lipp, Lise would go to the Deux Magots to meet Dora Maar and Picasso, there had always been an atmosphere of great cordiality. The friendship had been radiant then.[4]

Despite her distress, Dora Maar was exhibiting frequently in these years, as if in a frenzy to catch up with her career after lost time. She had a one-woman show at René Drouin in 1945, and at Pierre Loeb in 1946, by which time she had added to her still lifes a few waterscapes of the Seine. Picasso's influence on her style was now waning as their estrangement became definitive. Even so, he continued to see her until 1946. He gave her a number of portraits, quite a few still lifes, and enough little objects to fill a drawer. In 1946 she removed these and displayed them for Brassaï to photograph. Over the years she had accumulated an extensive collection. At every opportunity she would carefully excise with a knife the drawings Picasso made on restaurant menus and paper tablecloths, rolling them up and placing them in her bag. And in the late afternoon, after finishing his work, Picasso would often go around the corner to see Dora, taking pebbles he had engraved with his Opinel knife, tin birds and fishes or cardboard cutouts, 'small gifts intended to keep alive a fading love.'[5] In the absence of Picasso in future years, Dora would still have her treasured objects.

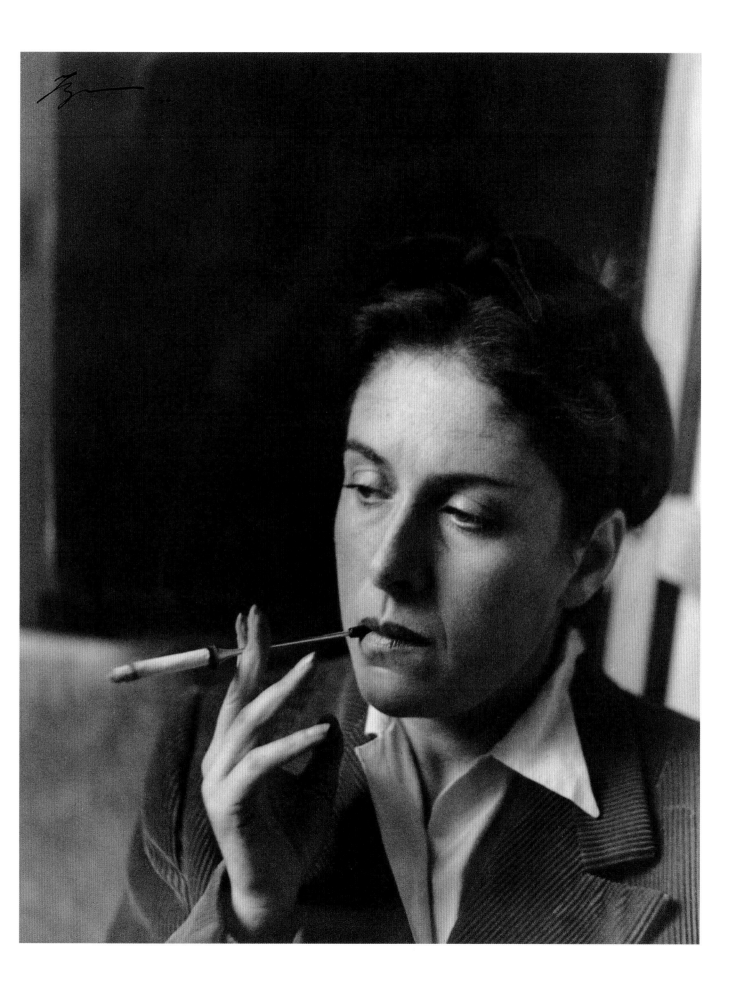

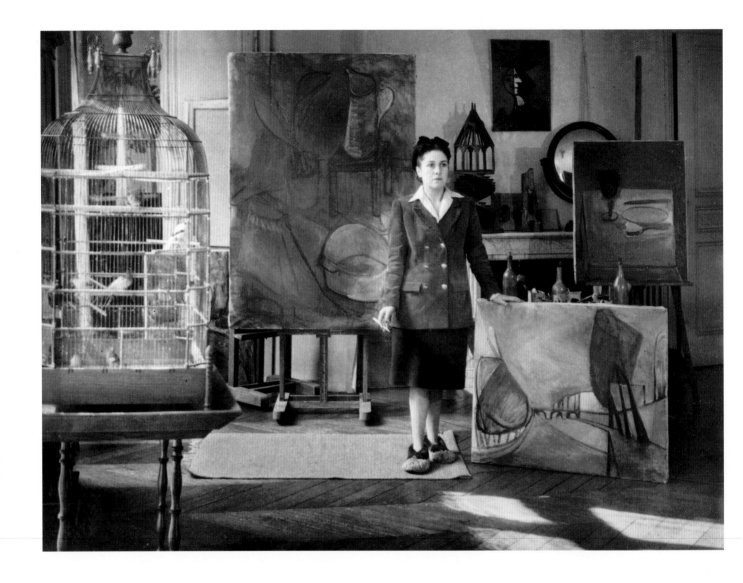

Above: Brassaï, *Dora Maar in her Studio*,
1944. The painting she is presenting is
The Quays of the Seine of 5 June 1944
(opposite), one of a series of waterscapes
of the Seine that she exhibited at
Pierre Loeb's gallery in Paris in 1946.
Brassaï's friendship with Dora was
renewed after her split with Picasso.
In 1946 she allowed him to photograph
the collection of Picasso's pebbles, bones,
cutouts and fragments that she had
amassed over the years.

BREAKDOWN AND RECOVERY

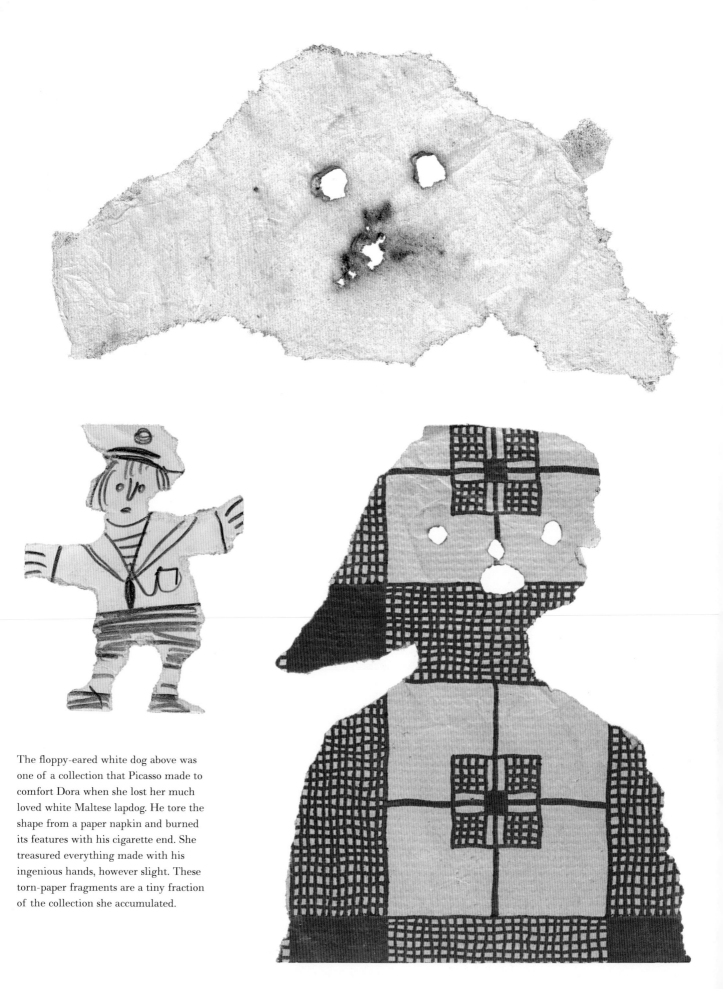

The floppy-eared white dog above was one of a collection that Picasso made to comfort Dora when she lost her much loved white Maltese lapdog. He tore the shape from a paper napkin and burned its features with his cigarette end. She treasured everything made with his ingenious hands, however slight. These torn-paper fragments are a tiny fraction of the collection she accumulated.

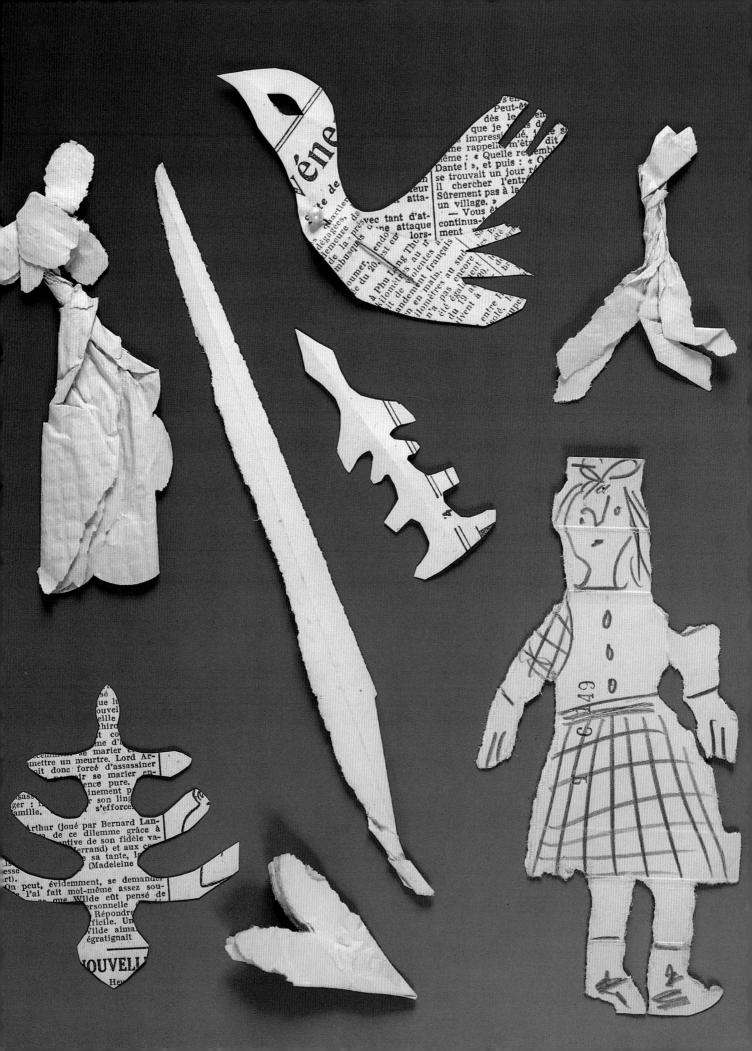

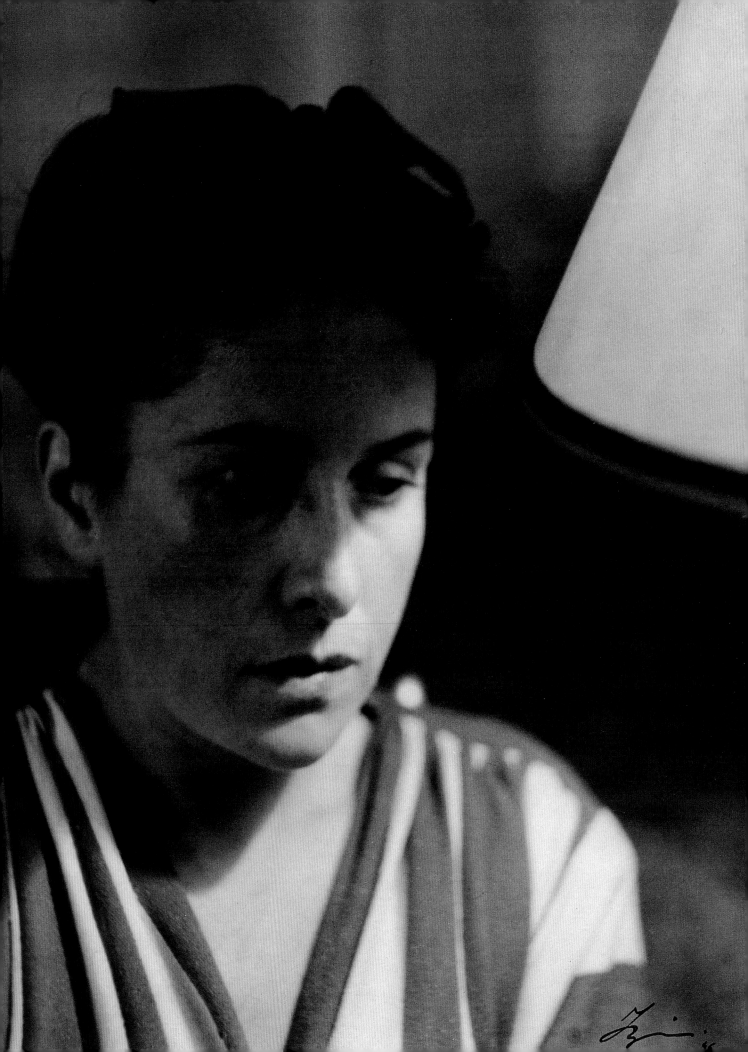

There was now another terrible loss. On 28 November 1946, just after she and Nusch Eluard had been talking on the phone and making plans to meet for lunch while Paul Eluard was away in Switzerland, Nusch suddenly collapsed with a fatal cerebral haemorrhage. Nusch had been everything to Eluard: wife, friend, secretary, guardian angel. How would he manage without her, whom he had loved so intensely after his first wife Gala left him for Salvador Dali? He lost everything in losing her: his confidence in life, his hope in the world, and even in poetry. 'The great singer of love, of happiness, of joy in living, fell silent.'[6] The next year, under his pseudonym Didier Desroches (which he had used in the Resistance), Eluard wrote the heart-rending poem '*Le Temps déborde*' ('Time Spills Over'), which was published with photographs of Nusch. It begins with the denial of poetry under such extreme grief, and ends with an explanation of the title. The date of her death was printed on a separate line, like a tombstone.

Twenty-eighth of November, nineteen hundred and forty-six

Dead seen Nusch unseen harsher than thirst
Than hunger to my worn body
Mask of snow on the earth and under
Source of tears in the night blindman's mask
My past dissolves I give way to silence

We shall not grow old together.
 This is the day
 Too many: time spills over.

To Dora, it must have seemed that she was losing everyone she loved at the same time: Nusch, Picasso…. She was facing a true severance with her past, and her future looked bleak. During this sad period, Picasso and Françoise Gilot chanced upon Dora at an exhibition of the Unicorn tapestries, and they all went to lunch together at the restaurant Chez Francis. As Gilot tells the story, Dora ordered caviar: 'You don't mind if I order the most expensive thing on the menu, do you? I suppose I still have the right to a little luxury, for the time being?' Picasso insisted on telling her all about how marvellous Françoise was: 'What a mind! I've really discovered somebody, haven't I?' Dora conversed in a witty fashion, but Picasso never laughed at her remarks at all, saving his hearty laughter for Françoise.[7]

Some time after that, Picasso ran into Dora again, this time at the Café de Flore. He invited himself and Françoise to Dora's rue de Savoie studio to see her paintings, and forced Dora to tell Françoise that it was all over between them. Françoise recalled that 'Dora Maar looked over at me briefly and witheringly. It was true; there was no longer anything between Pablo and her, she said, and I certainly shouldn't worry about being the cause of their breakup. That was about as preposterous an assumption as she could imagine.' Dora then ventured that their affair wouldn't last, that Françoise would be 'out on the ash-heap before three months had passed.' Dora turned to Picasso: 'You've never loved anyone in your life. You don't know how to love.'[8]

Opposite: Izis, *Portrait of Dora Maar Under a Lampshade*, 1946. Above: Nusch Eluard by Dora Maar, 1935. The death of Nusch in 1946 came as a huge shock to her husband and friends. Her frail beauty and vivacious temperament had made her much loved. She collapsed and died shortly after talking on the phone with Dora, making plans for lunch together while Paul was out of town. Overleaf: An anonymous portrait, perhaps a self-portrait, of Dora Maar in her studio on the rue de Savoie towards the end of the 1940s.

Dora had been acting most oddly. Tales of her strange comportment in this period abound: she claimed to have been attacked and to have had her bicycle stolen, when in fact it was where she had left it, by the Seine. The same act was played out over other possessions. She was discovered naked on her stairs, and had to be ejected from a cinema where she was making a disturbance. She would force Eluard and Picasso to their knees and accuse them of leading sinful lives, insisting that they confess. A scene that took place at the Catalan, faithfully recounted by Brassaï, represents Dora's state of mind in these months of jealous rage and wounded pride. The 'bande à Picasso' – the Eluards and others – were lunching together. Picasso had ordered his Chateaubriand, taken orders for the others, and saved a place for Dora, who came in very late.

> She is in a sombre mood. She clasps her hands together, clenches her teeth, says nothing to anyone, does not even smile. She sits down in the empty chair. Two minutes have not passed when she stands up again and says: 'I've had enough, I can't stay. I'm going.' And she leaves the room. Picasso, who has not yet had his Chateaubriand, leaps to his feet and runs after his friend…. An hour later he reappears, distraught, his hair in wild disarray. I have never seen such distress on his face. 'Paul, come quickly, I need you,' he says to Eluard.[9]

Neither returned. Picasso later told Françoise Gilot that Eluard had been so deeply shocked by the sight of Dora so ill and so unhappy that he smashed a chair to bits.[10] The love affair was ending, and badly.

Dora had suffered a nervous breakdown. She was taken off to a psychiatric hospital, where for three weeks she was subjected to a series of electric-shock treatments, and was then moved to a private clinic at the intervention of the psychiatrist Jacques Lacan, called upon by his close friend Paul Eluard. Lacan was Picasso's personal doctor, the painter preferring to be cared for by someone outside his specialization. His ideas had long been celebrated by the Surrealists, with whom he had been associated since the early 1930s, and would soon be world-famous. Breton had attended his seminars. Particularly attractive to the Surrealists was Lacan's idea of the 'mirror stage' of development, which renewed the Freudian idea of the divided self: 'I am nothing of what happens to me'. He was by now married to Sylvia Bataille, former wife of Georges Bataille, the lover who had first initiated Dora into various arcane erotic practices. In an imbroglio characteristic of their circle, Sylvia and Lacan and their daughter Judith lived for years next door to Georges Bataille and his new family.[11] Sylvia was also the sister of Rose Masson, herself married to the Surrealist painter André Masson. So Lacan, like Dora, had remained part of the Surrealist extended family.

Picasso blamed Dora's breakdown not on his abandonment of her but on her association with the Surrealists, those irrational eccentrics. Just look how they ended, he said to Françoise: Jacques Vaché, Jacques Rigaut, René Crevel, all suicides; Antonin Artaud, completely mad. And, added Picasso, she had always been crazy.[12] Think of the crazy hats she wore, he said to John Richardson, and that café scene. She always had a sense of the occult, and look what happened. To Eluard, he asserted that: 'If anyone is to blame, it's you and the Surrealists, with all those wild ideas promoting anti-rationalism and the derangement of all the senses.' He certainly accepted no responsibility himself.

BREAKDOWN AND RECOVERY

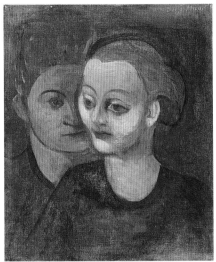

Opposite: Dora Maar photographed in
her studio in 1946 by Michel Sima with
her portrait of Alice B. Toklas, Gertrude
Stein's companion. This painting now
graces the Beinecke Library at Yale
University. Alice B. Toklas was part of
a circle of acquaintances in the late 1940s
and early 1950s that included Dora Maar,
Marie-Laure de Noailles, James Lord,
Lise Deharme and the painter Balthus.
Dora Maar's paintings *Bust of a Woman*
and *Double Portrait* (above) remained
undated at her death, but they were
probably executed around this time and
show her moving beyond the still lifes
and waterscapes of the postwar years.

Dora underwent two years of analysis with Lacan. Little by little, she regained her poise and composure. According to Picasso, Lacan found himself forced to decide whether to leave Dora to her madness (and an eventual strait-jacket) or to encourage in her a mystical tendency that was already apparent. He chose the latter, which, after a phase of occult belief and then a Buddhist period, placed her in the arms of the Roman Catholic Church. This did not, however, launch her immediately into a solitary life. Once past the worst of her private grief, there ensued a worldly period in which Dora Maar became once more a '*mondaine*', part of the sophisticated circuit. She went to lunches and dinners, and kept company, mostly with her close friends Lise Deharme and the art collector and *salonnière* Marie-Laure de Noailles, whose elaborate lunch and dinner parties often included Cocteau, Giacometti, and Dora's good friend, the painter Balthus.

The artist Raymond Mason first met Dora Maar during this period, at a dinner given by the American patron of the arts Katherine Dudley. It was through Dora that he was to meet all the people who were subsequently important in his career. He describes her at that time as being like a somnambulist, but always upholding a dignified reserve. He objects violently to the popular conception of Dora Maar as, above all, a weeping woman. She was, he says, anything but that. She in no way presented herself as a victim, understood everything anyone said and lived her life with all the poise and propriety that anyone could have mustered under these circumstances. 'I knew her immediately after her break with Picasso and she possessed perfect dignity, paying great attention to other people.' She exuded no bitterness, just an immense intelligence.[13]

Georges Bernier concurs with Raymond Mason. Bernier was the editor of the art journal *L'Oeil* and had known Dora Maar since she was a young woman in the sixteenth arrondissement, attending evening parties and society gatherings. 'Lacan had taken care of her, once more Dora was lively, playful. There was absolutely nothing of "the weeping woman" about her. She lived a dizzying social life, went out a great deal with the Vicomtesse de Noailles and Lise Deharme, picked up with her old friends again: Gallimard, Léonor Fini, Balthus, at the Catalan, in the rue Saint-André des Arts.' They also dined frequently at the Reine Christine, on the rue Christine near to Dora's apartment.[14]

Dora never lost her striking intelligence, on which all the people who knew her well remark. She was the only one of Picasso's lovers to match him in mind and temperament. She was always open to learning, in testimony to which there survives a lengthy letter from her friend Raymond Queneau, philosopher and writer of fiction (notably the delightful *Zazie dans le métro*), telling her exactly what she should read in philosophy and in what order: to start with the founding texts of Plato, Descartes, Kant and Bergson, to move on to various problems posed by Aristotle, Plotinus, Leibniz, Berkeley, Kant and so on, to confront a few canonical texts by Montaigne, Kierkegaard, Nietzsche and Léon Chestov, thinking about the relations between philosophy and psychology, and to finish with some existentialist texts by Rousseau, Marx and Sorel.[15] Knowing what we know about Dora Maar, she probably did read these, if she had not already. But her own opinions were to move ever further in the direction of mysticism and Catholic orthodoxy, with the most learned books on the subject filling her shelves and cupboards to overflowing.

Ménerbes, a tiny village in the department of the Vaucluse in southeastern France, was the location of a house that Picasso procured in exchange for a painting and gave to Dora Maar as a parting gift. This property was large and draughty, and remained sparsely furnished and in poor condition: when James Lord first visited in 1952, he found some of the rooms closed off, their ceilings collapsed. Ménerbes looks out over the valley of the Lubéron and has a long tradition as a home to artists and intellectuals. The painters Nicolas de Staël and Raymond Mason lived there, as well as the art historian John Rewald and the Gimpel family of art collectors and dealers.

In May, 1947, she was still seeking something to hold on to amid the ruins of her life, which had been reduced from a full-branched tree to just bare roots:

> It's a handful of earth on the earth
> …
> Looking in the black forest
> Amid the roots and barks

She tried to feel gratitude for the happiness of her friends, even as her own was reduced to bare roots and tree bark – may they have warm houses in the winter and, in the summer, a vast land in which to wander under a stormless sky. She will have only God.

Her house in the village of Ménerbes in the Vaucluse was given to her by Picasso in 1945. He had given her other gifts, smaller and more outlandish, among which was a wooden toilet seat which he painted 'to give it a Pompeiian air, and so Dora could sit on my work while she shits.'[16] In summer 1946 Picasso borrowed the keys and went to stay there with Françoise. Dora asked, upon his return, if he had been able to work there. Yes, he replied, he had – but he did not venture to say what he had been working on. According to James Lord, Picasso had made and left behind two drawings of her bedroom, which he had occupied with Françoise.[17]

It took all Dora's fortitude and faith to endure such incidents. Her increasing mysticism was to comfort her through the hard times to come. For she had not, of course, forgotten Picasso. Even ten years after they had separated, he continued to inflict on her further woundings to her pride. Both James Lord and John Richardson describe in their respective memoirs an evening in November 1954 spent at the Château de Castille, near Avignon, then home to Richardson and the critic and collector Douglas Cooper.[18] James Lord was staying with Dora in nearby Ménerbes, and she asked if she could bring him over for dinner. The other guests included Jean Leymarie (in later years director of the Musée National d'Art Moderne in Paris), Richard Buckle (a British ballet critic), and Picasso, who was delighted at the prospect of taking Dora by surprise. '"*Tant mieux*," he said with conspiratorial relish, "I haven't seen her in ages. Don't let her know I'm coming.'[19] Before their arrival, Picasso reminisced about Dora: 'how the steadfastness of her gaze reflected her intelligence, and how her outré sense of fashion had inspired the surrealistic hats trimmed with fish and fruit and sardine cans that figure in many of his portrayals of her – such a contrast, he said, to the tam-o'-shanter from Hermès that he gave her rival Marie-Thérèse.' Hats had differentiated the two rivals in his work, as had what he had come to realize was her incipient madness, of which there had always been an inkling. 'I left her out of fear. Fear of her madness,' said Picasso. 'Dora was mad long before she actually went mad.'[20] In the course of the evening, Picasso went out of his way to humiliate James and Dora; it clearly irked him to see her with someone else. He tormented Dora with elaborately affectionate glances followed by very public rejection. 'When are you two going to get married?' he mocked, knowing full well that James's homosexuality precluded this.[21]

Richardson confirms that Dora Maar was 'the only one of his wives or mistresses whose temperament and imagination had been on the same mystical

Dora Maar's pencil sketch of James Lord, never before published, was completed in 1954 during one of their stays together at Ménerbes, which he recounts in amusing detail in his memoir of their close but sometimes fraught friendship.

wavelength as his own…. I watched her as closely as politeness allowed and concluded that it was pride, bolstered probably by her new-found faith, that protected Dora through this unnerving evening…. It was pride, too, that prevented Dora from breaking down and giving Picasso the *frisson* of seeing her once again as his weeping woman.' To him it was entirely appropriate that his '*pleureuse*' should have become a weeping Magdalene.[22]

Picasso never ceased in his attempts to humiliate Dora. In 1958, when he gave Douglas Cooper permission to produce a fascimile edition of a 1906 sketchbook, Picasso suggested he also look at a Facteur Cheval sketchbook that was in Dora's possession (the Postman Cheval's Palais Idéal, a wonderfully outlandish construction in Hauterives, had been a favourite haunt of the Surrealists). Dora was initially reluctant to show Cooper and Richardson the notebook. When she did, tearfully and only at Picasso's insistence, it turned out to contain close-up drawings of her crotch.[23]

Dora Maar's mysticism, already apparent in her poems of 1947, was sometimes less a comfort than an articulation of her struggle against loneliness. These poems show no hesitations throughout their epic length, only serving as the records of her passionate past and desired calm before the cross. Let others lie and dominate and wield power; she, in her vulnerability, will survive in her virtue, shut away and forgiving of those morally feebler others:

> This sad hour is marked by a cross
> The impossible light turns upon the lost day
> This country is nothing to me but a bit of earth
>
> I am weakness
> that made me forget hope

She allowed fewer and fewer people into her life. One of those few was James Lord, who became her companion for several years in the early 1950s, mesmerized by her and, still more strongly, by her link to Picasso. They were extremely close, spending days together and nights under the same roof, each of them keeping their respective journals. They would even lie on the same bed, but nothing more intimate occurred. 'I am sorry,' said James. 'I am situated otherwise,' replied Dora, with dignity.[24] The situation was delicate, and both handled it delicately. They talked about every other subject imaginable. But Dora's pride could be overweening, her temper unpredictable. Their friendship came to an end soon after the dinner at the Château de Castille. What pushed it finally to breaking point was an exchange over the small bird of wood, wire and plaster made by Picasso in 1943 (p. 163). He had given this to Dora, and she in turn gave it to James. Then, after taking it back for safe-keeping in her apartment while they went away together for the summer, she refused to return it. 'Let's say that I'm keeping it as a guarantee of good conduct,' she told him.

This seems a detail, a foolish tug-of-war, but upon it hung a great deal. Both of these people were acutely attuned to the financial as well as the aesthetic value of art. Whatever motivated Dora to do and say such things, their intimacy was spoiled. On 22 November 1954 James wrote Dora a seven-page letter spelling out her failings: 'I have mentioned your pride. How alone you must feel, and I muse

sometimes with sadness upon the solitude you seem to want to build about yourself like a cage … what can you expect? – pride is a dish to be eaten alone.' He accused her of selfishness and avarice, and yet ended the letter by saying 'I want to be able to love you…. I want you quite simply to be my friend.' She did not answer Lord's extraordinary outpouring. Nor did she ever return the gift she had made. One should strive to be perfect, she had told Lord. But at a human level all was imperfect. 'One can pray,' said Dora. Or nothing.[25]

Dora Maar was a complex woman, in friendship as in love. She could also be uncooperative, as an exchange with Roland Penrose in 1956 indicates. He was organizing the exhibition 'Picasso Himself' at the Institute of Contemporary Arts in London in honour of Picasso's seventy-fifth birthday, and asked to borrow some of her photographs and drawings. She wrote to him including a handful of photographs, and expressed her regret at sending so few. She asked him not to reproduce those marked '*reproduction interdite*' because she wanted to make an album of them. Then she identified some of the places pictured, and said she would photograph the de Noailles' home that week. She included a meticulous list of what she had lent, and its value:

> 1) Picasso: Self-Portrait, original, 1904, insurance value 80,000 fr
> 2) Picasso: Max Jacob, drawing, original, 1915, value 1,000,000 fr
> 3) Picasso: Dora Maar, drawing, original, 1940, 500,000 fr
> 4) Picasso: Portrait of Apollinaire, 1939, pencil, 150,000 fr (crossed out)
> 5) Dora Maar: Portrait of Picasso, original, 1937, 5,000,000 fr
> All of this insured at 2,950,000 fr

Until the end of her life, Dora Maar read all the appropriate journals and auction catalogues in order to keep up-to-date with the market value of her collection.

Penrose wrote to thank her and ask to borrow the drawings for a little longer, since the editors of *L'Oeil* (Dora's friend Georges Bernier among them) wished to take the exhibition to a large gallery in Paris in spring, and the Arts Council of England wanted to show it outside London. 'Naturally, there will be a greater value to the show if you cooperate,' he wrote. 'I know it is a lot to ask, depriving you of your paintings for a long period, but I hope you will agree.'

'Alas, no,' she replied on 19 November. 'I have to ask you for my paintings back: that would be too long. I see from the catalogue that you were nice enough to send me and thank you, that you have many things, so I don't have any remorse and it won't get in the way of your exhibition: so as soon as it has closed in London, please send them back. For the Paris exhibition, we will see later.' She did not lend them again.[26]

A few years later, Penrose wrote to say that he had tried to telephone her many times, but had never found her. She was indeed hard to find, then and now. In what James Lord called her unmatched reticence, ambiguity and pride – that besetting and mortal sin for which she would punish herself her life long – she distrusted others and isolated herself.

For many years the former lovers maintained an unlikely exchange of gifts, whose meanings we can surmise. In 1954 Picasso sent Dora an elaborately packaged chair made of steel rods and coarse rope; it was both ungainly and uncomfortable. 'Isn't it the ugliest thing anybody ever saw!', Picasso later exclaimed to Lord.

Dora in return sent Picasso a rusty shovel blade, with which he was apparently rather impressed: 'Yes. Adorable Dora,' he said. 'She would have had to select something just right.'[27]

The London *Evening Standard* printed a letter from the journalist Sam White on 26 October 1956 describing how he had delivered a seventy-fifth birthday present to Picasso from Dora Maar:

> Mlle Maar is a Roman Catholic and the present she sent this gnarled old atheist was a devotional book by a Dominican priest.
> I had a moment of apprehension on delivering it, fearing that Picasso might receive it with a joking reference to her efforts at converting him. Not a bit of it. His eyes positively gleamed with pleasure as he handled this paper-backed book.
> UPROAR
> The next moment there was uproar. Picasso seemed to be in half a dozen different rooms at once as he shouted for his present companion Jacqueline Roque. 'Come at once, where are you? I have just had a present from Dora.'[28]

There was one more gift, never sent. While rummaging through Picasso's belongings in 1983, a doctor from Canada found a small parcel wrapped in tissue paper with 'pour Dora Maar' written on it. He wrote to her at the rue de Savoie many times to see when he could deliver this, but had no response. He tried to arrange a meeting through June Jones, but every time Dora refused. Finally, he unwrapped the parcel himself and found in it a small silver ring, 'resembling a flat signet ring with the engraved initials P-D [Pour Dora], but to my absolute amazement and horror, I found attached on the inside of the signet a large SPIKE! Thus it was absolutely impossible for anyone to wear it! I thanked my lucky stars for her refusing to accept this 'gift' from Picasso....'[29] Dora was saved by her instincts: perhaps being a recluse had its advantages after all.

After Picasso, Only God 1957–1997

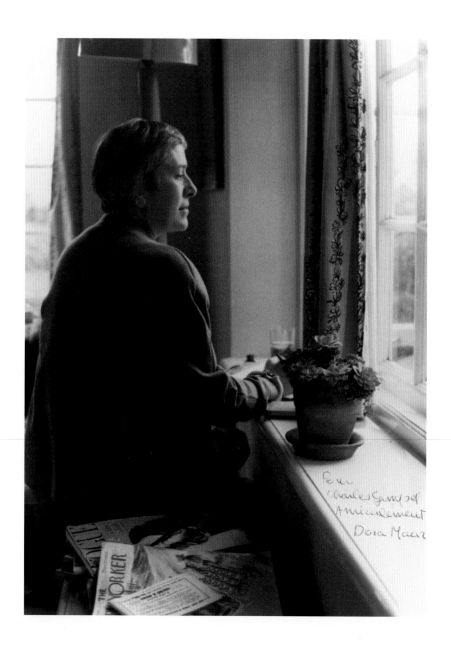

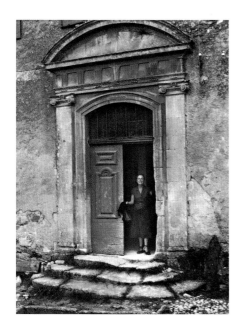

Vast space of ruins. Far off a tower
Tragic ugly stageset. Bitterness of days
foretold to us. Carnage and genocide
Reign of the Antichrists. The sordid music
Of bestiality incessant noise
Resounds night and day…
Praise in the heavens
Praise Praise to the Holy Table
Father Son and Holy Ghost true Trinity
DORA MAAR, OCTOBER 1970

By the late 1950s Dora was living between her Paris apartment on the rue de Savoie
and her house in Ménerbes, where she spent the summers. In Provence, she painted
still lifes and landscapes, and made some detailed drawings of the countryside, its
trees and lanes and vines, its houses and its hills. Her still lifes were as stark as the
Provençal landscape. She continued to concentrate on the pure object with the
simplest backdrop, as she had done in her early photography, under the mentorship
of Sougez and the influence of the New Photography. Now her focus was two-fold:
on her religious meditation and on her art. In the vast, bare rooms of her cold house
in Ménerbes she could concentrate fully on each object. There were no distractions.
Each bare detail took on something eternal for her:

> 5 November (1970?)
> Pure as a lake boredom
> I hear its harmony
> In the vast cold room
> The nuance of light seems eternal
> All is simple I admire
> the full totality of objects

She had always loved Provence. Some of her photographs of the 1930s had
captured perfectly the harshness of the raking light and the dry, often barren land-
scape of the hills (p. 23). This terrain was a fitting backdrop for her later life as a
recluse. Bernard Minoret points out the importance in all of Dora Maar's life and
work of her personal reserve and almost puritanical constraint, against which she
waged a constant struggle. He believes that even in Surrealism she had not sought
simply freedom but contradiction and its complexities. He describes her wooden
furniture, both in Paris and in Provence, as simple to the extreme – the kind that
sailors would use on a ship, or villagers in the provinces.

Opposite: Dora Maar in her home in
Ménerbes, in a portrait by Charles
Gimpel taken in the 1970s. Dora was
close to the Gimpel family in Ménerbes
before she became a recluse, and
Catherine Gimpel's children were
particularly fond of her. Kay Gimpel
recalled her 'stillness and serenity, which
were beautiful'. It caused them all great
pain when she shut herself off from the
world and her friends. Above: Dora in
the doorway of her house in the 1950s,
photographed by James Lord.

Dora Maar's landscapes of the desolate scrubland and hills around Ménerbes (pp. 202–3) were exhibited in 1957 at the Berggruen Gallery in Paris. Her old friend Douglas Cooper wrote the foreword to the exhibition catalogue. John Richardson describes these paintings as 'sad, romantic … slashed on with the palette knife.' John Russell wrote the foreword to another exhibition in the Leicester Galleries in London in 1958. He spoke of her 'modest and angelic landscapes' with their unpeopled expanse: 'they represent, beyond question, a solitary's view of the world.'[1]

Her acquaintances, in varying degrees of intimacy, remained loyal, and she remained well-connected. The phone book for Ménerbes in 1958 listed the painter Nicolas de Staël, a good friend of Dora's who owned the chateau on the top of the hill; John Rewald, the art historian; René Gimpel, the fabled collector and dealer; Raymond Mason, Dora's friend in Paris and Ménerbes; and Tony and Thérèse Mayer, to whom Dora remained close. These friends, and her continuing art work, provided some relief from her life of ascetic solitude. Her involvement with the Church also provided some human contact: from time to time over the years she opened her Ménerbes house to nuns for their work with unmarried mothers.

Another close friend, who lived in a range of hills not far off, was the poet André du Bouchet. Dora Maar illustrated his sparse and dense long poem *Sol de la montagne (Earth of the Mountain)*, which appeared in 1961. In those years she would get around the hills and villages of Provence by motorbike. She never learned to drive. James Lord had tried to teach her, but she could not concentrate sufficiently on the lessons. He thought that she was too set in her ways: 'Dora riding out on her motorbike to make watercolours in the countryside, I thought, looked rather ludicrous, her hair done up in a woollen scarf and with a sack slung over her shoulder, decidedly too old for that kind of conveyance. Even I would no longer have been willing to be seen whizzing around on a motorcycle.'[2] Dora was not immune to vanity, but it did not extend to her means of transport.

Arriving one day, she came upon du Bouchet's wife Tina Jolas holding their son, the tiny Gilles (now a painter). 'Ah,' said Dora, 'you are carrying a God there!'[3] Jolas was to leave du Bouchet for the Provençal poet René Char. Dora's affection for du Bouchet was great, and her understanding of his poems no less so. He can be counted among the most important French poets of his generation. The economy of his language, the rough-hewn illumination of his vision, and the typography of his texts, with all its silent spaces, make his poetry the perfect equivalent of her vision of this countryside – sensuous yet sparse, fragrant yet harsh.

Dora's four etchings in *Earth of the Mountain* are themselves sparse almost to the point of abstraction, and yet at the same time they are marvellously full and dark. They are meditations on the sweep and drama of the Provençal landscape: great swathes of black against the white of clouds, snow, emptiness. In one, the ascetic, seemingly snowswept mountainscape is relieved by the outline of a tree in the centre; in another, white clouds and crystals of frost burst against black, making an almost abstract composition. They possess majesty.

Du Bouchet's *Earth of the Mountain* starts with Dora's motorbike. The road is rough, the snow drifting across it. The wind cuts like a knife and blows the bike along: 'The air is colder than the road,' he exclaims. He has 'followed the day' as Dora traverses the lands, her bike approaching his house, and has felt, along with her, the airlessness of the mountains like a sort of nudity.

Opposite and overleaf: Two of the etchings contributed by Dora Maar to her friend André du Bouchet's poem *Earth of the Mountain*, published in 1961. He was living in the nearby Drôme region, an equally mountainous area. She would visit him on her motorbike with her paints in a bag slung over her shoulder. His poetry and her painting were equally transfused with the stark, unforgiving beauty of this area.

AFTER PICASSO, ONLY GOD

from EARTH OF THE MOUNTAIN
by André du Bouchet

The current forces on

risking oneself in daylight
as in the water
white and cold

harsh
for the cyclist

like a knife moved by a breath

the mountains scarcely leave the ground

when the road breaks
I change feet

it is covered with snow.

FRACTION

Far off is less distant than the ground, the biting
bed of air,
 where you stop, like a harrow
on the reddening earth.

I remain above the grass, in the blinding air.

The ground erupts ceaselessly towards us,
 without my moving off
 from the day.

 Nothing,
 today,
is trampled. I don't subsist in the naked air. On
this road growing.

Dora Maar's landscapes, executed in the late 1950s or 1960s, depict the harsh, desolate scrubland that was the backdrop to her life as a recluse. These works are lyrical, their colours delicate and their technique fluid, but her spiritual vision was ever more unforgiving and in their absence of human life they reflect the isolation that she imposed upon herself. Below: *Sky and Mountain* and *Large White Sky*. Opposite: *Landscape and Sky*, all undated.

In her final decades, Dora Maar's life became gradually more spartan, monastic and solitary. Guilt and judgment, which became drastic obsessions in her old age, haunt a long poem of 1970:

To the very shadows plains abyss of torture
To the dry lake. Hell flames flames flames
Victims and executioners God will judge our souls

But her chosen exile could sometimes be luminous and sure; around the following text, with its parenthetical additions, she drew a bouquet of flowers:

joy September in the year 1963. A (pale) yellow colour memory (as one is) spiritual (interior) to me. My sure secret in this exile. And now free to act through the voyage towards the country of blue this water my secret to my secret self.

1963 September. (Free to act.)

Through the voyage towards the country of blue I announce my love in this exile. My sure secret to my secret self.

She read extensively on the subject of religious meditation. She was sent some books by Jean Denoël of Editions Gallimard, whom she had met over lunch at the house of Marie-Laure de Noailles. She wrote to him in 1973 to say that she had read them with devotion. 'Certain spiritual reflections are of current interest,' she said, 'and these are among them.' With her usual exactitude, she pointed out a chronological error in one publication, which had said that Picasso went to visit Max Jacob at Saint-Benoît-sur-Loire in 1943; she informed Denoël that he could

202

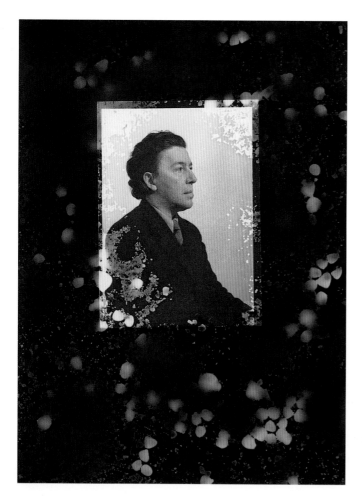

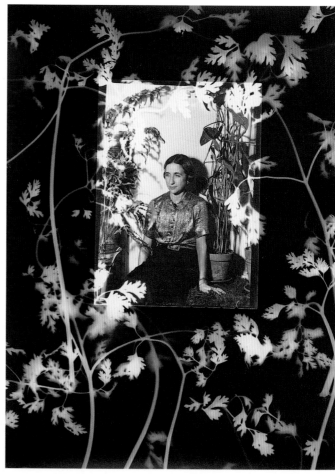

Dora Maar returned to her old craft of photography in the 1980s, when she was in her seventies. She resumed the photogram technique that she had practised in the 1930s, placing corn kernels over an old portrait of André Breton and sprigs of parsley over a portrait of Lise Deharme. She was fascinated by her Polaroid camera, and took many pictures with it, including one of her assistant Rose Toro Garcia. 'I was a famous photographer,' she told Rose proudly.

not have done, because it was wartime in 1943, and Picasso had no petrol (you had to have coupons), nor even a car. 'I don't remember,' she said, 'any trip after 1940.' Her memory of that epoch remained clear to the end.[4]

In the early 1970s she painted abstract compositions, one of which, a sort of radiant constellation of dots, she gave to James Lord. She also gave him a delicately drawn sketch of Ménerbes that he later gave to Raymond Mason. In 1989, the Californian art historian Herschel Chipp, who was writing a book on Picasso's *Guernica*, was stunned to come across some paintings by Dora Maar in the gallery of Marcel Fleiss, who had been given them to sell by Patrice Trigano. Chipp was about to meet with Dora Maar to discuss his project, and he told her that her paintings were on view. She immediately phoned Fleiss: 'This is Dora Maar. It seems you have some of my paintings. Impossible.' She instructed Fleiss to photograph the works and bring them to her at 3pm. He rang her bell at 2.30, then at 2.45, then at 3pm, at which point she answered. 'Young man, when I say 3 o'clock, I mean 3 o'clock, not 2.30, nor 2.45, but 3 o'clock.' He showed her the photographs: 'All fakes,' she declared. 'Fine,' says Fleiss, 'I will just tell Trigano.' Dora backed down: 'All right, bring me the paintings,' she told him. He returned with them, hovering in the doorway, hoping to be invited in. She looked at them back and front and once more repeated 'stolen'. Only when he said he was a friend of Man Ray did she relent and allow him into her apartment. There he saw plates piled high in the kitchen, thick layers of dust, and the famous insects that Picasso had made by

AFTER PICASSO, ONLY GOD

gouging out little legs in the plaster around protruding spots of paint near the fire-place. 'Everything people say about me is wrong,' she told him.

Fleiss become her dealer and in 1990 staged an exhibition of her paintings. She insisted on approving Edouard Jaguer's preface to the accompanying catalogue, and corrected facts and dates, though on the whole found it an accurate representation of herself as a person and a painter. As for the opening, she said, 'I warn you that I won't attend.' Nor did she, although many former friends waited in the hope of seeing her: the widow of the Surrealist Georges Hugnet, the writer Michel Leiris, and others.

After the exhibition, she telephoned Fleiss to say how wonderfully he had framed and exhibited her pictures. He responded by complimenting her photographs and offering to buy them. They spent six months arguing over the market value. Dora was adamant that her prints should be priced at the same level as those of Man Ray, Brassaï or Cartier-Bresson, and her paintings at the level of Victor Brauner and Max Ernst. Fleiss did eventually buy, but not quite at those prices.

Above all, she insisted, 'I don't want to hear anything about Picasso.' Even so, she could never enter a room unannounced, as Bernard Minoret put it. 'Her harsh and noble face, that lovely look, that warm, slightly nasal voice, the fact that she had been Picasso's mistress … she always brought this history with her.'[5] The relationship between artist and dealer was not to last. She phoned Fleiss about a photograph she saw in a catalogue to his 1991 exhibition 'After Duchamp'. 'I'm angry with you. You have exhibited something blasphemous.' The artist had photographed a crucifix next to *Fountain*, Duchamp's famous urinal. They never saw each other again.[6]

Interest in her photography and painting has remained steady. In 1995 there was a successful exhibition of her work in Valencia. This was the only major show devoted specifically to her work in her lifetime. The catalogue includes an important essay and biography by Victoria Combalía and an essay by Mary Daniel Hobson. On many occasions Dora Maar refused to allow her work to be included in books or catalogues. However, she did tell Victoria Combalía in an interview published in *Art Press* in 1993 that she had returned to her old craft of photography in the 1980s. 'I am making rayograms, with white shadows and a crucifix in the background. Also I am picking back up some old photographs I made, and working by superimposition.' No one but her trusted friend Rose Toro Garcia saw any of these works until after her death in 1997. She would take her old negatives and print them in a different format, and with different framing. Michèle Chomette describes this as a 'transformative play'. 'She was playing with what she had to hand. No camera at all.'[7] She scratched negatives, put sugar or salt on them, or superimposed arrangements of objects on portraits of Lise Deharme, René Crevel, Jacqueline Lamba and André Breton: parsley that looked like fern, a feather, corn kernels that might be exploding stars.

She continued to write down her poems in a hidden notebook that has only recently been recovered. She had kept them as 'this secret to my secret self…'. They show the same aloof pride that is visible in her work and thought throughout her life; the same distancing from her erstwhile public self that we have seen in her later years; the same acute sense of guilt and desire for forgiveness; the same courage and determination. And finally a sort of peace, in the seclusion of her rooms, and in meditation.

The Recluse

In the secret of myself to my secret self
living you have me live –
In this room I've lived out madness fear chagrin
the simple waking of a summer day
Exile is vast but it's summer, silence
in the sunlight a place of peace where the soul
invents only joy a child on the road to his home
DORA MAAR, 1970 OR AFTER

'She always asked about our family, and kept up with each one of them,' said all the people who helped Dora Maar in her large dim house in Ménerbes. Even in the last two years of her life, when she was bedridden and could no longer travel down from Paris, she would phone to inquire after them and their families. There was the man who drove her to Mass each day and brought her things, the gardener and his wife, her housekeeper.[1] Maxime Courtois, who knew her well, confirmed that Dora continued to paint up to the 'two last years of her life. I saw all her paintings, in all the rooms. I loved her greatly, and did many things for her.'[2] All of those in contact with her until the end are appreciative, admiring and rightly protective of her privacy. She was much respected, if from a distance.

Until 1984, she travelled first class by train from the Gare de Lyon in Paris down to Avignon, where she would be met and driven to her home in Ménerbes. Thereafter, she would take a taxi all the way from Paris, calling the driver up from Ménerbes. June Jones, a British neighbour whom Dora knew well and trusted, would see her off. Dora would keep the taxi driver waiting for up to two hours while she put on as many as five coats in the summer, which June would then help her take off again. Dora always packed her belongings into plastic bags rather than use the leather luggage stacked upstairs in her rue de Savoie apartment, labelled with all the places she had been. She still read in English; when I first visited her Ménerbes house I saw left behind a book by Oscar Wilde, side by side with the *Meditations* of Saint Bernard and various missionary tracts.

She always worried about money and in Ménerbes had a cleaning woman only once a week. Every day she was there she would go up to her studio and work. Her paintings were all around her. The last ones, ascetic and angular, had something of Bernard Buffet about them, and were often religious in theme.

Dora Maar was frequently domineering and angry. When she attended the meetings of the residents of 6 rue de Savoie, she often ended up screaming at the others. She lost her temper easily, and was dreaded by some; she was uncompromisingly proud from beginning to end.

> Accept the avoidable solitude
> as simple as transparency

The art historian and critic John Richardson was one of the few people to see Dora Maar until the end of her life. They had known each other as neighbours in the Vaucluse, and she was always fond of him. He believes she became a recluse not because she shied away from contact with people — she had many acquaintances with whom she would talk at length on the telephone — but out of vanity. Curved over painfully with arteriosclerosis, and not wishing to receive guests in her shabby dressing-gown, she would spend hours putting on one of her Chanel suits in anticipation of a visit. This same vanity led her to keep Picasso's earlier romanticizing portraits and sell the later, more familiar ones. Her anxieties about money eventually led to the deterioration of her apartment and studio. For the same reason she was unwilling to call out a doctor. 'What was it that you loved about Dora?' I asked John Richardson. 'Her intelligence,' he said. 'There was something magical about her.'[3]

They could talk about art together. She was, Richardson says, convinced of Picasso's supreme, even godlike nature, just like all the other women in his life, except Françoise Gilot. Dora had been ready and willing to sacrifice herself on the altar of his art. Her conversations with Richardson covered everything except religion — though occasionally they would turn to that topic, and she would insist that he go to confession. They visited together a monastery to which she was thinking of leaving her estate; two of the monks there had been her spiritual advisers. Her feelings towards the Church, according to Richardson, were nothing short of 'religious mania'. But there was one person with whom she could talk at length on the subject — her neighbour June Jones. They would have long discussions about the difference between Catholic dogma and tradition, or the role of women in the Church. Dora Maar was fond of the Chapel of the Virgin in the rue du Bac, and of the cathedral of Notre Dame. She refused to go with June to Saint-Severin because the lesson was sometimes read there by a woman. She greatly disapproved of that: women should not be opticians or rheumatologists or lawyers. Her politics had shifted dramatically since her youth. 'I was very left-wing when I was young,' she told Victoria Combalía, 'not like now.' She listened to Mass every day on the radio when she was too weak to go out, and read the missionary journal *La Croix* and devotional and learned books. She was also a passionate believer in the preservation of the French language. 'No one knows how to speak French any more,' she would lament, even the priests pronouncing Mass.

She was devout to the end. In Ménerbes, if the Mass was not being said in the local church, she would ask to be driven to nearby Notre-Dame-des-Lumières. During her last stay in Ménerbes she made line drawings of the murals and wooden supports that a cavalry officer, Pozhdoaev, had made for the small church on the property, where she sometimes worshipped. She kept these murals in her house, for their protection, and for her own devotion.[4]

By the 1980s, Dora Maar allowed very few people into her life. She continued to spend summers in Ménerbes (opposite) and winters in her apartment on the rue de Savoie in Paris. Despite crippling illness, she remained fiercely independent, resisting assistance, whether medical or domestic, and continuing to paint until she was in her late eighties.

Dora Maar's studio and paints in Ménerbes, photographed by Brice Toul after her death. During her lifetime her paintings lined the walls of her studio. When the capitals of the wooden columns had to be removed from the tiny church on the property, she brought them into the studio for safe keeping and sketched almost obsessively their baroque, flame-like curlicues.

In 1994, she fell in her Paris apartment and was unable to summon help. When eventually she was found, she was taken to hospital. She did return home, but remained bedridden for the last few years of her life. She still refused doctors. Berggruen, owner of the Berggruen Gallery where she had had an exhibition, sent his own doctor to care for her. Then Atmosphère, an organization that helps in such cases, sent one carer after another. Dora – or Madame Markovitch, as they knew her – would chase them away. One Polish lady ended up in hospital, said June Jones. Finally they sent Rose Toro Garcia, whom Dora took to straight away. Rose had studied art history and psychology, and they got along well. 'It's true that I liked Madame Markovitch and that she told me a great deal about her past,' Rose said, 'there was a closeness between us from the second year we knew each other.'[5]

Dora Maar covered her snow-white hair with a greyish-mauve wig, and preferred always to dress in grey. In her front hall a brass lamp hung over the red Provençal floortiles, but the walls inside were uniformly grey. She would have liked the facade of the building to be grey too, said Ariane Mercier, who lives with her husband, the musician Jacques Mercier, on the floor above.[6] She used a spyglass to see things in the distance and left rectangular magnifying glasses all around the room to help her see close to. She rigged up a series of strings around her room to pull over what she needed, and clattered two spoons against a saucepan to call Rose. In these last days, there also remained a great deal of affection between Dora and June, who would weather the storms of Dora's temper. When Dora occasionally screamed at her, she would say 'I don't have to take this' and start

THE RECLUSE

out of the room. Then Dora would ask anxiously: 'So you aren't my friend any more?' 'Of course,' June would reply.

Dora was, said June Jones, something of a snob, loving to hear about Roland Penrose, later knighted, and his sister. She read all the society magazines to see who was being talked about. Yet she never showed anyone but Rose her current paintings, drawings or reworked photographs. She also repeatedly turned down requests for photographs, interviews and visits. After one interviewer misrepresented her, she never gave another.

She read widely until the very end of her life. She retained her artist's eye and a vivid interest in many things, in spite of her reclusion; the shutters were closed, but not her mind. She would speak with the concierge in Spanish, with June in French, but wanted to read only in English. June brought her many books, and would share all sorts of reading and discussion with her, both worldly and religious. Dora Maar had always loved to discuss ideas for hours at a time – with James Lord, with Picasso, with Bataille all those years ago. She particularly took to perceptive travel writing such as Fanny Trollope's *Paris and the Parisians*, which she read and reread, and also her *Domestic Manners of the Americans*. Fascinated by the moral problems of Catholicism, she read the novels of Graham Greene, and she even loved to read Spanish books in their English translations, such as Gabriel Garcia Marquez's *Love in the Time of Cholera*.

She also read auction catalogues to see what prices Picasso's paintings were fetching, for these were what she lived on at the end. She kept many paintings, but sold others for large sums. Their value was increased by her ownership, as she well knew: 'and I'll tell you why. Because they're mine. On the walls of a gallery, maybe they're worth only half a million. On the walls of Picasso's mistress, they're worth a premium, the premium of history.'[7] So they hung in her apartment alongside family furniture, some Louis-Philippe chairs and a self-caricature by Picasso in the sitting room. She even kept, said the poet Yves Bonnefoy, the old gas heater that Picasso had decorated, instead of replacing it with one that might actually have kept her warm.[8]

The telephone was her connection to the outside world. After her faith and her reading, it was her main interest. On the phone she was lucid and full of laughter and did not have to be seen in her decrepit state. 'Come on over,' she would say vaguely to Raymond Mason, 'let's see each other.' But it was never convenient.[9] Though she never met them, she would talk for hours to Hélène Seckel Klein and Anne Baldassari of the Picasso Museum in Paris. Baldassari watched over her rights for five years and sent her information, until she and Seckel Klein finally decided that Dora was an old and tired lady, and stopped. When she was sent the text to the catalogue that would have accompanied an exhibition of her photographs at the Pompidou Centre in Paris, she found it erroneous and cancelled the entire show.

But she was not finished with drawing: she continued to sketch on bits of paper, which she would then put in her handbag at her side. She dismissed these as 'doodlings', but they mattered to her. Her pen was too thick, so Rose found her a special felt-tipped pen, which was perfect. One day they re-entered together her studio upstairs, which was always kept locked, the frail Dora leaning on Rose's arm. All the canvases piled everywhere made it hard to get through the doorway, but Dora was determined to see her old paintings again – to see her life once more. She signed pictures she hadn't signed and lamented over some that should have been redone, particularly one with a Crucifixion she thought needed retouching. She told Rose the story to each painting, and about the artists she knew and liked, particularly Giacometti. Rose even persuaded Dora to open the shutters for the first time in years.

> The soul that still yesterday wept is quiet – its exile suspended
> a country without art only nature
> Memory magnolia pure so far off
>
> I am blind
> and made from a bit of earth
> But your gaze never leaves me
> And your angel keeps me

Dora Maar died on 16 July 1997 at the age of eighty-nine. *Le Monde* announced the death ten days later. She was buried on 25 July alongside her parents and grandparents at Clamart in the Hauts-de-Seine. Rose Toro Garcia and June Jones went to the funeral, along with a few others: Gérard Régnier and Hélène Seckel Klein, Georges Bernier, her dealer Marcel Fleiss, and the concierge. Raymond Mason would have liked to go, but he was not informed.

She left a will, but the people named in it had predeceased her. There was no will leaving her assets to the Catholic Church, although she had talked of that. It was only after an extensive search that any relatives could be found, one in France and one in Croatia, neither aware of her existence. The bulk of her collection of paintings, drawings, sculptures and photographs was auctioned off amid a storm of publicity in a series of sales in late 1998. Ariane Mercier remembered the lights burning behind the closed blinds of Dora Maar's apartment until three in the morning after one of these sales. The rain that night was, she said, like 'the tears of Dora Maar'.[10]

An immense quantity of books – learned, religious and historical – were found after her death, wedged between the delicate Doric columns of her Paris studio. There were books on Michelangelo, Dürer, El Greco, Rubens and Velásquez; books on Cretan neolithic art and ancient Serbian art; voluminous dictionaries of Latin and French. High on the top shelf of a cupboard were the writings of Saint Augustine, the letters of Saint Jerome, the *Summa Theologica* of Saint Thomas Aquinas, Bourdaloue's sermons, the Acts of the Apostles in a rare sixteenth-century edition, and books on heresy and the Inquisition. A postcard attached to the glass door of a bookcase represented a naive scene in the life of Jesus.

A black and beige boxwood crucifix hung over her bed, with candlesticks on each side. Green satin curtains shaded the shutters and protected the delicate armchairs and the prewar wardrobe, with her paintings stacked alongside. Piled up atop the cabinets were all her leather suitcases with their tags recording her travels in the thirties: 'Starline Andalucia', 'Blue Star Line First Class to Boulogne.' All about her, Picasso's paintings kept watch. She had outlived him by twenty-four years. To the end of her life, she treasured all that she had preserved of him. The kitchen was precious because he had stepped inside, the chairs, because he had sat in them.

Her poems, kept in a medium-sized notebook from which a few pages are missing, end with a sketch headed:

Stage set for a tragedy

The stage was indeed set, and the drama enacted. But Dora Maar's recuperation through her painting, her photography, and her private poetic record of pain and something beyond it, is not a tragedy, but rather a courageous reclamation of her own life, even in – perhaps especially in – solitude.

> 'Desert'
> I have crossed the wave
> And now free to act
> Towards the summer within
> I hear
> this secret in being
> this secret to myself secret
> …
> The eye of boredom
> Of grass. And yet
> This day was a sapphire
> Here it is

Epilogue

Picasso's *Head of Dora Maar*, modelled in 1941 in his studio at 7 rue des Grands Augustins, stood until the late 1990s upon a plinth inscribed to Guillaume Apollinaire (1880–1918) in the tranquil Laurent Prache Square in Paris. There was no explanation of who she was (for clearly she was not Apollinaire), and more observant passers-by must have been puzzled. Only the plinth now remains; the head was carved off and stolen one night amid the publicity that followed Dora Maar's death.

There is a tragi-comic footnote to the love affair between Dora Maar and Picasso. In the little Laurent Prache Square beside the church of Saint-Germain-des-Prés, there stands a monument to the poet Guillaume Apollinaire. Passers-by must often have wondered whether Apollinaire looked quite like that, for the head mounted on his plinth until 1997 or 1998 was not his but that of Dora Maar, sculpted by Picasso in 1941. Picasso had a long friendship with Apollinaire and, faithful to his friends, joined many others every year to commemorate him as the poet of Saint-Germain-des-Prés after his sudden death in the flu epidemic at the end of the First World War. Picasso feared any thought of death, so when invited to construct a monument to the dead Apollinaire, he turned to the plaster head of the living Dora Maar and had it cast in bronze. A ceremony was conducted in the presence of Mme Apollinaire and a group of the poet's old friends, including André Salmon and Jean Cocteau. The piece became a sort of double memorial, to a great poet and a great love, both of them residents, present and past, of his neighbourhood.

There were at least two casts. When the bronzes returned from the foundry, Picasso urinated on one of them for several days in a row to give it a patina, just as Aristide Maillol 'watered' the large statues in his garden. This had the effect of turning the sculpture to what Dora called a 'hideous green'. Brassaï retrieved the unstained cast to be mounted as the monument, though the pigeons in the square made their own liquid offerings over the years. The sculpture has now disappeared, no doubt stolen say current residents, but the base remains. To Brassaï in November 1946 Picasso described the choice of Dora's head for the memorial as 'an accident', but given the public familiarity with the poet's features, the story reads as far from accidental. The gender-switch recalls the Surrealists' fascination with the plinth and its authority; the decapitation evokes a much older, Revolutionary tradition. The statue losing its head makes an evocative end to a tale that began with Dora's blood-stained gloves that Picasso had so wanted to possess and preserve.

Notes and Sources

Author, title, and date and place of publication are given when a source is first cited; subsequent references give author's surname and short title only.

p. 7 James Lord, *Picasso and Dora: A Personal Memoir* (New York, 1993) p. 123

Introduction: Not Just the Weeping Woman pp. 8–11

1. Lord, *Picasso and Dora* pp. 101–2
2. Raymond Mason in conversation with the author, October 1999
3. Françoise Gilot and Carlton Lake, *Life with Picasso* (New York, 1999) p. 340
4. Ariane Mercier in conversation with the author, October 1999
5. Michael Kimmelman, *New York Times*, and other newspaper sources
6. Lord, *Picasso and Dora* p. 60
7. Rose Toro Garcia, with whom the author shared several conversations between August and November 1999
8. Kimmelman, *New York Times*
9. John Richardson, *The Sorcerer's Apprentice: Picasso, Provence, and Douglas Cooper* (New York, 1999) p. 125
10. Souren Melikian, *Art and Auction*, 30 November 1998 (New York)
11. See the catalogue *Dora Maar Fotógrafa*, the exhibition that Victoria Combalía curated in Valencia, 1995, and also her interviews with Dora Maar published in *Kalias* VI no. 12 (1994) and *Artpress* no. 199 (February 1995)

Before It All 1907–1930 pp. 12–17

1. Lord, *Picasso and Dora* p. 120
2. My thanks to June Jones, Dora's closest friend at the end of her life
3. Gabriel P. Weisberg and Jane R. Becker eds, *Overcoming All Obstacles: The Women of the Académie Julian* (New Brunswick, N.J., 1999)

The Young Photographer 1930–1935 pp. 18–55

1. Brassaï (Gyula Halász) took his pseudonym from his birthplace in Transylvania, Brasso. See Brassaï's immensely readable *Conversations avec Picasso* (Paris, 1964), recently retranslated by Jane Marie Todd as *Conversations with Picasso* (Chicago, 1999), or the earlier English translation by Francis Price, *Picasso & Co.* (Garden City, 1966 and London, 1967)
2. Michel Frizot and Adam Biro eds, *Nouvelle Histoire de la Photographie* (Paris, 1994) p. 473
3. Frizot, *Nouvelle Histoire* p. 560. See also Emmanuel Sougez, *La Photographie: Son histoire* (Paris, 1968) and *La Photographie: Son univers* (Paris, 1969)
4. *Dora Maar Fotógrafa* (Valencia, 1995) p. 184
5. Brassaï, *Picasso & Co.* p. 43
6. Michael Kimmelman, *New York Times*
7. Lord, *Picasso and Dora* pp. 206–7
8. Not 1932, as stated by Victoria Combalía in *Dora Maar Fotógrafa*. My thanks to her for this information.
9. After the Liberation, opinion on *Le Corbeau* was radically split between those who accused Chavance and Clouzot of working too closely with Nazi propaganda and those – including Sartre, Prévert, de Beauvoir and René Clair – who supported them. About the expressionism, structure and lighting of this film, see Jean Mitry, *Histoire du cinéma* vol. V, ed. Jean-Pierre Delarge (Paris, 1968 and 1980) pp. 307–11. See also the wartime journal of Jean Cocteau, *Journal 1942–45* (Paris, 1989) p. 579
10. Mitry, *Histoire du cinéma* vol. IV p. 310
11. José Pierre, ed. *Tracts surréalistes et déclarations collectives* Vol. 1 (1922–1939) (Paris, 1980) pp. 262–63
12. Brassaï, *Picasso & Co.*, p. 103
13. Michel Surya, *Georges Bataille: La Mort à l'oeuvre* (Paris, 1992) p. 169. See also Georges Bataille, *The Absence of Myth* (London and New York, 1994) p. 10

14. Pierre, ed. *Tracts Surréalistes*, pp. 281–84
15. Michel Surya, *Georges Bataille: La Mort à l'oeuvre* (Paris, 1992) p. 270
16. Mitry, *Histoire du cinéma* vol. IV, pp. 478–80. See also 'Cinéma aujourd'hui: Jean Renoir' in *Le Spectacle, la vie* no. 2 (May 1975) p. 271
17. Georges Bataille, *The Story of the Eye*, tr. Joachim Neugroschel (San Francisco, 1987). See also 'The Pineal Eye', in *Georges Bataille, Visions of Excess*, ed. Alan Stoekl (Minneapolis, 1985)
18. Georges Bataille, *Documents* 4, September 1929
19. My thanks to Judith Young Mallin
20. *Encyclopedia Acephalica* pp. 62–64
21. Lydia Csató Gasman, the late Tina Jolas and others, in conversations with the author. See also Lydia Gasman, 'Mystery, Magic, and Love in Picasso, 1925–1938', unpublished PhD thesis, Columbia University, 1981
22. Lord, *Picasso and Dora* p. 101

Life Among the Surrealists 1935–1936 pp. 56–79

1. Marcel Jean's recollections of Dora Maar, for example, are quoted by Lea Vergine, *L'Autre moitié de l'avant-garde* (Paris, 1982) p. 290
2. Brassaï, *Conversations avec Picasso* p. 26
3. André Breton, *Manifestes du surréalisme* (Paris, 1962) p. 35
4. Yves Bonnefoy in conversation with the author, August 1999
5. Georges Hugnet, *Pleins et Délies* pp. 257–58, quoted in Mark Polizzotti, *Revolution of the Mind: The Life of André Breton* (New York, 1997) pp. 395–96
6. Whitney Chadwick, *Women Artists and the Surrealist Movement* (Boston and London, 1985) pp. 8–9
7. Chadwick, *Women Artists* p. 9
8. Indeed she was writing to him. His love affairs had much to do with his magnetic attraction, and they began suddenly: his friend Georges Hugnet's lover 'Miami' (Marcelle Ferry) fell suddenly into his arms on meeting him one night in late 1933; he then readdressed to her the famous poem 'Union libre' ('Free Union'), originally written to Suzanne Muzard; he later readdressed it once again, this time to Jacqueline Lamba.
9. André Breton, *Mad Love*, tr. Mary Ann Caws (Lincoln, Nebr., 1987) p. 6
10. Breton, *Manifestes du surréalisme* p. 289
11. This paper started as a speech called the '*Position politique du surréalisme*' ('Political Position of Surrealism'). It was given by Breton before the group '*Front Gauche*' ('Leftist Front') in Prague, on 1 April. Breton, *Manifestes du surréalisme* pp. 284–85
12. Combalía, *Artpress* no. 199 (February 1995) p. 56 and *Kalias* VI, no. 12 (1994) p. 14
13. André Breton, *The Lost Steps* tr. Mark Polizzotti (Lincoln, Nebr., 1996) pp. 28–29
14. Breton, *Manifestes du surréalisme* p. 22
15. In *Bachelors* (Cambridge, Mass., 1999) Rosalind Krauss discusses the '*informe*' and the theories of Georges Bataille. The '*informe*' blurs the neat structural opposition between definite terms: male versus female, hard versus soft, inside versus outside, life versus death, in a 'strategy of slippage' that dissolves distinctions. Mary Daniel Hobson in *Blind Insight: Three Routes to the Unconscious in the Photographs of Dora Maar* (unpublished M.A. thesis, University of New Mexico, 1996) also stresses the influence of Bataille's thought on Dora Maar's photography. Hobson points out the link between blindness and monstrosity as one of the dominant associations made by the human consciousness. All Maar's monsters are blind, she says, beginning with *Ubu*.

Love and War 1936–1937 pp. 80–131

1. Crespelle, *Picasso: Les femmes, les amis, l'oeuvre* (Paris, 1967) p. 146. Of course, the tale can be told more calmly. Roland Penrose, in *Picasso: His life and Work* 3rd ed. (Berkeley, Calif., 1981) p. 17, reports that Eluard

introduced Picasso to a young girl, a friend of his and of Georges Bataille, whose 'quick decisive speech and low-pitched voice were an immediate indication of character and intelligence.'

2. The incident in the café should also be put in the context of the artistic and literary gestures of this period and before. In de Chirico's *Enigma of Fatality*, a glove designates a move on a chess board as one would walk down a street full of mystery, while his *Love Song* shows another glove, this one red and empty. In his *Dream of the Poet*, a red glove hangs above the powerful head of Apollinaire. (His fascination itself is linked to the German tale '*Paraphrase über den Fund eines Handschuh*' of 1898.) The glove for de Chirico was one of 'the hermetic signs of a new melancholy'. Breton's *Nadja* of 1928 is haunted by a pale blue glove left behind by Lise Meyer (later married to Paul Deharme). Comparable incidents occur in André Gide's *Les Caves du Vatican* (1914) with its *'acte gratuit'*, the gesture that nothing motivates or explains, sufficient unto itself and without cause. In *Les Caves du Vatican* Lafcadio plunges his knife into his thigh. The young woman in the café of Jean-Paul Sartre's *L'Age de la raison* repeatedly stabs her hand (*Oeuvres romanesques*, vol. 1, Paris, 1981 p. 149). Simone de Beauvoir's *La Force de l'âge* (Paris, 1960) contains a scene of automutilation (pp. 266–67), similar to these other dramatic spectacles, after the scene has first appeared in her *L'Invitée* (Paris, 1943) p. 293: Olga burns her hand with a cigarette *'avec une patience manique...'* ('a manic patience...'). These scenes were composed during the period in which Sartre and de Beauvoir were writing in cafés. *L'Age de la raison* was written in the Café of the Trois Mousquetaires, on the avenue du Maine and the rue Cels, between 1938 and 1939.

3. Bernard Minoret in conversation with the author, 26 October 1999
4. Jean-Charles Gâteau, *Paul Eluard et ses amis peintres* (Paris, 1988) p. 232
5. Daix argues that Picasso taking flight doesn't fit with what we know of his character, *Picasso* p. 238
6. Lord, *Picasso and Dora* pp. 110–11
7. Olga, Picasso's wife, continued to live at Boisgeloup after their separation. Picasso moved to 23 rue la Boétie, and established Marie-Thérèse Walter and their daughter Maya in Tremblay-sur-Mauldre.
8. Richardson, *The Sorcerer's Apprentice* p. 125. Kazbek is described by James Lord as 'a sickly, silken wolfhound ... skeletal and frail' with a matted pelt (Lord, *Picasso and Dora* p. 46), and by Brassaï as 'that strange, always silent and apparently sad dog, [who] stretches his cadaverous frame and poses his delicate, interminable paws in front of him in an attitude resembling sculpture'. (Brassaï, *Picasso & Co.* p. 92]
9. Roland Penrose recalled the summer of 1936 in his *Scrap Book 1900–1981* (London, 1981) p. 80
10. '... Breton was generous in his admiration of the beings he found absolute, unshakable, intuitive geniuses. If ever, said Breton to Picasso, you find yourself alone, "I'd like to be on your path to greet you, and to put into this greeting all the emotion that I've never stopped feeling when I think of you: you know how much I admire you and how I dreamed, when I was young, of occupying a small place in your life." You are, he said later, "the great expert in human mystery ... one of the two or three beings who make life worth living."' Polizzotti, *Revolution of the Mind* p. 426
11. Breton rededicated this poem to several women in turn. Polizzotti, *Revolution of the Mind* p. 394
12. Brassaï, *Picasso and Co.* p. 45
13. Cocteau, *Journal 1942–45* p. 52
14. Cocteau, *Journal 1942–45* pp. 52 and 417
15. Cocteau, *Journal 1942–45* p. 52
16. According to John Richardson
17. For a discussion of Picasso's early collages, see Rosalind Krauss, *The Picasso Papers* (New York, 1997 and London, 1998) p. 25 ff.
18. Daix, *Picasso* p. 251
19. Penrose, *Picasso* p. 17
20. Daix, *Picasso* p. 250
21. Gilot and Lake, *Life with Picasso* p. 210
22. Brassaï, *Picasso & Co.* p. 26. Rosalind Krauss confirms this in *L'Amour Fou: Photography and Surrealism* (New York, 1985) p. 215
23. Daix, *Picasso* p. 358
24. From Gilot and Lake, *Life with Picasso*, quoted by Daix, *Picasso* p. 291
25. Bernard Minoret in conversation with the author, October 1999
26. Penrose, *Picasso* p. 310

Poetry in Provence 1937–1940 pp. 132–155

1. Don José was Picasso's teasing name for José-Luis Sert, the husband of Misia Sert, with whom he had a long flirtation.
2. My thanks, on this topic and others, to Lydia Csatò Gasman, who managed to track down Marie-Thérèse Walter, and to John Richardson. See also Daix, *Picasso* p. 358
3. My thanks to Judith Young Mallin for this information, some of which comes from her interviews with Eileen Agar in 1988, some from Eileen Agar's memoir written in collaboration with Andrew Lambirth, *A Look at my Life* (London, 1988)
4. Roland Penrose, unpublished interview with Dora Maar, Archives, Scottish National Gallery of Art, Edinburgh
5. Bataille quoted by Daix, *Picasso* p. 243
6. Cocteau, *Journal 1942–45* p. 110
7. Crespelle, *Picasso: Les femmes, les amis, l'oeuvre* p.160
8. Timothy Hilton, *Picasso* (London and New York, 1976) p. 249–53
9. Breton, who visited them in Royan off and on from January to July, read the poems early in the year

Occupation 1940–1944 pp. 156–175

1. Daix, *Picasso* p. 265
2. Letter from André Breton and Jacqueline Lamba to Dora Maar, dated 8 September 1940. Courtesy Aube Breton Elléouët. Document preserved in the Centre Historique of the Archives Nationales, Paris (515AP: no. 229)
3. Roland Penrose, unpublished interview with Dora Maar, Archives, Scottish National Gallery of Art, Edinburgh
4. Letter from Jacqueline Lamba to Dora Maar, dated 13 September 1941. Courtesy Aube Breton Elléouët. Document preserved in the Centre Historique of the Archives Nationales, Paris (515AP: no. 501)
5. Lise Deharme, *Les Années Perdues: Journal 1939–49* (Paris, 1961) p. 260
6. Judith Thurman, *Secrets of the Flesh: A Life of Colette* (New York and London, 1999) p. 449
7. Brassaï, *Picasso & Co.* p. 146
8. Cocteau, *Journal 1942–45* p. 57
9. Cocteau, *Journal 1942–45* p. 108
10. Cocteau, *Journal 1942–45* p. 598
11. Deharme, *Les Années Perdues* p. 77
12. Deharme, *Les Années Perdues* p. 84
13. Cocteau, *Journal 1942–45* p. 594
14. As Elizabeth Roudinesco recounts it in *Jacques Lacan: Esquisses d'une vie, histoire d'un système de pensée* (Paris, 1993) pp. 227–28
15. Picasso, *Ecrits* p. 424
16. Gilot and Lake, *Life with Picasso* p. 84
17. Quoted by Edouard Jaguer
18. Brassaï, *Picasso & Co.* p. 43
19. Brassaï, *Picasso & Co.* p. 205
20. Gilot and Lake, *Life with Picasso* p. 86
21. Letter from André Masson to Dora Maar, dated 14 July 1944. Document preserved in the Centre Historique of the Archives Nationales, Paris (515AP: no. 320)

Breakdown and Recovery 1944–1957 pp. 176–195

1. Lord, *Picasso and Dora*, pp. 3–31. The Dunhill lighter with a tiny portrait of Dora scratched into its cover by Picasso was auctioned in Paris on 7 December 1998 for $10,000
2. Deharme, *Les Années Perdues* 12 May 1945, p. 195
3. Deharme, *Les Années Perdues* 27 May 1945, p. 197
4. Deharme, *Les Années Perdues* 19 August 1959, p. 260
5. Crespelle, *Picasso: Les Femmes, les amis, l'oeuvre* p. 166
6. Brassaï, *Picasso & Co.* p. 211
7. Gilot and Lake, *Life with Picasso* p. 104
8. Gilot and Lake, *Life with Picasso* p. 106
9. Brassaï, *Picasso & Co.* p. 165
10. Gilot and Lake, *Life with Picasso* p. 303
11. Elizabeth Roudinesco in *Georges Bataille Après Tout*, ed. Denis Hollier (Paris, 1995) p. 205
12. Gilot and Lake, *Life with Picasso* p. 303
13. Raymond Mason, in interviews with the author August/November 1999
14. Lord, *Picasso and Dora*, p. 142
15. Letter to Dora Maar from Raymond Queneau. Document preserved in the Centre Historique of the Archives Nationales, Paris.

16. Lord, *Picasso and Dora* p. 183
17. James Lord in conversation with the author, Paris, October 1999
18. Lord, *Picasso and Dora* pp. 190–94 and Richardson, *The Sorcerer's Apprentice* pp. 208–12
19. Richardson, *The Sorcerer's Apprentice* p. 205
20. Richardson, *The Sorcerer's Apprentice* p. 206
21. Richardson, *The Sorcerer's Apprentice* p. 209
22. Richardson, *The Sorcerer's Apprentice* p. 209–10
23. Richardson, *The Sorcerer's Apprentice* pp. 217–19
24. James Lord in conversation with the author, Paris, October 1999
25. Lord, *Picasso and Dora* pp. 136–40, 150–51, 227–28, 273, 279–86
26. Unpublished correspondence with Roland Penrose, Archives, Scottish National Gallery of Art, Edinburgh
27. Lord, *Picasso and Dora* p. 181
28. *Evening Standard* 26 October 1956 p. 1 'Picasso, 75, gets a surprise present – a devotional book by a Dominican priest' by Sam White
29. Unpublished letter. Private collection

After Picasso, Only God 1957–1997 pp. 196–205

1. *Dora Maar: Paysages*, exhib. cat. (Paris, 1957). See also John Russell, *Dora Maar*, exhib. cat. (London, 1958)
2. Lord, *Picasso and Dora* pp. 172–73
3. The late Tina Jolas in conversation with the author, Vaison-la-Romaine, July 1999
4. Letter from Dora Maar to Jean Denoël, in the Bibliothèque Littéraire Jacques Doucet, Paris
5. Bernard Minoret in conversation with the author, October 1999
6. Marcel Fleiss in conversation with the author, Paris, October 1999
7. Michèle Chomette in conversation with the author at her gallery, 24 rue Beaubourg, Paris, 30 October 1999

The Recluse pp. 206–211

1. Alain Tallone in conversation with the author, 4 October 1999
2. Maxime Courtois in conversation with the author by telephone, 4 October 1999
3. John Richardson in conversation with the author, December 1999
4. Peter Montaignan in conversation with the author, London, October 1999
5. Rose Toro Garcia, letter to the author dated 12 November 1999
6. Ariane Mercier in conversation with the author, Paris, 29 October 1999
7. Lord, *Picasso and Dora* p. 117
8. Yves Bonnefoy in conversation with the author, Paris, October 1999
9. Raymond Mason in conversation with the author, Paris, July 1999
10. Ariane Mercier in conversation with the author, Paris, October 1999

Sources of French Poetry

Dora Maar's poems, never before published, were written in a notebook that is now in the Centre Historique des Archives Nationales in Paris (code 515/AP); all are © ADAGP, Paris and DACS, London 2000. Works by Pablo Picasso are from his *Ecrits* (Paris and New York, 1989), with the exception of three unpublished works in the collection of the Archives Picasso in Paris. All English translations are © Mary Ann Caws.

p. 9 Dora Maar, 23 May 1946
Oui. J'y crois. Mon destin est magnifique quoiqu'il en semble./Autrefois je disais mon destin est très dur quoiqu'il en semble.

p. 13 Dora Maar, after 1970
J'ai retrouvé le souvenir du jardin/Autour de la maison paisible/Ma mère et je l'aimais…/chants et larmes/Unique magnolia pur et si loin

p. 19 Pablo Picasso, 7.1.40, transcribed by Dora Maar
la plaque photographique tournant sur un axe à une plus grande vitesse trouve les images s'agitant autour d'elle et retrouvant fané déjà le bouquet des surprises non encore cueilli…
(*Ecrits*, p. 213 © Picasso Administration and Editions Gallimard, 1989)

p. 31 Dora Maar, 12 August (1932?)
Voici face à face nos destins/nous aimerons avec révérence

p. 46 Dora Maar, 4 May 1932
L'ombre de ta douceur ne peut se mesurer/Le temps surgit de la lumière

pp. 46–47 Dora Maar, *c.* 1932
que la patience et le silence/Me prennent les mains/que la jalousie/Laisse pendre ses superbes griffes/L'absence prépare ses aiguilles/Pour m'attendre au battement du jour/Elles m'éveillent/Le sang secoue ses ailes/Je parle

p. 47 Dora Maar, 8 mai 1932(?)
Je vois le paysage inaccessible/La lumière est répandue./Sa nuance paraît éternelle/et l'heure de mon tableau/marquera pour toujours l'après-midi/Mon bonheur est pareil au silence

p. 57 Pablo Picasso, 7 September 1936
…mais si la courbe qu'agite la chanson pendue au bout de l'hameçon s'enroule et mord au cœur le couteau qui la charme et la colore et le bouquet d'étoiles de mer crie sa détresse dans la coupe le coup de langue de son regard éveille la ratatouille tragique du ballet des mouches dans le rideau de flammes qui bout sur le bord de la fenêtre…
(*Ecrits*, p. 145 © Picasso Administration and Editions Gallimard, 1989)

p. 60 André Breton, from 'Tournesol'
La voyageuse qui traversa les Halles à la tombée de l'été/Marchait sur la pointe des pieds…/Les promesses de la nuit étaient enfin tenues
(André Breton, *Clair de terre*, Paris 1988, p. 187)

p. 81 Pablo Picasso, 7.1.40
…le jeu de balancier de la lumière l'éclairant soutient tout le poids de l'échafaudage de la sphère des couleurs broyées grossièrement sur le rideau transparent des sensations inaperçues à l'origine…
(*Ecrits*, p. 213 © Picasso Administration and Editions Gallimard, 1989)

p. 84 Pablo Picasso, 25.12.39
…bonsoir monsieur bonsoir madame et bonsoir les enfants petits et grands damassés et rayés en sucre et en guimauve vêtus de bleu de noir et de lilas mécaniques malodorants et froids…
(*Ecrits*, p. 211 © Picasso Administration and Editions Gallimard, 1989)

p. 96 André Breton, from 'Union Libre' 1931
Ma femme aux yeux d'eau pour boire en prison/Ma femme aux yeux de bois toujours sous la hache/Aux yeux de niveau d'eau de niveau d'air de terre et de feu
(André Breton, *Poèmes*, Paris 1948)

p. 96 Pablo Picasso, 1936
Ses grosses cuisses…/ses hanches…/ses fesses/ses bras/ses mollets/ses mains/ses yeux/ses joues/ses cheveux/son nez/sa gorge/ses larmes/les planètes les larges rideaux tirés et le ciel transparent caché derrière le grillage –/les lampes à l'huile et les grelots des canaris sucrées (*sic*) entre les figures –/le bol de lait des plumes, arrachées à chaque rire déshabillant le nu du poids des armes enlevées aux fleurs du potager –/tant de jeux morts pendus aux branches du préau de l'école irisée des chansons/lac leurré de sang et d'orties/rose trémière jouée aux dés/aiguilles d'ombre liquide et

bouquets d'algues de cristal ouverts aux pas de danse les mouvantes couleurs agités au fond du verre versé –/au masque lilas vêtu de pluie –
(Archives Picasso, Paris © Succession Picasso 2000)

p. 96 Pablo Picasso, 21 oct. 1936, 2 ½ du matin (transcribed by Dora Maar)
Narcisse se regardant dans le bouillon du pot au feu bouillonnant
(Archives Picasso, Paris © Succession Picasso 2000)

p. 110 Paul Eluard, 'Victoire de Guernica' 1937
1
Beau monde des masures
De la mine et des champs
2
Visages bons au feu visages bons au froid
Aux refus à la nuit aux injures aux coups
3
Visages bons à tout
Voici le vide qui vous fixe
Votre mort va servir d'exemple
4
La mort coeur renversé
5
Ils vous ont fait payer le pain
Le ciel la terre l'eau le sommeil
Et la misère
De votre vie
6
Ils disaient désirer la bonne intelligence
Ils rationnaient les forts jugeaient les fous
Faisaient l'aumône partageaient un sou en deux
Ils saluaient les cadavres
Ils s'accablaient de politesses
7
Ils persévèrent ils exagèrent ils ne sont pas de notre monde
8
Les femmes les enfants ont le même trésor
De feuilles vertes de printemps et de lait pur
Et de durée
Dans leurs yeux purs
9
Les femmes les enfants ont le même trésor
Dans les yeux
Les hommes le défendent comme ils peuvent
10
Les femmes les enfants ont les mêmes roses rouges
Dans les yeux
Chacun montre son sang
11
La peur et le courage de vivre et de mourir
La mort si difficile et si facile
12
Hommes pour qui ce trésor fut chanté
Hommes pour qui ce trésor fut gâché
13
Hommes réels pour qui le désespoir
Alimente le feu dévorant de l'espoir
Ouvrons ensemble le dernier bourgeon de l'avenir
14
Parias la mort la terre et la hideur
De nos ennemis ont la couleur
Monotone de notre nuit
Nous en aurons raison.
(From Paul Eluard, *Cours naturel* © Gallimard 1968)

p. 113 Pablo Picasso, [juin] 1937
à l'intérieur du coeur on pave les rues du village et le sable qui coule des sabliers blessés au front en tombant des fenêtres sert à sécher le sang qui jaillit des yeux étonnés qui regardent par les trous des serrures...

un intérieur brillamment illuminé pavé de neuf ruisselant de sang...

la lumière pavant de son sang les sabliers du trou de serrure de ses yeux efface de ses plumes l'odeur du pain trempant dans l'urine...
(*Ecrits*, p. 168 © Picasso Administration and Editions Gallimard, 1989)

p. 120 From Paul Eluard, 'Identités' dedicated to Dora Maar
Je vois les champs la mer couverts d'un jour égal/Il n'y a pas de différences Entre le sable qui sommeille/La hache au bord de la blessure/Le corps en gerbe déployée/Et le volcan de la santé/.../Je vois je lis j'oublie/Le livre ouvert de mes volets fermés.
(From Paul Eluard, *Cours naturel* © Gallimard 1968)

p. 133 Pablo Picasso, 7.1.40
des souvenirs déjà classés et ne laissant aucun doute sur leur identité pressée de tous côtés en feu de joie le jeu de balancier de la lumière éclairant soutient tout le poids de l'échafaudage de la sphère des couleurs broyées grossièrement sur le rideau transparent des sensations inaperçues à l'origine
(*Ecrits*, p. 213 © Picasso Administration and Editions Gallimard, 1989)

p. 144 Pablo Picasso, 'Mougins Vaste Horizon, le 12 septembre 37'
au bout de la jetée promenade/derrière le casino le monsieur/si correctement habillé si gentiment/déculotté mangeant son/cornet de frites d'étrons/crache gracieusement/les noyaux des/olives à la gueule/de la mer
(*Ecrits*, p. 179 © Picasso Administration and Editions Gallimard, 1989)

p. 144 Dora Maar, 1937
La petite, les mains serrées sur une croûte volée songe aux fissures de la nuit pleurs de sel et d'excréments d'oiseaux. Lorsqu'une lie de roses tachera ses draperies déchirées, traînant les pieds battant des ailes mêlant les soupirs furtifs des malhabiles aux cris savants des muets reviendra l'escroc exécuter ses farces journalières

p. 150 Pablo Picasso, 5.1.40
une figure jolie même celle de la femme aimée n'est qu'un jeu de patience le symptôme de la préfiguration de l'amas de fils emmêlés d'un système à établir coûte que coûte sur des plans perspectifs tirés par les cheveux du parfum si délicieux soit-il du tas de merde que les couleurs des projecteurs font s'épanouir en vase clos à la température du rose qu'il faut dessiner avec des cendres glacées de ses angles et ses courbes...
(*Ecrits*, p. 212–13 © Picasso Administration and Editions Gallimard, 1989)

p. 150 Pablo Picasso, 6.1.40
symptôme ... si emmêlés réseau des fils colorés d'une frequence plus ou moins accélérée sur métronome du + ou − chaleur sensationnelle allant du bien-être à douleur font aux formes des cristaux surnageant prendre dans une vue d'ensemble du tableau la direction voulue...l'angle la courbe nécessaire au jeu gagné d'avance sur le tableau prédit par tous les oracles déjà marqués au feu rouge au point voulu de la carte...
(*Ecrits*, p. 213 © Picasso Administration and Editions Gallimard, 1989)

p. 150 Pablo Picasso, 28.12.39
suinte du tambourin goutte à goutte le miel de la joue en feu de la maison qui claque sur le drap noir qui déploie l'aigle...
(*Ecrits*, p. 212 © Picasso Administration and Editions Gallimard, 1989)

p. 157 Pablo Picasso, 13 May 1941
Chasuble de sang jetée sur les épaules nues du blé vert frissonnant entre les draps mouillés de l'orchestre symphonique des chairs déchiquetées pendues aux arbres en fleurs du mur peint d'ocre agitant ses grandes ailes vert pomme et blanc mauve se déchirant le bec contre les vitres architectures du suif...
(*Ecrits*, p. 284 © Picasso Administration and Editions Gallimard, 1989)

p. 160 Pablo Picasso, May 1941
...la langue pendante de la charrue collée aux labours suant le plomb du poids de l'effort commis au centre du bouquet tordu par les chaînes des dents des fleurs ... la robe et ses plis cassés, ses déchirures, l'usure de l'étoffe couverte de taches les mille et un accrocs sa saleté, la vermine ... les grands cierges allumés des grosses barques couchées au bord du puits écoutent le parfum de la pluie qui souffle dans la flûte les doigts des olives vertes
(*Ecrits*, p. 284–87 © Picasso Administration and Editions Gallimard, 1989)

p. 160 Pablo Picasso, 'Le Repas' 2 February (1941?)
le drap se lève du lit et immédiatement ses roues en riant à gorge déployée déchirent en lambeaux la peau du bouquet ... le fil tendu à lui faire pousser des hurlements sur la bouche édentée de la fenêtre et de la fenêtre fuit un soldat très céremonieux et bien étrange
1er plat
on apporte les larmes en tas de sable et on les fait craquer entre les dents par des hommes et des femmes choisis parmi les plus beaux
(Archives Picasso, Paris © Succession Picasso 2000)

p. 162 Dora Maar, 1 février 1942
Aujourd'hui c'est un autre paysage dans ce Dimanche de la fin/du mois de mars 1942 à Paris le silence est/si grand que les chants des oiseaux domestiques sont comme des petites flammes bien visibles. Je suis desespérée

Mais laissons tout cela

p. 177 Dora Maar, 23 mai 1946
Je marche seule dans un vaste paysage/Il fait beau – Mais il n'y a pas de soleil. Il n'y a pas d'heure./Depuis longtemps plus un ami plus un passant. Je marche seule. Je parle seule.

p. 177 Dora Maar, c. 1942–43 (marked '20 mars 1947 fausse date')
J'ai reposé entre les bras de mes bras/Je ne dormais plus/C'était la nuit l'été l'hiver le jour/Un grelottement éternel de pensées/Peur amour Peur amour/Ferme la fenêtre ouvre la fenêtre

p. 177 Dora Maar, c. 1942–43 (marked '20 mars 1947 fausse date')
Des conseils absurdes/Une satisfaction comme un rêve/l'épouvante/Et la fatigue/Un grand courage moqué

p. 178 Dora Maar, c. 1942–43 (marked '20 mars 1947 fausse date')
Au miroir de face je j'interroge/Pour la nuit à venir/Que l'heure passe/Que je m'éloigne/Que le miroir soit vide/Pour toujours

p. 185 Paul Eluard, from 'Le Temps déborde'
Morte visible Nusch invisible et plus dure
Que la soif et la faim à mon corps épuisé
Masque de neige sur la terre et sous la terre
Source des larmes dans la nuit masque d'aveugle
Mon passé se dissout je fais place au silence.

Nous ne vieillirons pas ensemble
 Voici le jour
 En trop: le temps déborde.
(Didier Desroches [pseud. of Paul Eluard], from *Le Temps déborde* © Editions Laffont, Paris, 1947)

p. 190 Dora Maar, 7 May 1947
C'est une poignée de terre sur la terre/…/Cherchant dans la noire forêt/Parmi les racines et les écorces

p. 192 Dora Maar, 1947
Cette heure triste est marquée d'une croix/La lumière impossible tourne sur la journée perdue/Ce pays ne m'est rien qu'un peu de terre./Je suis faiblesse/qui m'a fait oublier l'espérance

p. 197 Dora Maar, October 1970
Vaste espace de ruines. Au lointain une tour/Décor tragique et laid. Amertumes des jours/qui nous furent prédits. Carnage et génocide/Règne des Antechrist. La musique sordide/De la bestialité le signal incessant/Retentit nuit et jour…/Louange Louange à la Sainte Table Père Fils et Saint Esprit Trinité véritable.

p. 197 Dora Maar, 5 November (1970?)
comme un lac pur l'ennui/j'entends son harmonie/Dans la chambre vaste et froide/La nuance de la lumière semble eternelle/Tout est simple et j'admire la/fatalité totale des objets

p. 201 André du Bouchet, 'Sol de la montagne'
Le courant force

se risquer dans le jour
comme dans l'eau
froide et blanche

dure
pour le motocycliste

comme un couteau déplacé par le souffle

les montagnes sortent à peine de terre

quand la route casse
je change de pied

elle est couverte de neige.

p. 201 André du Bouchet, 'Fraction'
Le lointain est moins distant que le sol, le lit mordant de l'air,
 où tu t'arrêtes, comme une
herse, sur la terre rougeoyante.

Je reste au-dessus de l'herbe, dans l'air aveuglant.

Le sol fait sans cesse irruption vers nous,
 sans que je m'éloigne
 du jour.
 Rien,
 aujourd'hui,
n'est foulé. Je ne subsiste pas dans l'air nu. Sur cette route qui grandit.
(both poems from *Dans la Chaleur vacante* by André du Bouchet © Mercure de France, 1962)

p. 202 Dora Maar, 1970
Aux ténèbres aux plans au supplice abyssal/Jusqu'au lac sec. Enfer flammes flammes flammes/Victimes et bourreaux Dieu jugera nos âmes

p. 202 Dora Maar, September 1963
de la joie septembre de l'an 1963. Une couleur jaune (pâle) souvenir (comme l'on) m'est (intérieur) spirituel. Mon secret stable dans cet exil. Et maintenant libre d'agir par le voyage vers la patrie d'azur cette eau mon secret à moi-même secrète.
 1963 septembre. (Libre d'agir.)
 Par le voyage vers la patrie d'azur j'annonce mon amour dans cet exil. Mon secret stable à moi-même secret.

p. 206 Dora Maar, 1970 or after
Dans le secret de moi-même à moi-même secret/vivant tu me fais vivre –/ Dans cette chambre ou j'ai vécu la folie la peur et le chagrin/c'est l'éveil simple un jour d'été/L'exil est vaste mais c'est l'été, le silence en plein/soleil une enclave de paix ou l'âme n'invente que/le bonheur un enfant sur la route de sa maison

p. 207 Dora Maar, 26 December 1943 (date scored out and replaced with 1934)
Accepte l'évitable solitude/simple comme la transparence

p. 210 Dora Maar, 1970 or after
L'âme qui hier encore pleurait se tait – l'exil suspendu/un pays sans art où seule est la nature/Souvenir magnolia pur et si loin

Je suis aveugle/et faite d'un peu de terre/Mais ton regard ne me quitte jamais/Et ton ange me garde

p. 211 Dora Maar, 'Desert', 1970 or after
J'ai dépassé la vague/Et maintenant libre d'agir/Vers l'été intérieur/J'entends/ce secret dans l'être/ce secret à moi-même secret/…/L'oeil de l'ennui/De l'herbe. Et pourtant/Cette journée fut un saphir/Le voici

Short Bibliography

Dore Ashton, ed. *Picasso on Art: A Selection of Views* (New York, 1972)

Roland Barthes, *Camera Lucida*, tr. Richard Howard (New York, 1981)

Georges Bataille, *Eroticism: Death and Sensuality*, tr. May Dalwood (San Francisco, 1986)

Georges Bataille [Lord Auch], *Story of the Eye*, tr. Joachim Neugroschel (San Francisco, 1987)

Germain Bazin, *Le Mont St.-Michel: Histoire et archéologie de l'origine à nos jours* (New York, 1933)

Brassaï, *Conversations with Picasso*, tr. Jane Marie Todd (Chicago, 1999)

André Breton, *Mad Love*, tr. Mary Ann Caws (Lincoln, Nebr., 1987)

André Breton, *Manifestoes of Surrealism*, tr. Richard Seaver and Helen R. Lane (Ann Arbor, Mich., 1972)

André Breton, 'Picasso Poète' in *Cahiers d'Art* no. 10, 1935, pp. 185–91

André Breton, *Poems of André Breton*, tr. and ed. Jean-Pierre Cauvin and Mary Ann Caws (Austin, Tex., 1982)

Mary Ann Caws, *The Surrealist Look: An Erotics of Encounter* (Cambridge, Mass., 1997)

Mary Ann Caws, ed. *The Surrealist Painters and Poets* (Cambridge, Mass., 2000)

Whitney Chadwick, *Women Artists and the Surrealist Movement* (Boston and London, 1985)

Jean Cocteau, *Journal 1942–45* (Paris, 1989)

Victoria Combalía, 'Conversaçion con Dora Maar', *Kalias* VI, no. 12 (1994); 'Dora Maar, Photographe', *Artpress* no. 199 (February 1995)

Jean-Paul Crespelle, *Picasso and his Women*, tr. Robert Baldick, New York 1969

Pierre Daix, *Picasso: Life and Art*, tr. Olivia Emmet (London, 1993 and New York, 1994)

Ginger Danto, 'Dora Maar: Galerie 1900' *Art News*, LXXXIX, November 1990, pp. 183–85

Lise Deharme, *Les années perdues: Journal 1939–49* (Paris, 1961)

Dora Maar: Paysages, exhib. cat., foreword by Douglas Cooper, Berggruen Gallery (Paris, 1957)

Dora Maar, exhib. cat., foreword by John Russell, Leicester Galleries (London, 1958)

Dora Maar: Oeuvres anciennes, exhib. cat., text by Edouard Jaguer, Galerie 1900–2000 (Paris, 1990)

Dora Maar: Fotógrafa, exhib. cat., text by Victoria Combalía and Mary Daniel Hobson, Centre Cultural Bancaixa (Barcelona, 1995)

Judi Freeman, *Picasso and the Weeping Women: The Years of Marie-Thérèse Walter and Dora Maar*, exhib. cat. (New York, 1994)

Michel Frizot and Adam Biro eds, *New History of Photography* (Cologne, Germany, 1998)

Françoise Gilot and Carlton Lake, *Life with Picasso* (New York, 1964 and Harmondsworth, 1966)

Timothy Hilton, *Picasso* (London, 1975 and New York, 1999)

Mary Daniel Hobson, *Blind Insight: Three Routes to the Unconscious in the Photographs of Dora Maar* (unpublished M.A. thesis, University of New Mexico, 1996)

Rosalind Krauss and Jane Livingston, *L'Amour Fou: Photography and Surrealism* (New York, 1985)

Rosalind Krauss, *Bachelors* (Cambridge, Mass., 1999)

Julie l'Enfant, 'Dora Maar and the art of mystery', *Woman's Art Journal* xviii, 1956–57 (Laverock, Pa.), pp. 15–20

James Lord, *Picasso and Dora: A Personal Memoir* (New York and London, 1993)

Marilyn McCully, ed. *A Picasso Anthology: Documents, Criticism, Reminiscences* (Princeton N.J., 1981)

Juliet Mitchell and Jacqueline Rose eds, *Feminine Sexuality: Jacques Lacan and the Ecole Freudienne*, tr. Jacqueline Rose (London, 1982)

Jean Mitry, *Histoire du cinéma: art et industrie* Vol. V 1930–1940, ed. Jean-Pierre Delarge (Paris, 1968 and 1980)

Steven Nash, ed., *Picasso and the War Years 1937–1945* exhib. cat. (New York and London, 1998)

October 36: Georges Bataille, Spring 1986 (Cambridge, Mass.)

Roland Penrose, *Picasso: His Life and Work* (Berkeley, 1958 and Paris, 1982)

Pablo Picasso, *Collected Writings*, ed. Marie-Laure Bernadac and Christine Piot, tr. Carol Volk and Albert Bensoussan (New York, 1989)

Pablo Picasso, *Ecrits* (Paris, 1989)

John Richardson, *The Sorcerer's Apprentice: Picasso, Provence, and Douglas Cooper* (New York, 1999 and London, 1999)

John Richardson, *A Life of Picasso* Vol. II, with the collaboration of Marilyn McCully (New York and London, 1996)

Naomi Rosenblum, *World History of Photography* (New York, 1969)

William Rubin, ed. *Picasso and Portraiture: Representation and Transformation* (New York and London, 1996)

Michel Surya, *Georges Bataille: La Mort à l'oeuvre* (Paris, 1992)

David Thomson, *A Biographical Dictionary of Film* 3rd ed. (New York, 1954)

Anthony Vidler, *The Architectural Uncanny: Essays in the Modern Unhomely* (Cambridge, Mass., 1992)

Acknowledgments

In preparing this book, I have been fortunate to have the help of many. My grateful thanks to the poet Yves Bonnefoy; to my departed and dear friend Tina Jolas; to André du Bouchet and to Sarah Plimpton and Robert Paxton for their encouragement; to Nasser and Isabelle Assar, Philippe Bernier, Monique Chefdor, Marie-Claire and Maurice Dumas, Etienne-Alain and Nicole Hubert, Elizabeth Lennard, and Judy Pillsbury in Paris; to Simon Baker, Catherine Gimpel, Kay Gimpel, Peter Montaignan and Rosemary Gordon in London; to Ann Aslan and Clive Blackmore, Vera and Don Murray, and Janet and Malcolm Swan in the Vaucluse; to Joe Downing in Ménerbes; to Ersi Breunig, Michèle Cone, Jeanine Parisier Plottel, Judith Young Mallin and Renate Ponsold Motherwell in New York. My intense gratitude to Victoria Combalía, whose initial biography and interviews were essential.

Particular thanks to Nancy Negley in Ménerbes, for her help and hospitality, without which this project would not have gone anywhere at all, least of all to where it mattered; to Psiche and Philip Hughes, there from the beginning, by some marvellous chance, and to Carolyn Gill, at the origin of that chance; to the artist Raymond Mason, for his gallant and informative accompaniment around Dora Maar's haunts in the 6th arrondissement, and for his memories of their friendship; to June Jones in Paris, for her warm welcome and generous conversations about the last part of Dora Maar's life; to Marcel Fleiss of the Galerie 1900–2000 for his informative discussion as Dora Maar's friend and dealer, and to his great generosity in making so many invaluable documents available; to Rose Toro Garcia for her patience in answering my questions; to Michèle Chomette for information on Dora Maar's last photographic work; to James Lord for his informative discussion with me in Paris and for Dora Maar's portrait of him, published here for the first time; to the genial Bernard Minoret for sharing his knowledge, his library, and his remembrances of Dora Maar; to Ariane and Jacques Mercier, for their spontaneous welcome just on the eve of their departure; to the Picasso expert John Richardson, for his helpful conversations with me in New York, right up until the last moment, and for his suggestion that I contact Lydia Csatò Gasman in Charlottesville, whose own work has been crucial; to Aube Breton Elléouët; and to Maxime Courtois and M. and Mme Alain Tallone for their kindness to a stranger.

My thanks to my longtime friends Peter Warner and Nikos Stangos of Thames and Hudson, to Thomas Neurath and Patrick Mauriès for entrusting me with this project, and to my editor Amanda Vinnicombe for her great patience and transformative energy; to Hélène Seckel Klein, Anne Baldassari and Sylvie Fresnault of the Archives Picasso; to Christine Nougaret and Henri Zouber of the Archives Nationales; to Yves Peyré of the Bibliothèque Littéraire Jacques Doucet; to Vincent Giroud at the Beinecke Library, Yale University; to Nicole Boyer of Mercure de France; to Anne Solange Noble and Florence Giry of Editions Gallimard; to the Fondation Picasso and to Claude Picasso; to my agents Gloria Loomis and Katherine Cussett in New York and Stella Wilkins in London; to my cousin Deborah Gage for her suggestion that I contact Antony Penrose, whose help was indispensable, as was that of Ann Simpson, Curator of the Archive and Library of the Scottish National Gallery of Modern Art. In New York, my thanks to the curators of the archives in the Museum of Modern Art and of the Print Room of the New York Public Library. Finally, my gratitude to my children, friends and students, for their indulgence of my impassioned involvement with Dora Maar's work and life.

List of Illustrations

Museum of Modern Art, New York. D. and J. de Menil Fund. Photograph © 2000 The Museum of Modern Art

p. 55: Dora Maar, *Forbidden Games*, 1935. Gelatin silver print (photomontage) 25.9 x 21.3 cm (10⅛ x 8⅜ in). © ADAGP, Paris and DACS, London 2000

p. 56: Pablo Picasso, *Dora Maar with Green Fingernails*, 1936. Oil on canvas, 65 x 54 cm (26 x 21 in). © Succession Picasso/DACS, London 2000

p. 57: Pablo Picasso, *Portrait of Dora Maar*, 1936 or 1937. Gelatin silver print 24 x 18.2 cm (9½ x 7⅛ in). © Succession Picasso/DACS, London 2000. Musée Picasso, Paris, Picasso Archives. Photo © RMN – Picasso

p. 58: Dora Maar, *Jacqueline Lamba Leaning out of a Window Surrounded by Foliage*, c. 1935. Gelatin silver print 38.2 x 29.8 cm (15 x 11¾ in). © ADAGP, Paris and DACS, London 2000

p. 60: Dora Maar, *Surrealist Action at the Gradiva Gallery, 35 rue de Seine*, c. 1935. Gelatin silver print 20 x 19.7 cm (7⅞ x 7¾ in). © ADAGP, Paris and DACS, London 2000

p. 61: Dora Maar, *The Studio of Alberto Giacometti ('The Invisible Object')*, c. 1936. Gelatin silver print 21.5 x 16 cm (33⅜ x 6¼ in). © ADAGP, Paris and DACS, London 2000. Private collection

p. 62: Title page of *Facile* by Paul Eluard (Paris, 1935), with frontispiece by Man Ray. © Man Ray Trust/ADAGP, Paris and DACS, London 2000

p. 63 left: Dora Maar, *Portrait of Nusch Eluard*, c. 1935. Gelatin silver print 24 x 17.8 cm (9⅝ x 7 in). © ADAGP, Paris and DACS, London 2000

p. 63 right: Man Ray, *Paul Eluard Kissing the Forehead of Nusch*, 1936 or 1937. Sepia-toned gelatin silver print 23 x 17.8 (9 x 7 in). © Man Ray Trust/ADAGP, Paris and DACS, London 2000

p. 64: Dora Maar, *Portrait of Nusch Eluard*, 1935. Gelatin silver print 27 x 19.2 cm (10⅝ x 7½ in). © ADAGP, Paris and DACS, London 2000

p. 65: Dora Maar, *The Years Lie in Wait for You*, c. 1932–34. Gelatin silver print 36.8 x 25.3 cm (14½ x 10 in). © ADAGP, Paris and DACS, London 2000. Lucien Treillard Collection, Paris

p. 66 left: Dora Maar, *Portrait of Georges Hugnet*, c. 1936. Gelatin silver print 24 x 18.2 cm (9½ x 7⅛ in). © ADAGP, Paris and DACS, London 2000

p. 66 right: Dora Maar, *Portrait of Yves Tanguy*, 1930s. Gelatin silver print 24.3 x 17.8 cm (9½ x 7 in). © ADAGP, Paris and DACS, London 2000

p. 67 left: Dora Maar, *Portrait of Jean-Louis Barrault*, 1936–37. Gelatin silver print 24.5 x 18 cm (9⅝ x 7⅛ in). © ADAGP, Paris and DACS, London 2000

p. 67 right: Dora Maar, *Portrait of René Crevel*, 1930s. Gelatin silver print 29 x 22.7 cm (11⅜ x 8⅞ in). © ADAGP, Paris and DACS, London 2000

p. 68 left: Dora Maar, *Léonor Fini in Black Stockings on a Bed*, c. 1936. Gelatin silver print 30.5 x 23.7 cm (12 x 9¼ in). © ADAGP, Paris and DACS, London 2000

p. 68 right: Dora Maar, *Léonor Fini Between Two Statues*, 1936. Gelatin silver print 30 x 23.8 cm (11¾ x 9⅜ in). © ADAGP, Paris and DACS, London 2000. Musée National d'Art Moderne, Centre Georges Pompidou, Paris

p. 69: Dora Maar, *Léonor Fini on a Clothes-Strewn Floor*, c. 1936. Gelatin silver print 18 x 24.3 cm (7⅛ x 9½ in). © ADAGP, Paris and DACS, London 2000

p. 70 above: Dora Maar, *Pont Mirabeau*, 1932–34. Gelatin silver print 27.6 x 24 cm (10⅞ x 9½ in). © ADAGP, Paris and DACS, London 2000

p. 70 below: Dora Maar, *Puppet Hooked on a Fence*, c. 1934. Gelatin silver print 27.3 x 23.2 cm (10¾ x 9⅛ in). © ADAGP, Paris and DACS, London 2000

p. 71: Dora Maar, *Grotesque*, c. 1935. Gelatin silver print 18.2 x 24 cm (7⅛ x 9½ in). © ADAGP, Paris and DACS, London 2000

p. 72 left: Dora Maar, *Untitled*, c. 1936. Photocollage with gouache 39.8 x 29.8 cm (15⅝ x 11¾ in). © ADAGP, Paris and DACS, London 2000. Private collection

p. 72 right: Dora Maar, *29 rue d'Astorg*, c. 1936. Hand-coloured gelatin silver print (photomontage) 29.4 x 24.4 cm (11⅝ x 9⅝ in). © ADAGP, Paris and DACS, London 2000. Musée National d'Art Moderne, Centre Georges Pompidou, Paris

p. 73: Dora Maar, *29 rue d'Astorg*, c. 1936. Gelatin silver print (photomontage) 29.1 x 24.1 cm (11⅜ x 9½ in). © ADAGP, Paris and DACS, London 2000

p. 74 left: Dora Maar, *Spanish Street Scene*, c. 1934. Gelatin silver print. © ADAGP, Paris and DACS, London 2000

p. 74 right: Dora Maar, *The Simulator*, 1936. Gelatin silver print (photomontage) 27 x 24.4 cm (10⅝ x 9⅝ in). © ADAGP, Paris and DACS, London 2000. Musée National d'Art Moderne, Centre Georges Pompidou, Paris

p. 75: Dora Maar, *Silence*, 1935–36. Gelatin silver print (photomontage) 27.6 x 22 cm (10⅞ x 8⅝ in). © ADAGP, Paris and DACS, London 2000

p. 76: Dora Maar, *Liberty*, 1935–36. Gelatin silver print (photocollage) 29.7 x 23.9 cm (11¾ x 9⅜ in). © ADAGP, Paris and DACS, London 2000

p. 77: Dora Maar, *Untitled*, 1935. Gelatin silver print (photomontage) 30 x 39 cm (11¾ x 15⅜ in). © ADAGP, Paris and DACS, London 2000. Musée National d'Art Moderne, Centre Georges Pompidou, Paris

p. 78: Dora Maar, *Portrait of Ubu*, 1936. Gelatin silver print 24 x 18 cm (9½ x 7 in). © ADAGP, Paris and DACS, London 2000

p. 80: Pablo Picasso, *Dora Maar in a Yellow Scarf, her Head Leaning to the Side*, November 1936. Oil on canvas 64.5 x 54 cm (25¼ x 21¼ in). © Succession Picasso/DACS, London 2000

p. 81: Pablo Picasso, *Dora Maar in a Polka-Dot Dress*, 14 September 1936. Pencil and stump drawing 37 x 27 cm (14⅞ x 10⅞ in). © Succession Picasso/DACS, London 2000

p. 82: Man Ray, *Dora Maar*, 1936. 24 x 30 cm (9½ x 11¾ in). © Man Ray Trust/ADAGP, Paris and DACS, London 2000. Lucien Treillard Collection, Paris

p. 84: Pablo Picasso, *Dora Maar in a Double-Breasted Jacket*, 20 October 1936 . Black ink on blue paper 27 x 21 (8⅝ x 10⅞ in). © Succession Picasso/DACS, London 2000

p. 85: Pablo Picasso, *Dora Maar and Classical Figure (Composition)*, 1 August 1936. Wash ink drawing 34.5 x 51 (13½ x 20½ in). © Succession Picasso/DACS, London 2000

p. 86: Pablo Picasso, *Portrait of Dora Maar*, 28 January 1937. Pencil and stump drawing 31.5 x 40.5 cm (12⅝ x 16 in). © Succession Picasso/DACS, London 2000

p. 87: Pablo Picasso, *ADORA*, 28 December 1938. Black ink drawing 27 x 35 (10⅝ x 13¾ in). © Succession Picasso/DACS, London 2000

p. 88–89: Roland Penrose, *Picasso and Dora Maar*, Mougins 1937. © Lee Miller Archives

p. 90 above: Pablo Picasso, *Dora Full Face, Fragment*, c. 1936. Pencil on torn tracing paper 32 x 14 (12⅝ x 5½ in). © Succession Picasso/DACS, London 2000

p. 90 below: Pablo Picasso, *Dora Maar in a Bikini*, c. 1936. Pencil on drawing pad sheet 32 x 23.5 cm (12⅞ x 9⅜ in). © Succession Picasso/DACS, London 2000

p. 91: Pablo Picasso, *Dora Maar as Bird-Woman*, 28 September 1936. Pencil and ink wash on blue paper 21 x 27 cm (8⅝ x 10⅞ in). © Succession Picasso/DACS, London 2000

p. 92 above: Man Ray, *Picasso on the Beach at Golfe Juan with Dora Maar and Kazbek*, summer 1937. Gelatin silver print 8.4 x 13.8 cm (3⅛ x 5½ in). © Man Ray Trust/ADAGP, Paris and DACS, London 2000

p. 92 below: Pablo Picasso, *Dora on the Beach (Portrait of a Woman)*, 1936. Pencil drawing 40.5 x 31.5 cm (16¼ x 12⅝ in). © Succession Picasso/DACS, London 2000

p. 93: Pablo Picasso, *Dora Maar on the Beach (Portrait of Dora Maar)*, 7 November 1936. Oil on canvas 65 x 54 cm (26 x 21⅝ in). © Succession Picasso/DACS, London 2000

p. 94: Dora Maar, *Portrait of Picasso under the Bamboo at the Hôtel Vaste Horizon*, 1936 or 1937. Gelatin silver print 22 x 17.2 cm (8⅝ x 6¼ in). © ADAGP, Paris and DACS, London 2000

p. 95: Dora Maar, *Picasso Standing in the Sea Holding up a Piece of Wreck Like a Sculpture*, 1936 or 1937. Gelatin silver print 20.4 x14.7 cm (8 x 5¾ in). © ADAGP, Paris and DACS, London 2000

p. 97: Pablo Picasso, *Dora and the Minotaur*, 5 September 1936. Charcoal, black ink, colour pencil and scratching on paper 40.5 x 72 cm (16¼ x 28¾ in). © Succession Picasso/DACS, London 2000. Photo © RMN – Michèle Bellot. Musée Picasso, Paris

p. 98: *7 rue des Grands Augustins, Hôtel d'Hercule*. © Roger-Viollet

p. 99: Brassaï, *Kazbek in the Studio on the rue des Grands Augustins*, 1944. © Estate Brassaï

pp. 101, 104–5, 108–9: Dora Maar, *Chronicle of the Development of Guernica*, May–June 1937. Nine gelatin silver prints from 19 x 29 cm to 24 x 30 cm (7½ x 11⅝ to 9½ x 11¾ in). © ADAGP, Paris and DACS, London 2000. © Succession Picasso/DACS, London 2000

pp. 102–3: Dora Maar, *Picasso on a Ladder in Front of Guernica*, May–June 1937. Gelatin silver print 19.7 x 20.4 cm (7⅝ x 8 in). © ADAGP, Paris and DACS, London 2000. © Succession Picasso/DACS, London 2000

p. 106: Dora Maar, *Picasso Crouching in Front of Guernica with a Ladder and Window Frame in the Background*, May–June 1937. Gelatin silver print 20.6 x 20 cm (8⅛ x 7⅞ in). © ADAGP, Paris and DACS, London 2000. © Succession Picasso/DACS, London 2000

pp. 106–7: Dora Maar, *Picasso in the Grands Augustins Studio Working on Guernica*, May–June 1937. Gelatin silver print 20.7 x 20 cm (8⅛ x 7⅞ in). © ADAGP, Paris and DACS, London 2000. © Succession Picasso/DACS, London 2000

p. 111: Dora Maar, *Picasso Seated on the Ground Behind his Ladder Painting Guernica*, May–June 1937 (detail). Gelatin silver print 20.6 x 20 cm (8⅛ x 7⅞ in). © ADAGP, Paris and DACS, London 2000. © Succession Picasso/DACS, London 2000

p. 112: Dora Maar, *Picasso's Head and Paintbrush over the top of his Ladder in front of Guernica*, May–June 1937. Gelatin silver print 20.3 x 29 cm (8 x 11⅜ in). © ADAGP, Paris and DACS, London 2000. © Succession Picasso/DACS, London 2000

pp. 114–115: Pablo Picasso, *Guernica*, May–June 1937. Oil on canvas 349 x 777 cm (137⅜ x 305⅞ in). © Succession Picasso/DACS, London 2000. Photo © Institut Amatller d'Art Hispanic. Museo Nacional Centro de Arte Reina Sofia, Madrid.

p. 116: Pablo Picasso in collaboration with Dora Maar, *Young Girl in Front of a Beach Hut (The Bather at Dinard)*, 1936–37. Left: oil on glass plate 30 x 24 x 0.2 (11¾ x 9½ x 1/16 in). Right: gelatin silver contact print 29.8 x 23.9 cm (11⅝ x 9⅜ in). © Succession Picasso/DACS, London 2000. © ADAGP, Paris and DACS, London 2000. Photos © RMN – Raux/Ojéda. Musée Picasso, Paris

p. 117: Pablo Picasso, *Profile of a Woman (Weeping Woman)*, 16 July 1937. Cliché-film 17.6 x 12.7 cm (6⅞ x 5 in). © Succession Picasso/DACS, London 2000. Photo © RMN. Musée Picasso, Paris

p. 118 left: Dora Maar, *Portrait of Pablo Picasso*, 1936. Oil on canvas 65 x 54 cm (25⅝ x 21¼ in). © ADAGP, Paris and DACS, London 2000

p. 118 right: Dora Maar, *Portrait of Pablo Picasso*, 1936. Oil on canvas 65 x 54.5 cm (26 x 21⅞ in). © ADAGP, Paris and DACS, London 2000

p. 119 left: Pablo Picasso in collaboration with Dora Maar, *Profile of a Woman (Dora Maar)*, 1936–37. Oil on glass 30 x 24 x 0.2 cm (11¾ x 9½ x 1/16 in). © Succession Picasso/DACS, London 2000. © ADAGP, Paris and DACS, London 2000. Photo © RMN. Musée Picasso, Paris

p. 119 right: Pablo Picasso in collaboration with

Dora Maar, *Woman in a Mantilla*, 1936–37. Gelatin silver contact print 29.8 x 23.7 cm (11¾ x 9⅛ in). © Succession Picasso/DACS, London 2000. © ADAGP, Paris and DACS, London 2000. Photo © RMN – Raux/Ojéda. Musée Picasso, Paris

p. 120 top to bottom: Pablo Picasso, ink and colour pencil drawing (*Female Nude with Raised Arms*) in frame-shaped pendant 1.7 x 1 cm (⅝ x ½ in) 1936–39; ink and colour pencil drawing (*Portrait of Dora*) in a yellow gold ring with polychrome enamel decoration 2.3 x 1.4 cm (1⅛ x ½ in) 1936–37; black and colour pencil drawing (*Portrait of Dora*) in an oval yellow gold pendant 2.5 x 1.5 cm (1 x ⅝ in), all 1936–39. © Succession Picasso/DACS, London 2000

p. 121: Pablo Picasso, *Dora Maar Seated*, 1937. Oil on canvas 92 x 65 cm (36¼ x 25⅝ in). © Succession Picasso/DACS, London 2000. Photo © RMN – J. G. Berizzi

p. 122: Pablo Picasso, *Woman Seated on a Chair*, 7 May 1938. Oil on canvas. © Succession Picasso/DACS, London 2000. Photo © Sotheby's

p. 123: Brassaï, *Picasso Stacking up Portraits of Dora Maar*, 1939. © Estate Brassaï. Photo © RMN – Michèle Bellot

p. 124: Pablo Picasso, four studies pencil and coloured pencil on matchboxes and (bottom left) a cigarette packet. © Succession Picasso/DACS, London 2000

p. 125: Pablo Picasso, *Portrait of Dora in a Garden*, 10 December 1938. Oil on canvas 131 x 97 cm (51½ x 38¼ in). © Succession Picasso/DACS, London 2000

p. 126: Pablo Picasso, *Weeping Woman (Study for Guernica)*, 22 June 1937. Oil on canvas 55 x 46 cm (22 x 18⅜ in). © Succession Picasso/DACS, London 2000

p. 127: Dora Maar, *Weeping Woman*, c. 1937. Oil on canvas 55 x 46 cm (21⅝ x 18⅛ in). © ADAGP, Paris and DACS, London 2000

p. 128: Dora Maar, *Weeping Woman*, 1937. Oil on canvas 60 x 49 cm (23⅝ x 19¼ in). © Succession Picasso/DACS, London 2000. Tate Modern, London

p. 129: Dora Maar, *Weeping Woman in a Red Hat*, c. 1937. Oil on canvas 61 x 50 cm (24 x 19⅝ in). © ADAGP, Paris and DACS, London 2000

p. 130: Dora Maar, *Weeping Woman on a Red Background*, c. 1937. Oil on canvas 65 x 54 cm (25⅝ x 21¼ in). © ADAGP, Paris and DACS, London 2000

p. 131: Dora Maar, *Weeping Woman Under a Lamp*, c. 1937. Oil on canvas 55 x 38 cm (21⅝ x 15 in). © ADAGP, Paris and DACS, London 2000

p. 132: Pablo Picasso, *Profile of Woman (Dora Maar)*, 30 November 1937. Cliché-film 17.7 x 12.7 cm (7 x 5 in). © Succession Picasso/DACS, London 2000. Photo © RMN. Musée Picasso, Paris

p. 133: Lee Miller, *Dora Maar*, Mougins, 1937. © Lee Miller Archives

pp. 134–35: Roland Penrose, *Picnic at Mougins*, 1937. © Lee Miller Archives

p. 136: Dora Maar, *Aperitif in the Garden of the Hôtel Vaste Horizon*, 1936 or 1937. Gelatin silver print 24.5 x 19.7 cm (9⅝ x 7¾ in). © ADAGP, Paris and DACS, London 2000

p. 137: Dora Maar, *Pablo Picasso and Paul Eluard in Conversation over Lunch at the Hôtel Vaste Horizon*, 1936 or 1937. Sepia-toned gelatin silver print 22.9 x 16.9 cm (9 x 6⅝ in). © ADAGP, Paris and DACS, London 2000

p. 138: Anonymous, *Dora Maar Photographing Nusch Eluard Asleep on the Beach*, 1936. Gelatin silver contact print 6.1 x 10.4 cm (2⅜ x 4⅛ in)

p. 139: Dora Maar, *Nusch Eluard Lying Face-Down on the Beach*, 1936 or 1937. Sepia-toned gelatin silver print 9.9 x 15.8 cm (3⅞ x 6¼ in). © ADAGP, Paris and DACS, London 2000

p. 140: Pablo Picasso, *Portrait of Nusch Eluard*, 1936–37. Pencil on a drawing pad sheet 32 x 23.5 cm (12⅞ x 9⅜ in). © Succession Picasso/DACS, London 2000

p. 141: Eileen Agar, *Dora Maar, Nusch Eluard, Pablo Picasso and Paul Eluard at Juan les Pins*, 1937

p. 142: Pablo Picasso and Dora Maar, clockwise from top left: *Dora Maar with Another Woman (Sonia Mossé?)*; *Picasso Sitting on the Bed, Half in Shadow*; *Jacqueline Lamba and Dora Maar, with the Shadow of Picasso*; *Jacqueline Lamba Seated Naked on the Floor*, all c. 1936. Four gelatin silver prints each 12.1 x 12.1 cm (4¾ x 4¾ in). © Succession Picasso/DACS, London 2000

p. 143: Pablo Picasso, *Portrait of Dora in a Crown of Flowers*, 13 February 1937. Pencil, pastel and scratching drawing 29 x 23 cm (11½ x 9¼ in). © Succession Picasso/DACS, London 2000

p. 144: Anonymous, *Dora Maar and Picasso on the Beach after a Dip in the Sea*, 1936 or 1937. Gelatin silver print 11.2 x 8 cm (4⅜ x 3⅛ in)

p. 145: Dora Maar, *Picasso With a Cow's Skull*, 1937. Gelatin silver print 29.5 x 22.8 cm (11⅝ x 9 in). © ADAGP, Paris and DACS, London 2000

pp. 146–47: Man Ray, *Ady, Marie Cuttoli and her husband, Man Ray, Picasso and Dora Maar Seated on Steps in the South of France (Antibes?)*, summer 1937. © Man Ray Trust/ADAGP, Paris and DACS, London 2000

p 148 top to bottom: Pablo Picasso, *Profile*, 1940, bone pendant/amulet, 9 x 5 cm (3⅝ x 2 in); *Eagle's Head*, 1937, bone, 8 cm (3¼ in); *Fish*, c. 1940, engraved terracotta, 2.5 x 4 cm (1 x 1¾ in). © Succession Picasso/DACS, London 2000

p. 149: Pablo Picasso, *Night Fishing at Antibes*, August 1939. Oil on canvas 205.8 x 345.4 cm (81 x 136 in). © Succession Picasso/DACS, London 2000. The Museum of Modern Art, New York. Mrs Simon Guggenheim Fund. Photograph © 2000 The Museum of Modern Art

p. 150: Dora Maar, *Picasso with Kazbek in Front of Reclining Nude, Marie-Thérèse of 3 April 1932*, no date. Autochrome on acetate 5.8 x 5.8 cm (2¼ x 2¼ in). © ADAGP, Paris and DACS, London 2000

p. 151: Dora Maar, *Portrait of Pablo Picasso in a Black Hat*, 3 November 1939. Oil on canvas

61 x 50 cm (24 x 19⅝ in). © ADAGP, Paris and DACS, London 2000

p. 152: Dora Maar, *Cubist Face*, c. 1939. Oil on panel 67 x 60 cm (26⅜ x 23⅝ in). © ADAGP, Paris and DACS, London 2000

p. 153: Dora Maar, *Portrait of Pablo Picasso in a Mirror*, no date. Oil on canvas 60 x 50 cm (23⅝ x 19⅝ in). © ADAGP, Paris and DACS, London 2000

p. 154: Dora Maar, *Portrait of Jacqueline Breton*, no date. Oil on canvas 92 x 73 cm (36¼ x 28⅜ in). © ADAGP, Paris and DACS, London 2000

p. 155: Dora Maar, *Man and Pink Tree*, January 1939. Oil on canvas 65 x 54 cm (25⅝ x 21¼ in). © ADAGP, Paris and DACS, London 2000

p. 156: Pablo Picasso, *Head of a Woman*, 11 June 1940. Oil on paper 64.8 x 45 cm (25½ x 17¾ in). © Succession Picasso/DACS, London 2000. Photo © RMN. Musée Picasso, Paris

p. 157: Rogi André, *Dora Maar*, 1941. Gelatin silver print 29.3 x 21.7 cm (11½ x 8½ in)

p. 158: Pablo Picasso, *Eight Heart-Shaped Faun's Heads*, c. 1943. Black and colour pencil on cut paper. © Succession Picasso/DACS, London 2000

p. 159: Pablo Picasso, *Three skulls*, 1943, torn paper 14 cm, 12 cm and 14 cm (5½ in, 4¾ in and 5½ in); *Head of a Faun*, 1943, torn paper 24 cm (9⅝ in). © Succession Picasso/DACS, London 2000

p. 160: Pablo Picasso, *Figure with Raised Arms*, 1943. Torn paper with cigarette burns 30 cm (12 in). © Succession Picasso/DACS, London 2000

p. 161: Pablo Picasso, *Woman Dressing her Hair*, June 1940. Oil on canvas 132 x 97.1 cm (51¼ x 38¼ in). © Succession Picasso/DACS, London 2000. The Museum of Modern Art, New York. Louise Reinhardt Smith Bequest. Photograph © 1998 The Museum of Modern Art, New York.

p. 162: Pablo Picasso, *Bird and Dancer*, 1943. Shaped tin bottle caps 7 cm (2⅞ in) and 5 cm (2 in). © Succession Picasso/DACS, London 2000

p. 163: Pablo Picasso, *Blackbird*, 1943. Wood and plaster 12 cm (14¾ in). © Succession Picasso/DACS, London 2000

p. 164: Rogi André, *Dora Maar*, 1941. Gelatin silver print 29.5 x 22.7 cm (11⅝ x 9 in)

p. 165: Pablo Picasso, *Portrait of Dora Maar*, 9 October 1942. Oil on panel 92 x 73 cm (36¼ x 28¾ in). © Succession Picasso/DACS, London 2000. Collection Stephen Hahn, New York

p. 166: Pablo Picasso, *Dora Maar's Studio*, 4 May 1943. Pencil drawing 28.5 x 40.5 cm (11½ x 16¼ in). © Succession Picasso/DACS, London 2000

p. 167 left: Dora Maar, *Jean Cocteau*, c. 1935. Gelatin silver print 10.6 x 8.1 cm (4⅛ x 3⅛ in). © ADAGP, Paris and DACS, London 2000

p. 167 right: Jean Cocteau, *Portrait of Paul Eluard*, 1942. Charcoal on canvas 91.5 x 65 cm (36½ x 26 in). © ADAGP, Paris and DACS, London 2000

p. 168: Title-page of Buffon's *Histoire naturelle* (Paris, 1942) with engraving and inscription by

Picasso. © Succession Picasso/DACS, London 2000. Photo © RMN. Musée Picasso, Paris

p. 170: Dora Maar, *Picasso and Kazbek in Dora Maar's Apartment on the rue de Savoie*, c. 1942. Gelatin silver print 22.8 x 17.2 cm (9 x 6¾ in). © ADAGP, Paris and DACS, London 2000

p. 171: Photolido, *Dora Maar and Picasso in a Small Padded Drawing Room*, 1940s. Gelatin silver print 17.5 x 23.5 cm (6⅞ x 9¼ in)

p. 172: Pablo Picasso, *Dora en Déshabillé*, 2 April 1943. Black ink and gouache on paper 28 x 7 cm (11¼ x 3⅛ in). © Succession Picasso/DACS, London 2000

p. 173: Pablo Picasso, *Dora Maar in a Mauve Scarf*, 26 April 1942. Oil on canvas 46 x 38 cm (18⅜ x 15¼ in). © Succession Picasso/DACS, London 2000

p. 174 above: Pablo Picasso, *Three Alarm Clocks*, 1940–42. Pencil on a shoe box 31 x 20 cm (12½ x 8 in). © Succession Picasso/DACS, London 2000

p. 174 below: Dora Maar, *Alarm Clock*, 9 August 1940. Oil on canvas 24 x 35 cm (9½ x 13¾ in). © ADAGP, Paris and DACS, London 2000

p. 175: Dora Maar, *Composition With Alarm Clock*, 20 April 1943. Oil on canvas 81 x 65 cm (31⅞ x 25¾ in). © ADAGP, Paris and DACS, London 2000

p. 176: Ina Bandy, *Portrait of Dora Maar*, late 1930s. Gelatin silver print 23.5 x 18.1 cm (9¼ x 7⅛ in)

p. 177: Izis (Israël Bidermanas), *Dora Maar in a Shirt and Corduroy Jacket*, 1946. Sepia-toned gelatin silver print 29.8 x 23.7 cm (11¾ x 9⅛ in)

p. 178: Anonymous, *Dora Maar Bare-Shouldered Behind a Bouquet (Self-Portrait?)*, early 1940s. Gelatin silver print 22 x 13.3 cm (8⅝ x 5¼ in)

p. 179: Izis (Israël Bidermanas), *Portrait of Dora Maar*, 1946. Gelatin silver print 29.7 x 23.8 cm (11⅝ x 9⅜ in)

p. 180: Brassaï, *Dora Maar in her Studio*, 1944. © Estate Brassaï. Photo © RMN – F. Raux. Musée Picasso, Paris

p. 181: Dora Maar, *The Quays of the Seine*, 5 June 1944. Oil on canvas, 81 x 100 cm (31⅞ x 39⅜ in). © ADAGP, Paris and DACS, London 2000

p. 182 top to bottom: Pablo Picasso, *White Dog*, 1943, torn paper burned with a cigarette, 14 x 21 cm (5¾ x 8¼ in); *Boy in a Sailor Suit*, c. 1940, pencil on torn paper, 8 x 6.5 cm (3¼ x 2½ in); *Head and Shoulders of a Woman*, 1943, torn paper tablecloth, 16 x 12.3 cm (6⅜ x 5 in). © Succession Picasso/DACS, London 2000

p. 183: Pablo Picasso, *Eight Torn Paper Fragments*, 1943. 10 to 36 cm (4⅜ to 14⅛ in). © Succession Picasso/DACS, London 2000

p. 184: Izis (Israël Bidermanas), *Portrait of Dora Maar Under a Lampshade*, 1946. Sepia-toned gelatin silver print 29.8 x 23.9 cm (11¾ x 9⅜ in)

p. 185: Dora Maar, *Portrait of Nusch Eluard*, 1935. Gelatin silver print 24 x 18.2 cm (9½ x 7⅛ in). © ADAGP, Paris and DACS, London 2000

pp. 186–87: Anonymous, *Dora Maar at Home in the rue de Savoie (Self-Portrait?)*, late 1940s. Gelatin silver print 20 x 24.6 cm (7⅞ x 9⅝ in)

p. 188: Michel Sima, *Dora Maar in her Studio*, 1946. © Rue des Archives. © ADAGP, Paris and DACS, London 2000

p. 189 above: Dora Maar, *Head and Shoulders of a Woman*, no date. Oil on canvas 41 x 33 cm (16⅛ x 13 in). © ADAGP, Paris and DACS, London 2000

p. 189 below: Dora Maar, *Double Portrait*, no date. Oil on canvas 55 x 46 cm (21⅝ x 18⅛ in). © ADAGP, Paris and DACS, London 2000

pp. 190–91: Photos © Brice Toul, 1999

p. 193: Dora Maar, *Portrait of James Lord*, July 1954. Pencil sketch 50 x 33.5 cm (19¾ x 13¼ in). © ADAGP, Paris and DACS, London 2000

p. 196: Photo Charles Gimpel, 1970s

p. 197: Photo James Lord, 1950s

pp. 199 and 200: Dora Maar, *Untitled*, etchings from André du Bouchet's *Dans la chaleur vacante* (Paris, J. Hughes, 1956), pp. 1 and 4. Print Collection. Miriam and Ira D. Wallach Division of Art, Prints and Photographs. The New York Public Library. Astor, Lenox and Tilden Foundations. © ADAGP, Paris and DACS, London 2000

p. 202 left: Dora Maar, *Sky and Mountain*, no date. Oil on canvas 46 x 38 cm (18⅛ x 15 in). © ADAGP, Paris and DACS, London 2000

p. 202 right: Dora Maar, *Large White Sky*, no date. Oil on canvas 55 x 46 cm (21⅝ x 18⅛ in). © ADAGP, Paris and DACS, London 2000

p. 203: Dora Maar, *Landscape and Sky*, no date. Oil on canvas 46 x 55 cm (18⅛ x 21⅝ in). © ADAGP, Paris and DACS, London 2000

p. 204 left: Dora Maar, *Portrait of André Breton, Superimposed with Corn and Crystals (Salt?)*, 1930s/1980s. Gelatin silver contact print 10.7 x 8.5 cm (4¼ x 3⅜ in). © ADAGP, Paris and DACS, London 2000

p. 204 right: Dora Maar, *Lise Deharme Seated Among Plants, Superimposed with Sprigs of Parsley*, c. 1936/1980s. Gelatin contact print on silver paper 11.7 x 8.7 cm (4⅝ x 3⅜ in). © ADAGP, Paris and DACS, London 2000

p. 206: Photo © Mary Ann Caws, 1999

pp. 208–211: Photos © Brice Toul, 1999

p. 212: *Saint-Germain-des-Prés, Monument to Apollinaire (Head of Dora Maar)* by Pablo Picasso. © Roger-Viollet. © Succession Picasso/DACS, London 2000

p. 215: Pablo Picasso, *Fish*, 1943. Torn paper 13 x 23 cm (5⅛ x 9 in). © Succession Picasso/DACS, London 2000

p. 217: Pablo Picasso, *Two Dogs' Heads*, 1943. Torn paper. © Succession Picasso/DACS, London 2000

p. 218: Pablo Picasso, *Eleven Studies*, c. 1939. Pencil on matchboxes. © Succession Picasso/DACS, London 2000

Index